Teaching Illustra- tion

Steven Heller
and Marshall Arisman

Course Offerings and Class Projects from the Leading Undergraduate and Graduate Programs

ALLWORTH PRESS
NEW YORK

School of
VISUAL ARTS

10 09 08 07 06 5 4 3 2 1

Published by Allworth Press
An imprint of Allworth Communications, Inc.
10 East 23rd Street, New York, NY 10010

Cover and interior design by James Victore
Typography/page composition by SR Desktop Services, Ridge, NY

ISBN-13: 978-1-58115-466-5
ISBN-10: 1-58115-466-6

Library of Congress Cataloging-in-Publication Data
 Teaching illustration: course offerings and class projects from the leading
 undergraduate and graduate programs/[edited by] Steven Heller and Marshall Arisman.
 p. cm.
 Includes bibliographical references and index.
 ISBN-13: 978-1-58115-466-5 (pbk.)
 ISBN-10: 1-58115-466-6 (pbk.)
 1. Commercial art—Study and teaching (Higher)—United States. 2. Commercial
 art—Study and teaching (Graduate)—United States. 3. Universities and colleges—
 Curricula—United States. I. Heller, Steven. II. Arisman, Marshall.

 NC1000.T42 2006
 741.6071'173—dc22

 2006035208

Printed in Canada

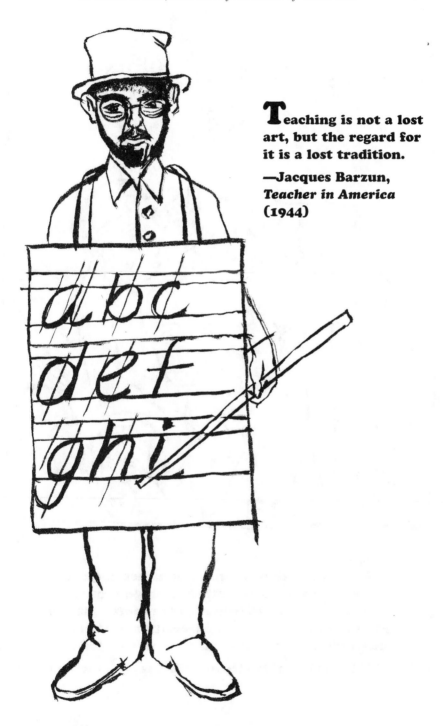

Teaching is not a lost
art, but the regard for
it is a lost tradition.
—Jacques Barzun,
Teacher in America
(1944)

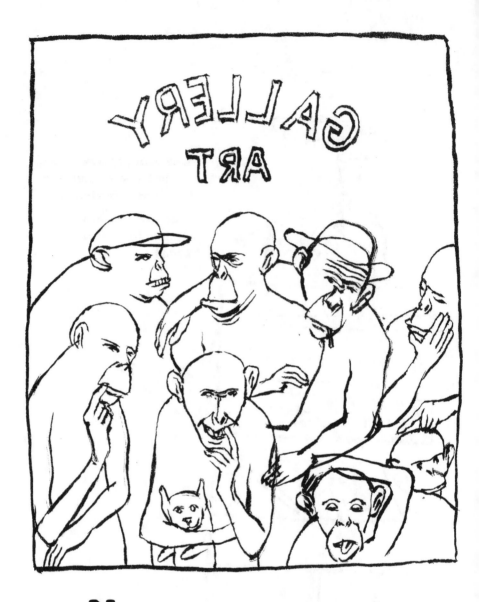

No generation is interested in art in quite
the same way as any other; each generation,
like each individual, brings to the contemplation
of art its own categories of appreciation, makes its own
demands upon art, and has its own uses for art.

—T. S. Eliot, *The Use of Poetry and the Use of Criticism* (1933)

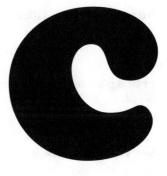

contents

Sophomore

Introduction to Illustration _ 27
Ann Field and Jeffrey Smith
Art Center College of Design

Principles of Illustration _ 31
Stephen Savage and Wesley Bedrosian
School of Visual Arts

Survey of Illustration _ 35
Julie Lieberman
Savannah College of Art and Design

Illustration II _ 38
Jon McDonald
Kendall College of Art and Design

Spring Illustration II _ 41
Lynn Pauley
Pratt Institute

Visual Studies: Drawing _ 44
Jorge M. Benitez and James Miller
Virginia Commonwealth University

History of Illustration _ 52
Dan Nadel
Parsons School of Design

**Etching and Monoprint as Illustration/
Illustrating Books with Prints _ 55**
Bruce Waldman
School of Visual Arts

Digital Illustration _ 57
Federico Jordán
Universidad Autónoma de Nuevo León

Part 2: Graduate

Knowledge is the true organ of sight, not the eyes.
—*Panchatanra* (c. First Century A.D.)

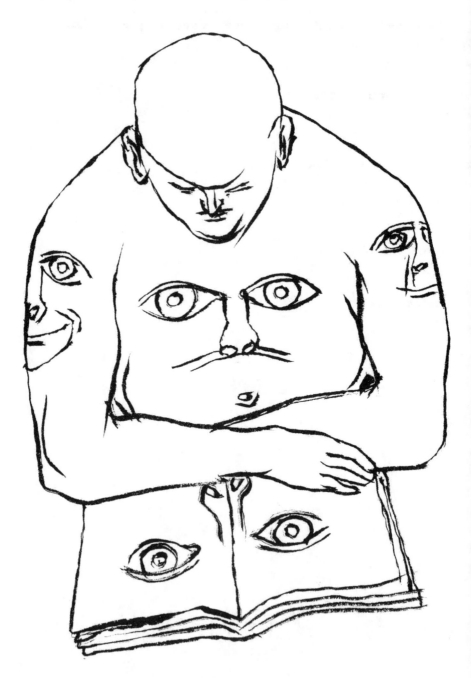

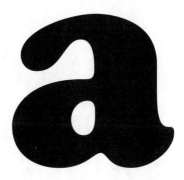

acknowledgments

Thanks to Kim Ablondi, without whose tireless support this book would not be possible. You are a saint.

Our friends at Allworth Press also earned their place in heaven. Thanks to Monica Lugo, associate editor, for her invaluable editing and molding of this unwieldy manuscript. Our gratitude to Michael Madole, Gebrina Roberts, Cynthia Rivelli, and Bob Porter for their hard work on our behalf. And to Tad Crawford, publisher, for his continued faith in our projects.

Of course, all the contributors must be commended for their fine syllabi, but also for their dedication to illustration and education.

Finally, thanks to James Victore for his cover and interior design schemes, and to Susan Ramundo for her fine production work.

—SH and MA

Never try to teach a pig to sing . . .
it wastes your time and annoys the pig.

—Anonymous, Texas Saying

foreword

Can Illustration be Taught? Are Illustrators Teachable?

Don't be misled by the title of this foreword. Illustration can most definitely be taught. After teaching at the School of Visual Arts for almost forty years, my co-editor Marshall Arisman would be a fool to say otherwise. What's more, his School of Visual Arts MFA Illustration program has turned out its fair share of successful illustrators, proving that some practitioners are indeed extremely teachable. So, if the readers of this text thought I was throwing myself into a hornet's nest with such provocative introductory questions, rest assured I'm convinced the tenets and techniques of illustration are routinely passed on from teacher to student. Nevertheless, an important question remains: How does this occur?

Some pedagogical issues have been more or less standardized, yet no text-book (save for those so-called applied art instructional guides found on book-store how-to shelves) exists to steer the erstwhile illustration teacher in the right direction. Of course, tried-and-true programs in drawing and painting (even in three dimensions) can be found in most art schools catering to illustration majors, but few schools teach the exact courses at the same pace or levels. Despite basic curriculum requirements, illustration coursework is usually a function of the respective teachers' interests, passions, and expertise rather than dictates from an "illustration academy." Since undergraduate illustration programs are an academic netherworld—often cobbled together from classes that are part art and part craft, with a little commerce thrown in for good measure—teaching is sometimes catch-as-catch-can depending on the intensity of the program, and students suffer the consequences.

Another problem, however, lies in the fact that a large percentage of students enrolled in illustration programs really have no idea what illustration actually is (and I include seniors in this assessment). Since it is a commercial discipline, parents don't have the same qualms about allowing their children to go to college for illustration as they do about the more ethereal fine arts. Yet

many students become illustration majors not because they want to make livings doing editorial, advertising, or children's books, but because it allows them a chance to make art. Many illustration classes are so art oriented that the distinction between fine and applied is virtually obliterated.

Of course, theoretically the basic principles of art universally apply—good illustration should be good art—but since the motives and outcomes are quite different there is often an evaluative contradiction. Generally, fine art is more about form than content; illustration is more about content (and style) than form (although the two should intersect). Students are, therefore, often confused by courses that emphasize "free expression" over the rigors of problem solving, and unless they are committed to becoming serious illustrators they find it rather difficult to adjust to the strictures of the illustration field. While visiting a class of seniors at a prestigious art school, I asked how many of them, upon graduation, wanted to pursue the illustration profession? Out of forty students, only two raised their hands—and one of them wanted to make graphic novels and comic animation—while the rest were nervously uncertain.

Is this profound lack of interest a failure of education? Or is it endemic to the education process?

Arguably, most undergraduates in all disciplines are unsure about their career paths, and only a few actually follow their majors into the workplace. The increase in graduate enrollment attests to the fact that an undergrad degree is not the end but the beginning. While illustration programs seem to focus on a narrow career path, students may nonetheless fulfill their degree requirements only to find they are not suited for illustration. Like English or sociology programs in liberal arts schools, illustration may be one of those all-encompassing art school majors whereby students are introduced to a potpourri of crafts and skills that may or may not benefit them later. But when I spoke with those forty students, I found honest concern that after three years they weren't prepared to meet the world. Some suggested that as hard and rewarding as their coursework was, they were unclear what to do next ("I don't want to draw pictures for magazines," said one anxious female student, "do you think maybe I should study art therapy?").

I have recently surveyed final thesis exhibitions by seniors in different undergraduate programs, and it is very clear that those students who were ambivalent about being illustrators in the first place produce work that blurs the boundaries (and not necessarily in a good, but rather a confused way). This does not mean they are doomed, but it does underscore the difficulties facing illustration students as a tidal wave of new technologies washes over media. It is no longer enough to be a good drawer or painter, although these are essential languages to master. Rather, one must now understand how image-making and image-conceiving fit into other new communications platforms, and be able to adapt to them. While it's fine to want to study art and good to focus on a discipline that can financially support the passion, it's more important to truly understand how art (once taught, learned, and mastered) interplays with a broad range of media. It is necessary to identify those ambivalent illustration majors and

help them find their strengths—be they graphic, motion, or Internet design—and provide viable learning opportunities for them. It is also important to precisely define the increasing parameters of an illustration education.

Illustration can no longer afford to be parochial. The days are over when the beautifully crafted picture was the quintessential virtue. Illustrators have branched out into animated film, graphic novels, Web and exhibition display, to name a few options. While this does not mitigate the need for intensive image-making courses, it demands more integration, which means new and more imaginative classes that stretch boundaries. It also suggests that the ad hoc principles of teaching illustration are obsolete. In lieu of the as-yet nonexistent illustration textbook (which at this stage should include ancillary design disciplines), illustration program chairs should be more rigorous about insisting on syllabi. Since students barely understand the nature of their programs from the brief and often vague descriptions in college registration books, illustration departments need to require that their instructors and professors chart out classes in a precise and systematic manner. This should not inhibit the creative teacher from diverging from the lesson plan, but it will provide a map and guidepost for the individual classes and the programs as a whole.

In compiling *Teaching Illustration*, a sequel to my *Teaching Graphic Design*, Marshall Arisman and I contacted scores of schools and about one hundred teachers only to find that a sizeable number do not have syllabi beyond a rudimentary listing of assignments. Unlike graphic design teachers who maintain detailed documents, this laissez-faire approach to teaching illustration was at once understandable and disquieting. Of course, there were exceptions—and many of those teachers' syllabi are represented here—but we also found we had to urge other good teachers to make syllabi for the first time. Having a detailed plan does not ensure a successful class, but it certainly helps the student on this confusing path. When the syllabi are compiled in this book, we also believe they aid other chairpersons and teachers who may want to compare, contrast, and refine their own programs.

Teaching Illustration is the first compilation of this kind. Organized by educational level, it begins with Freshman (only a few syllabi because in many schools this is also the foundation year), picking up steam with Sophomore, building to a peak with Junior (where much of the integrated programming is introduced), and leveling out with Senior (when students are instructed how to build their professional portfolios and finish more academic thesis work). We also have included a few graduate syllabi, though these were surprisingly harder to come by.

Illustration can be taught, and illustrators are teachable, but how is this being done these days, and how it should occur in the future? These remain the big questions. *Teaching Illustration* offers various means of molding future illustrators and inculcating them with the interest and passion they will need to continue—or apply their talents to the newest of new media.

—Steven Heller

Art does not
reproduce the
visible; rather, it
makes visible.

—Paul Klee, *The
Inward Vision* (1959)

introduction

Illustration is defined as an applied art. It's a definition wholly inadequate to explain the field or how it works. And yet, in many art colleges and universities across the country, it is now accepted that illustration *is* an applied art like graphic design. The real definition of illustration is a figurative art form based on storytelling. Despite this, some institutions have gone as far as to combine design and illustration into one department. The reasoning is usually based on perceived changes in both fields due to technology, but most often the real reason for the integration is financial. Unfortunately, the message such a structural change sends to the field and to students is that illustration can be taught as a skill, like 3D design, to fill out a student's education as a commercial artist.

That would be far easier to do, but nothing is further from the truth. Teaching illustration and teaching graphic design are entirely different processes. But the definition of illustration is so ingrained in art schools' lexicon that to define it correctly is almost impossible. This lack of clarity has resulted in the creation of illustration departments in various art institutions that have no focus. If the department chairperson and the faculty don't have a clear understanding of what illustrators need to know—the history of their art and the changing marketplace for illustration—they have a long way to go. If they are unable to help students to discover their personal vision, the chances of graduating students who can succeed in the field are highly unlikely.

The best teachers know from their own experience the importance of finding one's subject matter and are able to help students clarify their process. This time-intensive teaching method also calls for commitment from students if they are to be successful in bringing their vision forward onto paper, canvas, or the computer screen. Students, of course, can learn to draw and paint, often very well, without finding their subject matter, but chances are that *what* they draw and paint—people, animals, buildings, landscapes, etc.—will lack the conviction and authenticity that mark the work as personal and unique.

I believe it's important for illustration to be taught as a figurative art form—that is, emphasizing personal expression and subject matter with drawing and painting as its foundation. The foundation for illustration is figurative drawing and painting (figuration is the art term currently used to define this form). The only difference between figurative drawing and painting in illustration and fine art is in its application or use. (In the fine arts, the terms "drawing" and "painting" are inclusive of individual definitions such as abstract and conceptual art forms, and almost anything else.)

We should note here that the term "fine art" is not a judgment implying quality, although it has come to mean that. Imagery shown in galleries and museums is called "fine art," regardless of subject matter, size of the work, or substance. What "fine art" really means is that the work of art was created to express the personal subject matter of the artist. So it seems to me that today's broad application of imagery in the growing multimedia scene makes defining figurative drawing and painting with terms like "illustration" or "fine art" irrelevant. Let's simply call it figuration. When an existing painting (or "figurative fine art" work) is used as a book jacket referencing the content of the story, it is illustration, whatever its original intent. When the imagery is applied—that is, used by magazines, books, advertising, and moving media (film, television, video, or computer animation) to enhance text, sell a product, create a specific mood, and so on—we call it *illustration*. Therefore, it is my view that most fine art programs miss an opportunity to expand the venues for their students' work by implying—sometimes insisting—that galleries and museums are the only appropriate ones.

When artists find their unique expression, they can take advantage of all outlets for their work, including galleries and museums. Intellectually and emotionally, they will be prepared to survive the difficulties and complications of seeing their work out in the world. They will understand that energy comes from being connected to their subject matter. They will be amazed that new outlets for their art will continue to develop as they grow and mature.

The responsibility of educators is to encourage, coerce, and even manipulate students to help them discover what is unique in them. If what they have to say is banal, the educator's job is to find in the students the individualistic vision that lies at the heart of interesting pictures. If the execution of their vision is unsure or inadequate, the instructors are responsible for showing the

way to source material that inspires—books, music, mentors, whatever it takes to challenge the imagination. Excellent teaching also demands a call for improving picture composition, making certain that students have the drawing and painting skills needed to express a personal vision. Our job as teachers is to make sure our students don't graduate without this.

For the artist today, with widespread, deep, and rapid changes taking place in the very structure of our lives, understanding the importance of the creative process is not theoretical. It must be personal and experiential. I don't want to be dramatic about this, but making art for artists is not only a career but more importantly, it is crucial for our emotional and psychological survival. The experience of creating work is at the core of living a meaningful life. A finished product for an artist is more often simply a steppingstone. For this reason, I disagree strongly with a style-driven education for an illustrator. As teachers, we need to arm students with enough technical expertise to seize the moment when concept and inspiration happen. Demanding that students develop a "style" is to limit their career opportunities. Such a narrow definition can rob your most talented students of their personal artistic drive—the impetus that gives them the energy to focus on what they have to say and how they say it.

I've observed a number of illustration programs over the years. Inevitably, those programs that gear curricula to respond only to "the market" or the latest "style" fad will turn out hacks. Can these students get work? Sure. Can they earn a living? Yes. Will they have the opportunity to grow and develop as artists, create new directions for application of their talent, and successfully change the work they do to match personal growth, knowledge, and experience? Will they last as artists? Unlikely.

Illustration history proves that artists have set a precedent that we would do well to consider in developing a curriculum for figurative artists. In the early twentieth century, figurative fine artists who had already established their subject matter were brought into the marketplace to illustrate books and magazines. The artists determined the content of the visuals in the publications, not the art directors or publishers (as is widely assumed). The artist's vision brought the market to the artist. In fact, the personal vision of Charles Dana Gibson in the 1930s redefined the role of women in society. J.C. Leyendecker created the "ideal" American male. By the 1940s, it was Norman Rockwell's vision of America devoid of gangsters, prostitutes, and social corruption that captured the publishing world and the market. The imagery was deemed "commercial"—meaning it had a broad range of appeal across the country. Simply because it was popular does not diminish Rockwell's personal vision as an artist any more than Cezanne's views of Paris, Monet's gardens, or Gaugin's vision of Tahiti.

The 1950s saw a more complicated society reflected in its publications. Society was evolving, and magazines like *Esquire*, *Playboy*, and *Psychology Today* needed images to accompany their stories of a multi-layered culture. Again,

artists like Robert Weaver, the undisputed pioneer of expressive illustration, were producing personal work combining figurative and abstract elements, dividing pages in ways not seen before. Perfectly suited to the needs of the market, his personal work defined his times. He once said, "I wonder how Norman Rockwell would handle this article I have to illustrate titled 'The Psychological Complications of Being Left-Handed'?" Once again, one artist's personal vision was applied to illustrate a multi-faceted story. He was fortunate to find an outlet for his personal subject matter. It just happened to be in magazines instead of on gallery walls, and he was comfortable with the outlet.

By the end of the 1960s, illustration moved onto the op-ed page of the *New York Times*. For a brief period, artist/illustrators with strong personal visions appeared on the op-ed page. Their work could be applied to the political arena to make graphic commentary on the issues of the times. The visual styles included Surrealism, Symbolism, Dadaist Collage, and Expressionism. The driving force for using these artists was a strong art director; J.C. Suarez believed that visuals as powerful as the words they accompanied belonged on the same page, and I know he had to fight editors for the images he wanted to include. If artists are ever concerned that pictures have no impact, one would have to be a fly on the wall of the editorial department of the *New York Times* as they argued whether an image was "too strong" or "too graphic" for the readers of the paper to see. As you well know, stories and photographs of horrific events with vivid description appear daily on the pages of newspapers and a few select magazines, creating little comment, but a drawing or painting on the same subject with a personal perspective is seldom commissioned and if, by chance, it is, often the image is not used. That's the downside of personal vision, but I for one would occasionally like to know that a picture was rejected because it was too powerful, rather than accepted because it said little.

The 1980s saw a more personal approach to drawing. Draftsmanship took a back seat to personal expression influenced by the popularity of *Outlaw Art*—often powerful imagery inspired by personal experience and created by untrained artists. The fresh imagery—an intent to express deeply personal observations and feelings—was chosen by galleries and museums to exhibit on their walls. Traditional media—including magazines, film, video, etc.—followed their lead and found appropriate uses for these pictures.

These examples from the history of illustration confirm again that figurative artists who have found their subject matter and have undergone the process to develop a personal vision will find work and be successful. The questions, "Draw what? Paint what? Express what?" need to be asked if there is to be an effective system to develop artists, one that we as artists, teachers, and department heads must consider seriously. The only acceptable answer is "Anything goes as long as the vision is authentic and the story is personal."

Learning basic skills and developing an understanding of one's own subject matter is essential to becoming an illustrator. Bringing these two concepts

together in a teaching method to educate illustration majors is the responsibility of the department chairperson, who needs to hire faculty who believe in the philosophy of the curriculum, are strong at teaching skills, and are talented in helping students discover their own content. It also demands that the chair and the faculty step back from their own egos, not imposing their own biases and preferences on the students. It's been my experience that all good teachers do this naturally. They are usually highly accomplished artists, deeply interested in their own creative process, which incidentally is of importance only to them. Choosing the right faculty and creating a curriculum where skill and content overlap seamlessly is the challenge. It is not easy. A healthy curriculum is based upon the understanding that the teaching of both skill and content must have a wide approach base and that there is no single right way to do either.

It is well known that the majority of students accepted into art schools and art institutions do so with portfolios showing skills in figuration. Drawing and painting the figure is often their first interest in art. Being good at it in high school is sometimes a strong enough drive to push students to go on to college with the hope of using those skills in a career. Illustration departments hope to keep that motivation alive through the freshman year. Ideally, during that year their improving skills in drawing and painting, exposure to the possibilities of developing their own content, and exploring a personal vision should motivate them to choose figuration as a major in their sophomore year. It should happen this way, but seldom does because, in general, foundation programs are deeply flawed. By the end of the year, what began as enthusiasm becomes a sense of disappointment. But there's no one to blame. A system has been set in motion, and throughout the years it has been too time consuming and troublesome to change it. Even when there are real questions about the effectiveness of the foundation system, students keep enrolling anyway. So the bureaucrats say, why change? But it may be the right time to question once again. In education, we have to constantly remind ourselves that making changes in the system begins and ends with the needs of the students.

The freshman year today, in most art colleges, is based on the Bauhaus. The Bauhaus, the most famous school of architecture, design, and craftsmanship in modern times, has had an inestimable influence on art school training worldwide. Founded in 1919 at Weimar, Germany, by architect Walter Gropius, the Bauhaus continued to function until 1933 when the Nazis closed the school. The backbone of the Bauhaus system was the preliminary course—or the foundation year, in today's terminology—in which students studied the various arts of painting, drawing, photography, typography, 2D and 3D design, materials, and so on, in addition to literature, creative writing, and art history. But what Gropius did was to take a curriculum originally shaped by artists who created work primarily for gallery walls and expand it to include the applied arts. It was a major change that influenced the course of art history. Gropius said, "What the Bauhaus preached in practice was the common citizenship of

all forms of creative work and their logical interdependence on one another in the modern world." What I take from this quote is that there is no hierarchy among artists and that the work they produce could share applications—gallery walls, posters, book jackets, etc.—when appropriate. The advantage of this philosophy applied to all artists is that it provides opportunities for them to see their work out in the world in many mediums, to have multi-media careers, and to earn more money.

Most art schools we polled continue to reflect the Bauhaus curriculum in the foundation year but—and it's a big but—*without* the Bauhaus philosophy. They do combine illustration majors, graphic designers, and fine arts majors in the first year, disregarding the conventional distinction between "fine" and "applied" arts—a good first step—but they lack both a Walter Gropius with a strong philosophical intent heading the foundation year and a faculty with shared beliefs about the "common citizenship of all forms of creative work." This not only distorts the intent of the Bauhaus curriculum but confuses students. We unnecessarily deny them a creative, exciting foundation year, where exploration of their own content should begin and where broad experimentation and self-discovery of new skills, attitudes, and growth are its goals. Instead, the foundation year system encourages chairs of the various disciplines to hire faculty who will define their fields very narrowly to protect their own biases and influence students in their attitudes, opinions, and definitions in an effort to sustain recruitment numbers in their departments for the following year. For example, fine arts faculty tend to stereotype illustration as commercial art, eliminate figuration from the definition of drawing, and demean the outlets for figuration as trivial. And it works to undermine what may be a student's opportunity to remain an artist. A broader perspective will allow students to come to their own conclusions.

In larger art institutions, the foundation year is separated into more than six sections. The students in these sections may get entirely different definitions of drawing, painting, 2D design, and so on, depending on the biases of the different instructors. It goes without saying that whoever heads the foundation year and hires the faculty is the person who sets policy and indirectly determines the students' futures in the institution. The frustration for chairpersons of the major departments is that unless one is a very close colleague and friend of the foundation year chair, there is no way to influence students' choices in the foundation year. And the students are often overwhelmed by a Chinese menu of course offerings that they are assigned that may or may not be useful to them or even enlighten them when they enter their major field.

In the case of students who lean toward illustration, often the drawing and painting they are exposed to is not figurative. Don't misunderstand me; I am not implying that students should only see figurative painting, but a balance is essential. And for those students leaning toward the fine arts with a bent for figuration, the same problem obtains. It may be time to seriously consider

structuring a foundation specifically for figuration. And beyond that, restructure the illustration major into a new department called Figuration, Personal Vision, and Storytelling. Such a program would offer students who are philosophically drawn to work grounded in the figure the broadest opportunities for personal and professional success. The current trend for combining illustration departments with graphic design departments does not help one understand the field or where it is headed. Combining the figurative fine art majors with illustration majors, placing them in the same department, makes the most sense.

The current structure featuring a general foundation with disparate definitions of drawing and painting, as well as other requirements, pushes students with figurative leanings—feeling as if they have wasted a year—into choosing an illustration major with the hope of finally improving figuration skills. If, however, the department presents illustration as problem-solving, design-oriented, market-driven applied art with little connection to personal subject matter and vision, the majority of illustration majors will opt not to go into the field at all after graduation. In Steven Heller's foreword to this book, he relates a story of being present at a large institution where only two graduating students intended to pursue editorial illustration. He was shocked, as he should be. Clearly, there is something wrong with this picture.

After forty years of teaching illustration and chairing both undergraduate and graduate illustration departments at the School of Visual Arts, I have learned that it is possible to integrate the humanities, art history, and studio—skill and concept—into a single program. In 1984, I initiated an MFA program called Illustration as Visual Essay at SVA. I hired a faculty consisting of fine artists, illustrators, authors, art historians, graphic designers, and computer artists to approach storytelling in figuration with no distinction between the fine and applied arts. Twenty-two years later, we are still going strong. Alumni work is hanging on gallery walls and appearing on the pages of magazines and newspapers. Graduates write and illustrate their own children's books, graphic novels, comic books, and animated films. They are designing Web sites and toys. Stylistically, the work all looks different, one from the other. Beware a department where all the work produced looks like the work of the chair or where an entire class is a clone of its teacher. The content needs to reflect the unique vision of each student, and consequently, every picture produced is individual.

Admittedly, the curriculum was easier to coordinate in the graduate program than in the undergraduate structure. We accept twenty students per year in grad school. The core faculty is twelve, with another twenty thesis advisors hired to work with the individual needs of each student in the second-year thesis projects. Faculty members believe in the educational intent of the program, and they work hard to draw out what lies within the hearts and minds of the students for subject matter and do everything they can to help them hone their skills so they can make their pictures say what they mean.

As chair of the undergraduate Illustration program (1970–1984), it was more problematic integrating the various disciplines simply because of the numbers. At that time, there were approximately 500 illustration majors. As in most institutions, the humanities and art history had separate chairs. Although the humanities and art history teachers were open and some even enthusiastic about the possibility of more interaction, the numbers of students made this difficult. The illustration majors were mixed into the total population of the school in these classes. I began asking the illustration faculty to incorporate other aspects of what they did into the classroom. If they wrote, I wanted them to teach more writing. If they loved history, then it was important for them to integrate history into their teaching.

What I was really asking was that each one of them teach from their knowledge and experience of art and life—their process in discovering literature, their passion for music, gardening, dance, their observation of nature, birds, animals, landscapes, and how it applied to the art work they personally created. I asked them to find a way to integrate who they were, what they loved, and what they believed in into their class curriculum. I encouraged them to teach process by example. It was not a total success, but the majority of faculty—forty teachers in all—supported and rallied behind the concept. I also implemented a history of illustration requirement and writing classes for studio credit as necessary for illustrators to know their own history and to be able to express ideas in words as well as visually.

What I learned from all this was not to hire teachers to teach something they do not believe in passionately. I have seen illustrators and fine artists teach materials and technique classes without a conceptual component and turn out amazing results. There are artists who believe that craft or skill is crucial to the creative process. It is not that these artists are incapable of conceptualizing, it is simply that in their life experience, skill and craft come first. The reverse is also true—I have hired artists who believe that conceptualizing is the first step, confident that skill will follow. It is the job of the chairperson to place faculty in classes where content will overlap with other classes and yet not be competitive. The curriculum will then begin to balance itself.

Illustrators are artists. No matter in what situation they are placed, they think, feel, and live lives wanting to express themselves. We can't educate them like accountants, even though it's important for them to be responsible for their financial lives. Illustrators are not designers, even though they need the skills to use the computer and learn to develop an aesthetic for the pages they create. But artists are egotistical. You can count on that. Give them permission to tell you who they are, what they care about, what they have to say, and then teach them to put it on paper with truth and intensity. Style will follow. Work will follow. The market will follow.

What I am suggesting is that without a clear educational purpose and mission, illustration departments will continue to be taken over by departments that would like to see illustration merely as an elective. If that happens, it will be our fault for not clearly defining ourselves and not fighting for long-term goals that establish the importance of figuration and storytelling as an art. We want figuration to be fulfilling as a career, but we also know that following the mission offers students options and opportunities to diversify their talents and gives them courage to explore new directions for their work as a natural extension of making art. For any artist, there is no more enriching way to spend a life.

—Marshall Arisman

Tim was so learned that he could name a horse in nine languages: so ignorant that he bought a cow to ride on.

—Benjamin Franklin, *Poor Richard's Almanack* (1732–57)

part 1

undergraduate

First he wrought, and afterwards he taught.
—Chaucer, "Prologue," *The Canterbury Tales*

fresh-
man

COURSE TITLE: GRAPHIC ILLUSTRATION 1

INSTRUCTOR: Frederick Sebastian

SCHOOL: Algonquin College, Ottawa, Ontario

FREQUENCY: One semester, once a week

CREDITS: Three

3

goals and objectives

What is style? How can it communicate specific content and information? When is it appropriate to use symbolic realist- or surrealist-derived imagery and why?

The course seeks to examine illustration from two perspectives: from the would-be illustrator's perspective toward realizing a career in Illustration but also from the perspective of the would-be art director or designer for knowing how to use illustration effectively; how to art-direct an illustrator and communicate effectively what the art director wants, be it technique or medium. This is an essential skill set expected of a successful art director/designer within the graphic design industry.

Application Component

The objective of the application component is to offer students the opportunity to apply and hone their skills while furthering their appreciation and understanding of the various illustrative approaches open to the potential illustrator and designer. The application component offers students the opportunity to practice hands-on skills needed should they pursue a career as an illustrator or designer, for being able to communicate ideas, offer solutions, and provide resolutions are a fundamental skill required by the successful illustrator and designer.

Students/artists will explore various techniques and media, both digital and traditional, through sketchbook assignments and assignments provided to allow them to explore various media and techniques. The goal is to help the students further their skills and help them develop their own unique style.

Reflection Component

The objective of the reflection component is to offer the students the opportunity to reflect on the process that they used to complete their illustration. The reflection component offers them the opportunity to practice hands-on skills needed should they pursue careers as illustrators or art directors. Being able to communicate ideas, offer solutions, and provide processes for resolution are fundamental skills required by a successful illustrator and art director. The students shall provide a concept map with thumbnail sketches, outlining their thought processes, choices, and critical conception for their final illustration. The students will also include or cite specific influences, whether they be photographs, drawings, or artists who helped the students complete their illustration.

Students analyze separate elements of art and how these elements are manipulated to communicate in a symbolic realist and surrealist aesthetic; how style effectively communicates specific content; and how as both illustrator and designer, content and style can be effectively married. Students also study industry trends, practices, and developments regarding illustration such as marketing, stock imagery, and issues pertaining to illustration within the design world.

4

grading

Sketchbook Assignments—10 percent

Students shall keep a sketchbook, which they will hand in for evaluation, and will contain all in-class exercises and homework (for computer-generated assignments, students will produce a hard copy printout of the exercise and paste this into their sketchbook for evaluation).

Exercises will be provided that will afford the students the chance to apply their knowledge through meaningful, practical problem-solving exercises or through technical application. These projects shall assist the student in completing the four main assignments.

Course Participation—10 percent

Students will be evaluated based on their participation within the course through attendance, group discussions, class discussions and peer evaluation assignments.

Assignments—80 percent

Students will create four illustrations based upon the two styles covered during this term: symbolic realism and surrealism. Each assignment will be worth 20 percent, producing a total of 80 percent of their final mark.

description of classes

Week 1

Introduction: Course objectives, evaluation, syllabus are introduced to the students through blackboard and discussed in class, and the college's policies regarding attendance, plagiarism, and business acumen are brought to their attention.

Sketchbook Assignment 1

Students are asked to produce a polished comprehensive illustration based on text (one or two sentences) taken from various novels (such as *Moby Dick* or *Frankenstein*); they are to have the illustration complete by next week and must present their illustration while addressing the following: How did they interpret the text? What was their vision? What problems did they encounter?

The instructor can start preliminary assessments of various skill sets of students; this allows students to ease into the course.

Week 2

Presentation and Critique: Students will present their polished comprehensive illustration for sketchbook assignment. The instructor will garner responses and address common issues (problem solving, chained to photographic resources, copyright issues, dealing with limitations, redefining the problem, etc.).

Introduction to Symbolic Realism Photography and Realism: What is realism? (Advantages and disadvantages of photography, realist imagery; techniques of the realist illustrator.) The instructor demonstrates/role-models the symbolic realist assignment from specs of the assignment, from concept (brainstorming, mind-mapping) to visual solution.

Symbolic Realism Assignment 1

Students choose one from an assortment of actual assignments from the field that require a symbolic realist interpretation. They are to have mind-maps and thumbnails completed by next week.

Week 3

Consultations: Students meet with the instructor showing their mind-maps and thumbnails, and how they plan to solve Symbolic Realism Assignment 1. While students are consulting with the instructor, exercises and supplemental readings will be provided for the rest of the class.

Review and Demonstration: The instructor will demonstrate another symbolic realism illustration, this one done digitally with scanners and Photoshop, from specs and mind-mapping to visual solution, as introduction to sketchbook assignment.

6

For the Love of Alex; wife cannot let go of comatose husband; by Marcia Ann Ali

Supplemental Readings: The instructor will provide profiles of successful illustrators who work in a symbolic realist style; traditional media technique/colored pencils provided for students should they opt for traditional media response for assignment.

Sketchbook Assignment 2

The instructor will provide the resources used to create illustration and have students construct the image as a means of testing their Photoshop skills. A worksheet will offer them technical assistance through step-by-step instruction in order to complete the sketchbook assignment. The due date is provided.

Homework: Work on final artwork for Symbolic Realism Assignment 1 and Sketchbook Assignment 2.

Week 4

Consultations: Students can consult with the instructor regarding their progress on Symbolic Realism Assignment 1 or Sketchbook Assignment 2.

Homework: Final artwork for Symbolic Realism Assignment 1 and Sketchbook Assignment 2 to be handed in next class. A printout of the final artwork will be mounted, according to the college's guidelines for presentation. All resources used to create the image must be included in an envelope that is placed within the folder.

Week 5

Presentations: Students will hand in Symbolic Realism Assignment 1.

Peer evaluation/reinforced learning: Students will evaluate two of their colleagues' work based on an evaluation sheet provided by the instructor. To ensure anonymity, the instructor will cut away the reviewers' names after marking the reviews and place the resulting review within the artist's folder before handing the graded assignment back. The review/peer evaluation will be part of the student's course participation grade.

Supplemental Readings: Provide checklist of elements for a successful graphic narrative, which the instructor will go through point by point; the instructor will provide profiles of successful illustrators who work in a symbolic realist /graphic narrative style.

Symbolic Realism Assignment 2

Assignment 2 will be issued on graphic narrative. The instructor will deconstruct successful graphic narrative illustrators.

Homework: Students should have mind-map and thumbnails for Symbolic Realism Assignment 2 complete by next class for consultation.

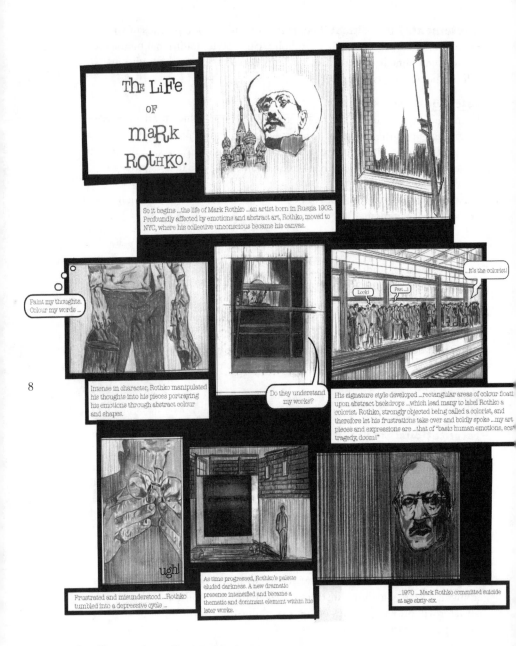

8

Graphic narrative on Mark Rothko; by Cristina Valenzuela

Week 6

Consultations: Students meet with the instructor, showing their mind-maps and thumbnails and how they plan to solve Symbolic Realism Assignment 2. While they are consulting with the instructor, exercises and supplemental readings will be provided for the rest of the class.

Supplemental Readings: The instructor will provide inking techniques that will be instructive to those students interested in traditional media.

Sketchbook Assignment 3
Digital Exercise: The instructor will provide a worksheet offering students technical assistance through step-by-step instruction in order to complete the sketchbook assignment and further their skills in realizing their final assignment. The assignment due date is provided.

Hand back Symbolic Realism Assignment 1

Homework: Work on Symbolic Realism Assignment 2 and Sketchbook Assignment 3.

Week 7

Consultations: Students can consult with the instructor regarding their progress on Symbolic Realism Assignment 2 or Sketchbook Assignment 3.

Homework: Final artwork for Symbolic Realism Assignment 2 to be handed in next class. A printout of the final artwork will be mounted according to the college's guidelines for presentation. All resources used to create the image must be included in an envelope that is placed within the folder.

9

Week 8

Presentations: Students will hand in Symbolic Realism Assignment 2.

Peer evaluation/reinforced learning: Students will evaluate two of their colleagues' work based on an evaluation sheet provided by the instructor. To ensure anonymity, the instructor will cut away the reviewers' names after marking the reviews and place the resulting review within the artist's folder before handing the graded assignment back. The review/peer evaluation will be part of the student's course participation grade.

Industry Trends and Practices: Supplemental readings will be provided to the students that focus on how illustrators market themselves, how art directors like to be approached, and what art directors look for in a portfolio/illustrator. Students will be divided into groups where they will read an assigned article and present the information from that article to the class. The class will be assembled, and each group will present the relevant information from each article, fueling class discussion.

Week 9

Surrealism: What is surrealism? The instructor presents exemplars and techniques of the surrealist illustrator. The instructor demonstrates/role-models the assignment from specs and concepts (brainstorming, mind-mapping) to visual solution.

Surrealism Assignment 1

Students choose one from an assortment of actual assignments from the field that require a surrealist interpretation/*trompe l'oeil*. The assignment due date is provided (students are encouraged to consult their syllabus).

Seeing More; Seeing Less; medical student reflects on how ocular view of world has shown more but also less of world; by Erin English

Consultations: Students show the instructor their mind-maps and thumbnails for Sketchbook Assignment 3 and discuss how they plan to solve Surrealism Assignment 1. While students are consulting with the instructor, exercises and supplemental readings will be provided for the rest of the class.

Review and Demonstration: Instructor will demonstrate solution to a surrealist illustration, from specs and mind-mapping to visual solution, as introduction to sketchbook assignment. This is done digitally with scanners and Photoshop.

Sketchbook Assignment 4

Instructor will provide the resources used to create illustration and have students construct the image as a means of testing their Photoshop skills. A worksheet will offer them technical assistance through step-by-step instruction in order to complete the sketchbook assignment. The assignment due date is provided.

Hand back Symbolic Realism Assignment 2

Supplemental Readings: Instructor will provide profiles of successful illustrators who work in a surrealist/trompe l'oeil style.

Homework: Students should have mind-map and thumbnails for Surrealism Assignment 1 completed by next class for consultation.

Week 10

Consultations: Students can consult with instructor regarding their progress on Surrealism Assignment 1 or Sketchbook Assignment 4.

Homework: Work on Surrealism Assignment 1 and Sketchbook Assignment 4.

Week 11

Consultations: Students can consult with instructor regarding their progress on Surrealism Assignment 1 or Sketchbook Assignment 4.

Homework: Final artwork for Surrealism Assignment 1 to be handed in next class. A printout of the final artwork will be mounted, according to college's guidelines for presentation. All resources used to create the image must be included in an envelope that is placed within the folder.

11

Week 12

Presentations: Students will hand in Surrealism Assignment 1.

Peer evaluation/reinforced learning: Students will evaluate two of their colleagues' work based on an evaluation sheet provided by instructor. To ensure anonymity, instructor will cut away the reviewers' names after marking the reviews and place the resulting reviews within the artist's folder before handing back the graded assignment. The review/peer evaluation will be part of the student's course participation grade.

Surrealist Assignment 2
Students choose one from an assortment of actual assignments from the field that require a surrealist interpretation/editorial illustration. The assignment due date is provided.

Homework: Students are to have mind-maps and thumbnails for Surrealism Assignment 2 completed by next week for consultation.

Week 13

Consultations: Students can consult with instructor regarding their progress on Surrealism Assignment 2 or Sketchbook Assignment 4.

*Corporate Cannibals; demanding bosses who tyrannize
their workplaces; by Kyle Skinner*

Supplemental Readings: Instructor will provide profiles of successful
illustrators who work in a surrealist/editorial illustration style.

Homework: Work on Surrealism Assignment 2 and Sketchbook Assignment 4.

Week 14

Consultations: Students can consult with instructor regarding their progress
on Surrealism Assignment 2 or Sketchbook Assignment 4.

Homework: Final artwork for Surrealism Assignment 2 to be handed in next
class. A printout of the final artwork will be mounted, according to college's
guidelines for presentation. All resources used to create the image must be
included in an envelope that is placed within the student's folder.

In addition, all sketchbook assignments for the term are due for evaluation
next week.

Guest Speaker Assignment

Instructor will inform students that a guest speaker will be invited to class on
the final week of the course and that the students should prepare a tear sheet

of their best illustrative work complete with their contact information. The students will be encouraged to leave their tear sheet/contact sheet with the guest speaker as an opportunity for employment. This will be part of their course participation grade.

Week 15

Presentations: Students will hand in Surrealism Assignment 2.

Peer evaluation/reinforced learning: Students will evaluate two of their colleagues' work based on an evaluation sheet provided by the instructor. To ensure anonymity, the instructor will cut away the reviewers' names after marking the reviews and place the resulting reviews within the artist's folder before handing the graded assignment back. The review/peer evaluation will be part of the student's course participation grade.

Sketchbook assignments for the term are handed in for evaluation.

Hand Back Surrealism Assignment 1

Guest Speaker (Art director): Guest speaker will be invited to class to discuss art directing illustration and illustrators. He or she will provide students with work samples and provide insights on the industry.

The students will be encouraged to leave their tear sheet/contact sheet with the guest speaker as an opportunity for employment.

13

goals and objectives

Illustration I is an introductory course balancing an emphasis on concept and individual expression with continuous development of skills. Demonstrations and discussions on the creative process and media are given. Students will be exposed to the many different usages of illustration from editorial, book, advertising, and personal work. Various black-and-white and color media will be demonstrated as well as guest speakers from practicing illustrators to art buyers.

description of classes

Week 1

• Introduce goals and class rules.

Homework: Students are asked to bring two examples of their favorite illustrations to the next class to show the range and diversity of contemporary illustration.

Week 2

• Project One assigned and to be finished in class that day.

Homework: Project Two (Part One): The Conversation

Project One: Series

Create multiple illustrations using the word that is randomly pulled from an envelope. The words include dog, cat, chicken, car, bike, lamp, fish, and so on.

> • **Specifics:** Six black-and-white illustrations each on a 10" × 10" square.
> • **Objectives:** To limber up, to learn how to design within a specific space and to explore different black-and-white media.
> • **Evaluation:** This project will be evaluated on creativity, process, technical achievement, and time management.

Project Two (Part One): The Conversation

Students are to write down an overheard conversation between strangers in a public place. The conversation could be from someone on a cell phone or two people chatting together in an open area.

Week 3

- Workshop and demonstration on pen-and-ink and scratchboard techniques.
- Workshop on quality drawing and watercolor papers that illustrators use.
- Work on thumbnail sketches for Project Two in class

Homework: Pencils for Project Two (Part Two): The Conversation

Project Two (Part Two): The Conversation

Create an illustration of the conversation that you overheard.

- **Specifics:** One black-and-white illustration on a 14" × 14" square.
- **Process:**
 - Create fourteen thumbnail sketches. Circle your best concept and meet with instructor to discuss your ideas.
 - After concept is approved, work through a larger pencil sketch exploring composition and other design issues.
 - Transfer drawing to a new board or paper and create a final illustration.
- **Objectives:** Students are to learn how to develop their ideas using thumbnail sketches and to explore black-and-white media.
- **Deadline:** Finished art critiqued in two weeks.

Week 4

- Review pencil sketches for Project Two: The Conversation.
- **PowerPoint lecture:** "Contemporary Illustration," examples from "American Illustration," *Communication Arts*, and *3 × 3 Magazine*.

Homework: Finish art for Project Two (Part Two): The Conversation

Week 5

- Critique Project Two: The Conversation.
- Workshop and demonstration on ink wash and pencil.
- Show examples from the *New York Times* op-ed section and discuss visual metaphors.
- Work on thumbnail sketches for Project Three: Opinion Editorial in class
- Complete pencils for Project Three: Opinion Editorial in class

Homework: Finish art for Project Three: Opinion Editorial

Project Three: Opinion Editorial

Select one current, controversial headline in the news to illustrate

- **Specifics:** One black-and-white illustration at 11" × 14" (portrait format)
- **Process:**
 - Create twelve thumbnail sketches. Circle your best concept and meet with the instructor to discuss ideas.

- After idea is approved, work through a larger pencil sketch, exploring composition and other design issues.
- Transfer sketch to a new board or paper and create a final illustration.
- **Objectives:** Learn how to communicate conceptual ideas using visual metaphors and continue to develop working with black-and-white media.
- **Deadline:** Pencils due in three hours, finished art critiqued next week.

Week 6

- Workshop on colored pencil and wet media combinations.
- Critique Project Three: Opinion Editorial
- Complete Project Four: Halloween Card in class

Project Four: Halloween Card
Students are to design and create a Halloween card with any colors except orange and black.
- **Specifics:** Square no smaller than 10" × 10".
- **Objectives:** This project will introduce students to color media, encourage them to avoid clichés and to work with a very tight deadline.
- **Deadline:** Art critiqued at the end of class.

Week 7

- Guest speaker: An illustrator who will present his or her work
- Work on thumbnail sketches for Project Five: Editorial in class

Homework: Pencils for Project Five: Editorial

Project Five: Editorial
Illustrate the article "You're Wearing That to Work?" that first appeared in *The Wall Street Journal* in July 2004.
- **Specifics:** One full color illustration. 4¼" × 7¼" (Portrait format).
- **Objectives:** Work with a specific audience and to create an irregular shaped illustration to be scanned and dropped into a layout.
- **Process:**
 - Create eighteen thumbnail sketches. Circle your best concept and meet with instructor to discuss the best ideas.
 - After concept is approved, work through a larger pencil sketch exploring composition and other design issues.
 - After pencil sketch is completed, create three different color roughs before going onto finished art.
- **Deadline:** Finished art critiqued in two weeks.

Week 8

- Midterm reviews. Instructor meets individually with students to review projects created up to this point in the semester.

- Look at pencil sketches for Project Five: Editorial

Homework: Finish art for Project Five: Editorial

Week 9

- Critique Project Five: Editorial
- Conclude midterm reviews.
- Work on thumbnail sketches for Project Six: Shopping Bag in class

Homework: Pencils for Project Six: Shopping Bag

Project Six: Shopping Bag

Students to create illustrations for a shopping bag for one of the following specialty stores: hardware, plant, recycled sports equipment, wine, or shoe store. The stores can be actual retail shops or fictional ones.

- **Specifics:** Final art needs to be scanned, printed, and assembled into a mockup comprehensive.
- **Objectives:** This project will encourage color media exploration and develop creative solutions for packaging.
- **Process:**
 - Create twenty thumbnail sketches. Circle your best two and show them to one of your classmates.
 - After concept is approved, work through a series of design sketches exploring compositions, placement, contrasts, and typography.
 - Take your best two concepts and develop them into two e-mail-ready sketches.
- **Deadline:** Finished art and comprehensive critiqued in two weeks.

17

Week 10

- Critique e-mail-ready sketches for Project Six: Shopping Bag
- PowerPoint presentation on the use of watercolor in illustration.

Homework: Finish art for Project Six: Shopping Bag

Week 11

- Critique Project Six: Shopping Bag
- Work on thumbnail sketches for Project Seven: Extraordinary Origins in class

Homework: Pencils for Project Seven: Extraordinary Origins

Project Seven: Extraordinary Origins

Students are to create two images for a high school textbook illustrating either the history of Tupperware, the Frisbee, or the Slinky.

- **Specifics:** Two color illustrations: One 8½" × 11" (portrait format) and one 4" × 4" spot image.

- **Process:**
 - Create eighteen thumbnail sketches. Circle your best concept and meet with instructor to discuss the best ideas.
 - After concept is approved, work through a larger pencil sketch exploring composition and other design issues.
- **Objectives:** This project will encourage color media exploration and development of research skills.
- **Deadline:** Pencils due in one week, finished art critiqued in two weeks.

Week 12

- Critique pencils to Project Seven: Extraordinary Origins
- PowerPoint presentation on the art of collage.

Homework: Finish art for Project Seven: Extraordinary Origins

Week 13

- Critique Project Seven: Extraordinary Origins
- Workshop on acrylic painting
- Work on thumbnail sketches for Project Eight: A is for Apple in class

Homework: Pencils for Project Eight: A is for Apple

18

Project Eight: A is for Apple

Illustrate a double page for a children's book using one letter from the alphabet. Include in your image at least ten words starting with the letter. For example, using the letter A you could show a guy wearing a shirt with **Adam** on it. Adam could be holding an **aardvark** and standing next to an **apple** tree with an **ax** leaning on it. An **aquarium** with a tiny **alligator** could be next to the tree. **Ants** could be climbing on the ground, and an **airplane** could be flying in the sky with a sign that has **Aztec** images written on it. Finally, an **automobile** could be in the far distance.

- **Specifics:** 11" × 17" (landscape format). Please note that this is a double-page illustration and that you need to be aware of the gutter of the pages.
- **Process:**
 - Today create eighteen thumbnail sketches. Circle your best concept and meet with instructor to discuss the best ideas.
 - After concept is approved, work through a larger pencil sketch exploring composition and other design issues.
- **Objectives:** The difficulty of this project is to make sure that the composition has a clear focus and a central theme.
- **Deadline:** Finished art critiqued in two weeks.

Week 14

- Critique the pencil sketches for Project Eight: A is for Apple.
- Workshop on Photoshop.

Homework: Finish art for Project Eight: A is for Apple.

Week 15

- Critique art for Project Eight: A is for Apple.
- Complete pencils for Project Nine: Short Story Illustration in class.

Homework: Finish art for Project Nine: Short Story Illustration.

Project Nine: Short Story Illustration

Illustrate a short story provided from *The Best of American Short Stories 2004*.

- **Specifics:** Two illustrations at 8½" × 11" (portrait format) each.
- **Objectives:** To learn to work in sequence observing a consistent style and tone.
- **Deadline:** Finished art critiqued in one week.

Week 16

- Final critique of Project Nine: Short Story Illustration.

COURSE TITLE: GRAPHIC DESIGN/ILLUSTRATION WORKSHOP
INSTRUCTORS: Whitney Sherman and Zvezdana Rogic
SCHOOL: Maryland Institute College of Art
FREQUENCY: One semester, 2 sections once a week
CREDITS: Three

goals and objectives

Freshman students have seven weeks of introduction to illustration and seven weeks of introduction to graphic design. The course gives a broad view of both disciplines. Using imagination, professional attitude, and motivation for artistic and personal growth, students are expected to follow these primary expectations:

- **Original thinking:** The wheel has already been invented, but people continue to come up with a new way to envision it or use it. That's original!
- **Conceptual clarity:** Does that idea in your head make sense once outside your head?
- **Awareness of contemporary themes:** Reality TV is just one sociological experiment, so what else is going on in the world?
- **Learn new skill sets to augment existing ones:** If you don't know basic skills with traditional and digital media, you are already behind. If you do, use something you know to start with, then move toward experimentation.
- **Respect your artistic voice while you learn ways to get though to others:** Can I tell the work is yours and not a tired mimic of the last big thing? What keeps coming back into your head again and again? And is it a bad habit or a new idea?
- **Learn your discipline's history or be doomed to repeat it:** You have been an artist all your life, now learn the language of illustration and design. Learn what has come before in order to see the future.
- **Attend class and stay on top of assignments:** There is a collaborative nature to illustration and design. If you are not working with the effort, you are working against it.

This workshop was developed to address three types of freshman students on the verge of choosing their major area of study:

1. Those with an interest in both illustration and design who have some awareness of both, but wish to learn ways to integrate them.

20

2. Those who either know something about the disciplines or know nothing of either and use the course to assist them in choosing one of the two as a major.

3. Those who have determined their major or have advanced placement credits that allow them to take interesting additional freshman electives outside their decided area of major study.

For many freshman college students, this is the first time they have examined the language of illustration and design. The goal is to acquaint them with these disciplines enough to encourage additional independent research, allow the students to determine whether either is an appropriate means of expression for them, correct misinformation they have on both fields, and instill a love and appreciation for illustration and design. Assignments require hand-drawn sketches.

Freshman students come in with a wide range of technical abilities. They are surveyed to determine their skills and their cultural awareness. Those with advanced skills are allowed to move ahead of the syllabus or are challenged to work at the same pace, but at a higher level of complexity.

By the end of the course, the students will be better able to convey ideas in sketch and final form, integrate critique, and gain technical proficiency in digital and traditional media. This is accomplished with short lecture presentations, skill workshops, DVD screenings, in-class work, and projects that start with a basic idea and expand it to demonstrate connections in forms, markets, communication theory, symbols, and devices. Students learn the value of recording ideas, collaboration, and peer community.

resources

Articles to help students grasp the theme of the course:

- "Futuristic fashion forward" by Suzie Ridgeway; *http://news.digital-trends.com/featured_article28.html*
- "MIT to uncork futuristic bar code" by Alorie Gilbert; *http://news.com.com/2100-1017_3-5069619.html*
- "Call for 'designer' hearing aids" by Geoff Adams-Spink; *http://news.bbc.co.uk/2/hi/technology/4706923.stm*
- "A design for (long) life" by Christine Jeavans; *http://news.bbc.co.uk/1/hi/uk/4079345.stm*
- "Hearing Aids for the Unimpaired" by Robert Andrews; *www.wired.com/news/medtech/0,1286,68419,00.html*
- "Army Public Affairs: Emerging technologies form futuristic uniform" by Sgt. Lorie Jewell; *http://www4.army.mil/ocpa/read.php?story_id_key=6629.*
- "Company creates futuristic home network" by Nick Bunkley; *http://www.control4.com/company/inthenews/2005-7-detnews.htm*

Resources for Illustrators Conference/Discussions
- *www.illustrationconference.org*
- *www.comicon.com*
- *www.moccany.org*
- *www.tcj.com*

Portfolio Sites
- *www.theispot.com*
- *www.ai-ap.com*
- *www.folioplanet.com*
- *www.altpick.com*

Galleries/Collections
- The National Museum of American Illustration *www.americanillustration.org*
- Illustration House (*www.illustration-house.com*)
- The Society of Illustrators (*www.societyillustrators.org*)
- The Library of Congress (*http://lcweb2.loc.gov/pp/caiquery.html*)
- The Brandywine River Museum (*www.brandywinemuseum.org/collect.html*)
- Delaware Art Museum (*www.delart.org/view/collections/am_illus_home.html*)
- Norman Rockwell Museum (*www.nrm.org*)
- Storyopolis (*www.storyopolis.com*)
- Every Picture Tells a Story (*www.everypicture.com*)
- Eich Gallery (*www.eichgallery.abelgratis.com*)

Books on the Art and Business of Illustration
- *Art is Work*, Milton Glaser (The Overlook Press, NY)
- *The Business of Illustration*, Steven Heller + Teresa Fernandes (Watson-Guptill Publications, NY)
- *The Push Pin Graphic: A Quarter Century of Innovative Design and Illustration*, Seymour Chwast (Editor), Steven Heller (Editor), Martin Venezky (Editor), Foreword by Milton Glaser (Chronicle Books, SF)

Graphic Novel Publishers
- *www.topshelfcomix.com*
- *www.onipress.com*
- *www.darkhorse.com*
- *www.fantagraphics.com*
- *www.indyworld.com*

Comics/Characters Web Resources
- *www.giantrobot.com*

Booksellers
- *www.bpib.com*
- *www.taschen.com*

description of classes

In weeks 1–7 of this course, students work with the illustration faculty. In weeks 9–15, they work with the design faculty. The projects done in weeks 1–7 are repeated in weeks 9–15. A "final" critique is done at the end of each section (weeks 8 and 16). The projects, created collaboratively by the illustration and design faculty, work in parallel. A high degree of cooperation with faculty is needed to accomplish this intense schedule.

Projects assigned are derived from current cultural events. The specific events would change annually, but not the spirit of the assignments.

Week 1

Overview the Semester's Theme: Museum of the Future, Future Visions in Art, Design and Science
Focus: Introduction to understanding illustration and ways of seeing.

Assignment 1—Museum of the Future Poster

What will the future look like? Will digital technology be ever-present? Consider our use of advanced cultural media (like SMS, IM, podcasting, satellites, etc.) or other broader visions of the future. Will it become more noticeable or submerged and softened? Will art influence science more or vice versa? What will our environments (inside and outside) look like? What nationalistic or age culture will reign? Which will blend? Will we go back to go forward to the future? How socially conscious will we be?

Use these and other questions from our discussion to develop twenty tiny but effective sketches that envision the future of our society. Be imaginative, not predictable. Have the sketches show your opinion of how things are and how you can imagine them being. Describe this in a brief 125-word statement.

This assignment ends with one or more finished images at a square proportion, scanned at 300 dpi and saved as a TIFF file with hard copy output on an 8.5" × 11" sheet of paper.
Homework: Bring twenty tiny black-and-white sketches for Assignment 1 to class. Visit an exhibition at a contemporary art museum.

Week 2

Focus: Developing and Editing Ideas
Pin Up: Students present homework
Workshop: Illustrator: Using vector-based program
Work in Class: Refine idea sketches with color
Lunchtime: Brown bag DVD screening of Raymond Loewy film
Homework: Create twenty color sketches with tiny variations for Assignment 1

Week 3

Focus: Creating Variations
Pin Up: Students present homework. Review/feedback in class.
Work in Class: Meet in class with assigned design partner to discuss collaboration.

Assignment 2—Portrait/Icon of the Future + Simple Book

Portraiture holds a long-standing tradition indicating status and position. In the past, nobles, artists (through self-portraits), religious figureheads, and public officials have largely been the subjects of portraiture. Today, this group includes celebrities and characters that only exist as logos or toys are included in the contemporary consciousness. Celebrity and logomania are pervasive now. What will it be like in the future? Who will be our icons, the subjects of these portraits? Take one of these directions for this project:

- Choose someone of note today and imagine him years from now. Has he risen or fallen in status? How have age and the effects of our futurescape changed him? Is he the bearer of tyranny or benevolence?
- Imagine a new icon of the future and create a portrait worthy of his notoriety. Imagine the society he emerged from and why he is a memorable part of our world. Write a commentary of this iconic person to later refine into a brief memorable statement.

Homework: Final art for Museum of the Future poster

Week 4

Focus: Controlling and Transmitting Imagery
Pin Up: Students present homework
Workshop: Photoshop: Scanning and File Manipulation
Work in Class: Scaling, cleaning up files, burn to CD for designers, e-mail low-resolution 3" × 3" image to faculty.
Lunchtime: Brown bag DVD screening of Quidam/Cirque du Soleil film.
Homework: Twenty tiny black-and-white sketches of Assignment 2.

Week 5

Focus: Use and Nature of Portraiture and Icons.
Pin Up: Students present homework
Discussion: Commentary and parody, psychological portraits, character and celebrity.
Workshop: Ink and wash techniques
Work in Class: Refine visuals for Assignment 2.
Homework: Final art for Assignment 2.

Week 6

Focus: Do-It-Yourself/Self-Publication Methods
Pin Up: Students present homework
Workshop: Fabric paint, basic in design, simple bookbinding, basic comping
Work in Class: Translate Assignment 2 onto a T-shirt, button, or sticker, with commentary and Simple Book.

Assignment 3—Simple Book

Create a Simple Book using the poster and portrait sketches, translations, and finals as material for making a small sequential piece in black and white using a

photocopier. The object of this is to reinterpret the "future" assignment in a sequential narrative giving a deeper meaning to single images. An eight-page Flash or other Web-based sequence is also acceptable.

Homework: Final art for Assignment 3.

Week 7

Focus: Production and Documentation.

Pin Up: Students present all final art for Assignments 1–3. Review/feedback.

Work in Class: Finalize work for Assignments 1–3.

Assignment: Final work for Assignments 1–3.

Week 8

Final critique on Assignments 1–3.

Week 9

Give details on Assignment 1.

Week 10

Twenty tiny black-and-white sketches due; color variations in class.

Week 11

Twenty tiny color variation sketches due; refine in class.

Week 12

Final art for Assignment 1 due; Scan/Manipulation in class, deliver file to design partner. Give details on Assignment 2.

Week 13

Twenty tiny black-and-white sketches due, color variations in class.

Week 14

Final art for Assignment 2 due. Give details on Assignment 3.

Week 15

Final art for Assignment 3 due.

Week 16

Final critique.

To learn is a natural pleasure not confined
to philosophers, but common to all men.

—Aristotle, *Poetics* (Fourth Century B.C.)

sopho-
more

COURSE TITLE: INTRODUCTION TO ILLUSTRATION

INSTRUCTORS: Ann Field and Jeffrey Smith

SCHOOL: Art Center College of Design

FREQUENCY: One semester, once a week

CREDITS: Three

27

goal and objectives

The objective of this class is to explore "picture/word" relationships, as well as to begin to understand illustration as a means of clarifying a body of text with narrative pictures, symbols, and icons. In this class, we will also explore visual and verbal concepts such as irony and metaphor. A very important aspect of your development as an illustrator is how you solve illustration assignments. What is your style? Therefore, in this class you will be asked to find your conceptual voice (ideas) and your visual medium (technique).

description of classes

Week 1

Introduction to course

Assignment 1: Depression and Anxiety
Or as Alex Trebek would say, "The answer is, things that make you depressed or anxious."
Fill up one sheet of 30" × 40" foam core board with 3" × 4" thumbnail sketches, and most importantly, the definitions of *depression* and *anxiety*, as well as the definition of every other descriptive or obscure word in each of those

definitions. For instance, *unhappy, hopeless, psychiatric, disorder, resources, flattened, downward, pressure, nervousness, agitation, causes, worry, wish, apprehension, fear, danger, sweating, trembling, discomfort,* and so on.

This is primarily a research assignment. Use the words you find, as well as the definitions, to create a changing, sequential, linear development of your picture/word concept. Be prepared to give a five to ten minute presentation of your thought process and ideas in our critique next week.

Week 2

Presentations and individual critique for Assignment 1
In-class assignment: Sketchbook Assignment 1

Sketchbook Assignment 1: Drawing

Dedicate a minimum of one double-page spread in your sketchbook to this subject. Select a metaphor to draw, either from an external source or one of your own making. A metaphor is a comparison of two unlike things using the verb "to be." This is a color assignment. Please use any drawing tool with inks.
Homework: Use in-class feedback to revise and develop your ideas for Assignment 1. Bring Assignment 1 painting to next class. The surface (i.e., illustration board, watercolor paper, German etchers paper, canvas, canvas board, etc.) should have a drawing and perhaps some under-painting already in place before you get to class. The farther along you are, the better.

28

Week 3

Individual Consultation: We will work all day in class, so come prepared.
Homework: Complete Assignment 1 for next class. All works on paper, illustration board, or canvas board no larger than 20" × 30" should be matted.

Week 4

Final critique of Assignment 1. Grades will be based on research, conceptual thinking, and technical execution of the assignment and presentation.

Assignment 2: Fiction (A Short Story)

Find and read Raymond Carver's story, "So Much Water So Close To Home." The title of the book of short stories is *Where I'm Calling From*, published by Vintage. This story was one among several other Raymond Carver stories used for the screenplay in a film titled *Short Cuts* by Robert Altman.

After reading the story, divide the text into three parts: Act I, Act II, Act III. Act I ends with "I could weep"; Act II ends with "She looks off and begins shaking her head as the tears roll down her cheeks"; Act III ends with "For God's sake, Stuart, she was only a child."

Select an excerpt from each act. Each excerpt should be no longer than two paragraphs. When you have selected your three excerpts, draw three sketches per excerpt (nine in total).
Homework: Work on sketches and bring them to the next class.

Week 5

Wall Critique of Assignment 2 sketches in class.

Week 6

Individual Critique: Revise and develop ideas from week 5.
In-class Assignment: Sketchbook Assignment 2.

Sketchbook Assignment 2

Please dedicate a minimum of one double-page spread in your sketchbook to this idea. You may select a simile to draw, either from an exterior source or one of your own making. Simile is the comparison of two unlike things using *like* or *as*. You may use any media.

Homework: Choose one of the sketches from Assignment 2 and make a painting of it. Bring painting for Assignment 2 to class. The surface (i.e., illustration board, watercolor paper, German etchers paper, canvas, canvas board, etc.) should have a drawing, and perhaps some under-painting already in place before you get to class. The farther along you are, the better.

Week 7

Individual Consultation: We will work all day in class, so come prepared.
Homework: Complete Assignment 2 for the next class. All works on paper, illustration board, or canvas board no larger than 20" × 30" should be matted.

29

Week 8

Wall Critique of final art for Assignment 2. Grades will be based on research, conceptual thinking, and technical execution of the assignment and presentation.

Assignment 3: The Los Angeles Times Project

Select an article from the *Los Angeles Times*. The article must be journalistic and topical in nature. Also, the article must be culled from an edition that ran no more than two weeks before this assignment. Once you have selected your story, create a powerful, imaginative, and essential illustration that is based on, but not limited to, your article.

Homework: Create five to ten thumbnail sketches.

Week 9

Wall Critique of the selected article and thumbnail sketches.
Homework: Continue working on Assignment 3.

Week 10

Individual Critique: Revise and develop your ideas from week 9.
In-class Assignment: Complete Sketchbook Assignment 3.

Sketchbook Assignment 3

Please dedicate a minimum of one double-page spread in your sketchbook to this idea. Select an alliterative simile from an exterior source or one of your own making. Alliteration is the use of the same consonant at the beginning of each stressed syllable in a line of verse: "around the rock the ragged rascal ran." You may use any media.

Homework: Choose one of the sketches from Assignment 3 and make a painting of it. Please bring Assignment 3 painting to class. The surface (i.e., illustration board, watercolor paper, German etchers paper, canvas, canvas board) should have a drawing and perhaps some under-painting already in place before you get to class. The farther along you are, the better.

Week 11

Individual Consultation: We will work all day in class, so please come prepared.
Homework: Complete Assignment 3 for next class. All works on paper, illustration board, or canvas board no larger than 20" × 30" should be matted.

Week 12

Wall Critique of final art for Assignment 3.Grades will be based on research, conceptual thinking, and technical execution of the assignment and presentation.

30

Assignment 4: Souvenir

Bring a souvenir to class. Based on your souvenir, write a three-paragraph story that recalls your memory of a particular place or occasion. Then, based on the souvenir's reminder of a particular place or occasion, create an image that evokes and possibly goes beyond your written story. This painting can be a fable, a fantasy, or a factual account.

Week 13

Wall Critique of final art for Assignment 4.

COURSE TITLE: PRINCIPLES OF ILLUSTRATION

INSTRUCTORS: Stephen Savage and Wesley Bedrosian

SCHOOL: School of Visual Arts

FREQUENCY: One semester, once a week

CREDITS: Three

goal and objectives

To provide students with the fundamental skills both physically and mentally to solve pictorial problems.

description of classes

Week 1

Introduction of class requirements

Handout: Daily materials.

Artists of the Week: Wesley Bedrosian and Stephen Savage.

Request portfolios.

Assignment 1: Christmas Card

Students get a red or green envelope. They are asked to make a Christmas card using any subject matter of choice, using any medium of choice. Inside must read, "Merry Christmas" in black and white, and the card has to fit in the envelope.

Homework: Christmas Card Assignment.

Week 2

Artist of the week: Rockwell.

Critique Christmas cards.

Look at portfolios.

Lecture on color theory (intro to color wheel).

Assignment 2: Color study

Given a simple line drawing of a house scene, students must paint the scene four times, using flat areas of color, to describe Midnight, Summer, Autumn, and Spring. Paintings should be made with acrylics (acrylic palette demo given).

The intention of the project is to explore the influence of mood, time of day, or season using only color.

Week 3

Artists of the Week: Golden age illustrators (Rockwell, Remington, Leyendecker, Wyeth, Flagg, Gibson, Parrish).
Paint first *Mona Lisa* page in class.

Assignment 3: Thirty Mona Lisas

To exercise hand skills, students are given a high-contrast black-and-white image of the *Mona Lisa*. Using only primary and secondary colors, thirty combinations (six pages of five *Mona Lisas* each) of the image should be produced. The project will be graded on craft and following directions.
Homework: Final art for Assignment 3.

Week 4

Artist of the Week: Elizabeth Catlett.
Critique final art for Assignment 3.
In-class assignment: High-contrast still-life study.
Give out materials for linocuts. Make linocuts of Mickey Mouse and penguin. Print linocuts.

Assignment 4: New York City Nightscape

After the in-class assignment, students should create a high-contrast New York City nightscape. Composition has to include streets, buildings, and sky.
Homework: Sketches of Assignment 4.

Week 5

Artist of the Week: Chris Ware.
Critique sketches of Assignment 4.
Give out linoleum technique directions.
Do composition exercises in class.
Give out *Mona Lisa* grades.
Homework: Finalize Assignment 4; will print plates next week.

Week 6

Artist of the Week: Kathe Kollwitz.
Final linoleum plates printed and then critiqued.
Perspective lecture.

Assignment 5: Perspective

Use three different types of perspective to make interior spaces (using grid lines; place items in them). Students should make twelve drawings using each type of perspective (thirty-six total).
Homework: Thirty-six drawings based on lecture.

Week 7

Give evaluations of linocuts to students.

Trip to the Metropolitan Museum of Art.

Assignment 6: Temple of Dendur

Students use perspective to recreate the Temple of Dendur room at the Met (or any large room). If permissible, have students take pictures to study at home. **Homework:** Draw the room using three types of perspective. Complete three finished drawings.

Week 8

Artist of the Week: Richard McGuire.

In-class exam on perspective (allow students to use their notes). Offer extra credit by asking them to name three artists of the week.

Week 9

In-class assignment: black objects on white paper, white objects on black paper, and the *Mona Lisa* grid.

Assignment 7: Mona Lisa Grid

Students are given the image of the *Mona Lisa* and asked to recreate it on a blank grid using shades of gray and a grid. Up close, the work looks like a tile work of squares varying in value. From far away, it looks like the *Mona Lisa*.

Have students hang their work and gather in the back of the classroom. From a distance, vote which *Mona Lisa* looks the best. **Homework:** Two self-portraits, one in black on white paper, and one in white on black paper.

33

Week 10

Artist of the Week: TBA

Critique self-portraits.

In-class assignment: Instructor poses for students to make sketches. Photos of poses are projected onscreen and used as a virtual model.

Assignment 8: Manimal

Get photo references of animals. Make sketches of a "manimal" (a human/ animal hybrid) using in-class drawings of instructor and the photo reference. **Homework:** Complete nine sketches of Assignment 8.

Week 11

Artist of the Week: TBA

Critique sketches.

Homework: Render best two sketches of Assignment 8 in detailed pencils.

Week 12

Artist of the Week: Albrecht Durer.

Critique Assignment 8 pencil drawings.

Crosshatching lecture.

In class assignment: Copy a woodcut by Albrecht Durer.

Homework: Use the best pencil of Assignment 8 for crosshatched drawing.

Week 13

Artist of the week: Brad Holland.

Critique Assignment 8 crosshatched drawings.

Give slideshow about metaphors.

Assignment 9: The Lookers

Picking from provided subject suggestions, students solve the visual problem of a character watching another character across a space—that is, "The referee watches the player from across the field." Students are invited to use any black-and-white medium.

Treat assignment like art director/illustrator situation. Students submit thumbnail in-class sketches until they get an approval.

Homework: Create final art for Assignment 9.

Week 14

Artist of the Week: Anita Kunz.

Critique Assignment 9. Cite problems, if any, and art-direct changes.

Lecture on drawing hands.

Week 15

Critique changes to Assignment 9.

COURSE TITLE: SURVEY OF ILLUSTRATION

INSTRUCTOR: Julie Lieberman

SCHOOL: Savannah College of Art and Design

FREQUENCY: One semester, twice a week for two half-hour sessions

CREDITS: Five

goals and objectives

Students focus on illustration and its historical relationship to both fine arts and commercial applications. Illustration is directly linked to ever-changing social and political trends, fine art movements, and technological advances in the field of publishing. Through the use of videos, slides, book references, and lectures, students explore a variety of images and concepts regarding past and present illustration markets.

The objective of this course is to give students background in their field. It will also expand illustration resources and knowledge. After successfully completing this course, students will possess knowledge about history, concepts, and relationships to society within the field of illustration.

35

description of classes

Weeks 1 and 2

Focus: Simplified stylization and their influence on contemporary illustration.
- Cave art (iconographic drawing)
- Graffiti (influence on trained artists)
- Children's drawings (their similarities to untrained artists)
- Art brut
- Folk art
- Outsider art movement

Assignment 1

Research a creation myth from any culture, past or present, and illustrate it using iconographic drawing.

Week 3

Focus: Evolution of pictures as human reflection.
- Development of visual documentation
- Illuminated manuscripts
- Pictographs

- Art of Classical antiquity as roots of illustration
- Interpretive art during the Middle Ages
- Contemporary illustration influenced by schematic representation
- Semiotics

Weeks 4 and 5

Focus: Classical art and its influence on contemporary illustration
- Renaissance thought and its impact on illustration (fourteenth, fifteenth, and sixteenth centuries)
- Application of scientific and mathematical approaches to picture making
- Perspective
- Allegory
- Light and shadow
- Technical illustration
- Hyper-realism
- Working from reference
- David Hockney theories on mechanical aids

Assignment 2

Research the seven deadly sins. Illustrate one of the sins using allegory, chiaroscuro lighting, and perspective.

Week 6

Quiz.
Review and critique Assignment 1.

Weeks 7 and 8

Focus: Development of illustrated books and their contemporary counterparts.
- Reproduction processes that changed the form of illustrated books
- Innovative illustrated books
- Illustrated book covers
- Children's books

Week 9

Mid-term exam

Weeks 10 and 11

Focus: Historical illustration genres.
- Fantasy illustration
- Effect of the Industrial Revolution
- Pre-Raphaelite Brotherhood
- Influence of Japanese wood block print
- Anthropomorphism
- Art nouveau
- English book illustration from 1850 to 1920

Weeks 12 and 13

Focus: American illustration.
- The golden age of American illustration, 1900–1920
- Influence of European market
- Historical adventure
- Illustration as advertisement
- Illustration after World War II (1940s–1960s)
- Influence of film on illustration (1940s–1960s)
- Push pin studios—influence of graphic design on illustration
- Pop art
- Narrative realism

Week 14

Focus: Illustration as social commentary.
- Left-wing publications in Europe and America, 1850–present
- Expressionism
- Degenerate art
- Illustrated poster
- World War I, World War II, art deco
- Patriotism, the power of man and machine

Assignment 3

Students prepare presentation on contemporary illustrators.

37

Week 15

Quiz.
Review and critique Assignment 2.

Week 16

Focus: Conceptual illustration, 1970s–present
- Psychology, dream states, Freud and Jung
- Surrealism
- Surrealistic illustration
- Conceptual illustration

Weeks 17 and 18

Student presentations (Assignment 3).

Week 19

Review for exam.

Week 20

Final exam.

COURSE TITLE: ILLUSTRATION II
INSTRUCTOR: Jon McDonald
SCHOOL: Kendall College of Art and Design
FREQUENCY: One semester, twice a week
CREDITS: Three

goal and objectives

The goal of the class is to introduce the student to three media: colored pencil, watercolor, and oil painting. This will also include techniques that exhibit the many steps available to the artist within each medium. Students will receive basic knowledge of three media as a foundation for future classes in the illustration program. This class will allow them the freedom to choose a technique and have the confidence in their ability to execute the assignment successfully.

description of classes

Week 1

Grid demonstration: Instructor will show how to properly draw a grid. Color pencil demonstration.
Homework: Students must bring in a photograph of a famous person.

Week 2

Work on Assignment 1 in class.

Assignment 1: Distorted Grid

Create an image of the person in the photograph using the distorted grid. The students must submit ten sketches to be approved by the teacher before starting the final art. It will be executed in colored pencil on smooth gray matt board.
Homework: Final art for Assignment 1 due next class.

Week 3

Critique Assignment 1.

Assignment 2: Self-portrait

Create a self-portrait with dramatic lighting using colored pencil on matt board. The instructor must approve the working photograph.

Week 4

Work on Assignment 2 in class.
Homework: Final art for Assignment 2 due next class.

Week 5

Critique Assignment 2.
Watercolor demonstration.

Assignment 3: City Scene or Landscape

Create a watercolor of a city scene or a landscape on 400-pound rough paper.
The instructor must approve the image.

Week 6

Work on Assignment 3 in class.

Week 7

Work on Assignment 3 in class.
Homework: Final art for Assignment 3 due next class

Week 8

Critique Assignment 3.
Oil painting demonstration.

Assignment 4: Still Life

Create a still life in oil on three-ply, medium surface illustration board with two
coats of gesso applied. Students must generate the image from objects in their
apartments. They are encouraged to work from life.

Week 9

Work on Assignment 4 in class.

Week 10

Work on Assignment 4 in class.
Homework: Final art for Assignment 4 due next class.

Week 11

Critique Assignment 4.
Lecture on illustration, using the techniques and mediums students have
learned over the past eleven weeks. It will cover composition, color, story-
boards, and various techniques. The lecture is to assure the students that they
now have the beginning skills that will enable them to produce an illustration
from a story using sketches.

Week 12

A guest reader will read stories he or she has written.

Assignment 5: Story Illustrations

The students must take notes and create sketches based on the stories.
Homework: Sketches of guest reader's work due next class.

Week 13

Students bring their sketches to the instructor and provide an explanation for their decisions based on their notes. They will also choose a medium and technique for the final art. Once the instructor approves this, they can use photo references and perform any additional research.

Week 14

Work on Assignment 5 in class.
Homework: Final art for Assignment 5 due next class.

Week 15

Critique Assignment 5. The students must bring sketches and explain to the class how they approached the project from start to finish.

Week 16

All of the work done this semester is brought in for grading. If a student has reworked an assignment during the sixteen weeks, the final grade should reflect the effort.

COURSE TITLE: SPRING ILLUSTRATION II
INSTRUCTOR: Lynn Pauley
SCHOOL: Pratt Institute
FREQUENCY: One semester, once a week
CREDITS: Three

goals and objectives

This class takes off from what the student learned in Illustration I. Research, reference and writing, and authoring their own work is emphasized. Students fine-tune their personal palette; their methods of gathering references; verbal skills; and ways of presenting their illustration work in large and small printed formats.

I believe that great teaching extends beyond the classroom and into the community, so each semester, I take the students to a different location to bring the community into their classroom assignments. The locations are close to campus.

objectives

Personal Voice: All students are encouraged to find their way of working and gathering references to create a personal palette. Emphasis is placed on the content within each assignment that interests the student.

Reference: Students take their own photographic references, draw from life, go to sites, and find images online to complete these projects. They write their own text for each assignment.

Production: Illustration is not an illustration until it is printed. Students learn to find reputable, affordable full-color vendors on campus and in the surrounding area that can produce and print their work effectively. Emphasis is placed on personal palette and what will reproduce well.

description of classes

Week 1

Introduction to the class and discussion of instructor's expectations. Provide syllabus and materials list.

Week 2

Hierarchy of shapes.
Poster demonstration.

Week 3

Onsite drawing and gathering of photographic references at a location of the instructor's choice, to be used for Assignment 1.

Assignment 1: Oversized Poster Project

Create three posters—collages using drawings/references. Each has a headline and subhead. They must be full color, printed at 200 percent (students must scan the final image). The minimum printed size will be 22" × 34".

Week 4

Work on Assignment 1-Poster 1 in class: paint, put poster together, print.

Week 5

Onsite drawing and gathering photographic references at a second location of the instructor's choice, to be used for Assignment 1-Posters 2 and 3.

Week 6

All photo references for Poster Assignment 1 due.
Work on Assignment 1-Posters 2 and 3 in class: print, process layout.
Homework: Final art for Assignment 1 due next class.

Week 7

Mid-term critique.

Week 8

Faculty meeting with students.

Assignment 2: The Uniform Project

Over the next six classes, students will create a printed, full-color portfolio of images of a subject in uniform for which they researched, interviewed, and wrote original text.
Homework: Research ideas for Assignment 2; be able to present ideas for in-class presentations.

Week 9

Verbally present idea for Assignment 2 and all references to class.
Homework: Written interview due for next class.

Week 10
Verbally discuss paintings/ideas for Assignment 2 to class.

Week 11
Work on four images for Assignment 2 in class.
Pricing, selling, and mailers discussed.

Assignment 3: Mailers
Create mailers for portfolio.
Homework: Work on six images and typed text for Assignment 3.

Week 12
Layout discussion.
Homework: Final art for Assignment 2 due next class.

Week 13
Assignment 2 assembled in class.
Printing and production discussion.
Homework: Final art for Assignment 3 due next class.

Week 14
Critique Assignment 3.

COURSE TITLE: VISUAL STUDIES: DRAWING

INSTRUCTORS: Jorge M. Benitez and James Miller

SCHOOL: Virginia Commonwealth University

FREQUENCY: One semester, twice a week

CREDITS: Three

goal and objectives

This is a course in drawing from direct observation of specific references. It includes a visual analysis of structure, space, surface, light, and context. Assignments incorporate applicable references to the history of art and contemporary developments.

Drawing is used as a means to enable the student to see analytically and critically, and to understand the relationship between content and context.

Today, students come of age in a flat world. They grow up with photographs, movies, television, videos, DVDs, and computer screens. These flat sources of visual information are compelling but provide little incentive for visual exploration of three-dimensional space. Drawing, however, demands a level of visual, technical, and stylistic flexibility rooted in direct observation. Skills steeped in life drawing and visualization form the basis of even the most stylized art. Great ideas stay locked in the head of the would-be artist who lacks a thorough understanding of the translation from three-dimensional space to the picture plane.

The daily bombardment of images blinds the potential artist with sensory overload. Nothing demonstrates this better than the slavish imitation of Anime common to freshmen and sophomores. Of course, there is nothing new or surprising about this form of imitation except for the lack of desire to surpass or even understand the original form. Few students ask about the art historical or cultural origins of the Anime. Fewer still ask about the nature of its appeal. To paraphrase Marshall McLuhan, the medium is more than the message—it is the seduction.

This visual studies class balances technique, and intellectual and aesthetic understanding. Drawing well and knowing why a drawing is made in the first place must be addressed together. Visual studies allow the young artist to see the world in its entirety rather than as a collection of predigested images waiting to be cut and pasted. Not only does the course introduce the skills necessary to depict whatever the eyes see and the imagination conceives; it also presents the student with questions that challenge comfortable preconceptions. An understanding of optical phenomena allows the student to make informed visual choices that extend beyond formulas and derivative stylizations. By

44

opening the eyes and seeing fully, the student takes a crucial first step from adolescent imitation toward maturity and originality.

Drawing is a discipline based on practice and an empirical understanding of the visual world. It frees its practitioner to exercise the imagination. The artist who draws and observes constantly acquires the freedom to distort and stylize the work in ways that defy clichés. Such an artist enjoys a level of expressive possibilities unknown to those who fail to use their eyes and hands. This class opens the door to those possibilities.

The goal of this class is to provide the student with the intellectual skills and technical knowledge necessary to draw proficiently, confidently, and accurately within a contextual understanding based on art history as well as contemporary communications and theoretical issues. Most importantly, however, the student will understand the importance and application of visual skills to communications.

Each class begins with a one-hour lecture and discussion designed to place the larger issues and problems within an art historical and theoretical context. These lectures and discussions, often accompanied by assigned readings, help the student to understand drawing within an intellectual framework. They also enable the student to think critically and make informed decisions that extend beyond personal taste.

assigned readings

Jean Baudrillard, "The Ecstasy of Communication," from *The Anti-Aesthetic: Essays on Postmodern Culture*, ed. Hal Foster (New York: New Press, 1998).

Michael Camille, "Simulacrum" from *Critical Terms for Art History*, ed. Robert S. Nelson and Richard Shiff (Chicago: University of Chicago Press, 2003).

Clement Greenberg, "Avant-Garde and Kitsch," from *Art and Culture: Critical Essays* (Boston: Beacon Press, 1972).

Marshall McLuhan and Quentin Fiore, *The Medium Is the Message* (New York: Bantam Books, 1967).

weekly assignments

This course involves practical problems designed to help make the student see in ways that produce tangible drawing skills. Most of the assignments are meant to be neither stylistic nor interpretative but are based on observation. The last third of the semester ties everything together and emphasizes the communicative functions of drawing.

In order to wean the students from their dependence on preexisting flat imagery, they must first be taught to see accurately and correctly. The first half of the semester deals mostly with spatial issues such as intuitive as well as linear perspective. The assignments stress sighting, gauging, and plotting.

There are also in-class exercises that fool the students into drawing complex objects and spatial situations without seeing the results until the very end. These exercises allow the students to grasp the underlying geometric structure of objects that would otherwise intimidate them. By demystifying the three-dimensional world, the students begin to understand and see pictorial possibilities that previously seemed daunting or impossible.

The second half of the semester is more organic and intuitive. The skills acquired during the first half are applied to drawing complex objects and environments without resorting to mathematical solutions. Looseness and accuracy are combined in drawings that stress scale, presence, and believability. These formal exercises and assignments are reinforced by keeping visual journals or sketchbooks.

description of classes

Throughout the semester, the instructor reviews the visual journal/sketchbook of each student. The sketchbook must serve as a visual record of creative abilities, as the narrative element is introduced in anticipation of the final assignment.

Week 1: Sighting

Students learn to see proportions and spatial relationships through sighting and understanding the position of the artist relative to the subject.

The class is taken outdoors to observe and measure the sidewalk paradox: the phenomenon whereby the sidewalk is shown to be optically wider than it is long. This exercise is followed by observation of buildings that can be drawn in two-point perspective without resorting to vanishing points. The students learn to sight the relative height, depth, and width of the building.

In spite of art foundation perspective classes, this exercise demonstrates that most students remain visually naïve and find it difficult to reconcile their preconceived understanding with the empirical evidence before them.

Assignment 1

The students draw five household objects using lines only. This assignment reveals the students' strengths and weaknesses and allows the instructor to address basic drawing problems in anticipation of more complex assignments. The assignment is followed with demonstrations and in-class exercises.

Week 2: Sighting and Negative Space

Students learn about the relationship between seeing and drawing negative spaces and the emergence of objects. This challenges preconceived ideas by demonstrating the advantages of defining objects and their relative positions through the depiction of the surrounding negative areas.

Students are taught to eliminate details by squinting, a tool that is reinforced by a demonstration of the *camera obscura* and its role in allowing artists to see only the most important visual information. Squinting also allows the students to reduce objects to silhouettes that reveal their underlying geometric structures.

Assignment 2

Draw five household objects in a one-to-one ratio using a sighting stick for gauging proportions, position, and perspective. The assignment is accompanied by in-class demonstrations and exercises.

Week 3: Introduction to Perspective

Sophomores are often frustrated by their inability to place objects and figures within believable spaces. The perspective they learn in art foundation is divorced from practical application and is difficult to apply to drawing assignments. More often than not, they reject it as a tedious mathematical exercise that limits creativity. Who can blame them for reaching such conclusions?

Still, the student realizes that something is missing. Why does Spider Man occupy a believable space while his characters live in an arbitrary space closer to that of a naïve artist? Is it necessary to become a perspective master in order to remedy the problem? The answer is, of course, no. It is, however, necessary to learn something more useful and systematic than the cursory perspective taught in art foundation. The student must be given the tools with which to depict real and virtual spaces suitable to any situation.

The instructor demonstrates in class how a floor plan can be projected as an accurate perspective image from any angle. Such a demonstration quickly shows the student the speed and ease with which virtual reality can be achieved by hand.

The demonstration is followed by discussions of how artists—ranging from Degas to N.C. Wyeth and Katsuhiro Otomo to Masamune Shirow—handle illusionistic space to enhance pictorial space and communicate a message. The students practice in class by projecting simple plans into illusions of three-dimensional objects.

Assignment 3

Students draw a one-tenth-scale floor plan of their bedrooms. The purpose of the assignment is to give the student a powerful tool with which to manipulate space toward creative, communicative ends. The floor plan assignment usually points to the challenges faced by students unaccustomed to measuring with nondigital tools. It forces them to be observant, precise, and self-reliant.

Weeks 4 and 5

The students project their floor plans into perspective drawings and transfer them to high-quality paper for rendering. Now they must deal with lighting

and composition, but they soon learn that if the projection is correctly executed, the composition is quickly resolved.

Lighting is another matter. The instructor demonstrates various lighting and shading approaches for life and virtual situations. How do shadows fall? How does light affect texture? What is the difference between natural and artificial light, and how does indirect light differ from direct light? What effect do these issues and choices have on an illustration and the viewer?

The instructor demonstrates practical alternatives to linear perspective, including how to draw believable panoramic views through sighting. The students are shown examples by the British-American painter Rackstraw Downes, whose highly realistic panoramic views are often mistaken for photorealist paintings. At this point, the students begin to internalize their spatial understanding in order to work more intuitively.

Weeks 6 and 7

Although the class emphasizes a highly representational approach, the students are reminded that "realism" is a tool, not necessarily an end in itself. The goal is to communicate effectively. The means to that end are almost infinite, but a thorough understanding of representational processes is fundamental to the communication of ideas.

By the sixth week, the students are ready to combine newly learned skills in more challenging and complex ways. But new issues arise. Freedom and looseness often reveal a lack of dexterity. Many students only know the keyboard and mouse. They do not know how to hold a pencil, brush, or charcoal stick in a correct or classical manner. Their marks are clumsy and heavy by default rather than design. Drawing's inherent physicality now poses new problems of scale and touch to students accustomed to computer screens. Furthermore, they must make material choices and learn to combine the right paper or board for a given medium or purpose. The arbitrary paper choices that sufficed for a floor plan do not work for a more formal charcoal or pastel drawing.

Assignment 4

In class, students learn to handle proportions, light and shade, and the suggestion of complex details by drawing a skeleton. At home, they must draw a clothed figure in a believable setting.

Students learn to draw a believable ribcage by working with the negative spaces, and they observe the connection between the skeleton and the clothed figure. Now they must also learn to communicate a sense of presence by relating the subject to the picture plane's edges.

More often than not, this assignment reveals a continuing preoccupation with extraneous information and schematic shortcuts. Unnecessary details clog the drawings as substitutes for thorough observations. Proportions that were accurately observed in class fall prey to familiar distortions. Features are depicted as symbolic shapes (oval eyes and linear noses) instead of fully

dimensional objects subject to the rules of optical phenomena. Furniture that was completely convincing in the perspective assignments suddenly defies its surroundings. This project is always reassigned with Cézanne's dictum that "there is no difference between a woman and an apple."

Week 8

At this point, most students understand the concepts presented in class, but they still find it challenging to combine them. The relationship between simplicity and complexity must be stressed through exercises that emphasize working from the general to the specific. Now they must learn to see light and dark patterns that allow them to quickly grasp an environment. Spatial issues continue to be stressed, but the main concentration becomes patterns through an understanding of shadows as shapes. The mathematical approaches from the first half of the semester are now used intuitively.

In class, the instructor conducts speed drills during which the students must quickly and accurately sketch the inside of the classroom in the broadest and simplest visual terms. The goal is to work with negative spaces and shadow patterns in order to depict a believable environment. Sighting is also emphasized for spatial accuracy. The speed drills continue with increasingly complex situations, ending with an exercise in which pairs of students simultaneously draw one another.

The class ends with a demonstration in which the instructor shows the students how to draw a portrait by measuring the sitter's face and features, using either calipers or a sighting stick. The demonstration is designed to show that empirical observation tends to contradict preconceived ideas. Furthermore, the students learn to see faces and features as solid objects defined by light and dark rather than as schematic symbols.

Assignment 5

Students create a frontal self-portrait (face, neck, and shoulders only) drawn by taking exact measurements of their features.

Week 9

The class begins with a discussion of Holbein, Velasquez, Ingres, Eakins, and Sargent in order to discuss different approaches to portraiture by masters known for their accuracy.

This is followed by a critique of the self-portraits. The critical stress is on accuracy, composition, lighting, drawing, skills, craftsmanship, and choice of substrate upon which to work.

Speed drills are followed by drapery and focus studies. Students learn to bring objects in and out of focus by training themselves to temporarily bypass the brain's automatic synthesis of background, middle ground, and foreground. The ability to see like a camera allows them to develop a cinematic outlook that will serve them well in narrative situations.

Assignment 6

Students create a three-quarter-view self-portrait (face, neck, and shoulders only) drawn by taking exact measurements of their features.

Week 10 to the End of the Semester

Class time is divided into lectures, discussions, demonstrations, practice, and reviews.

Topics include what defines an object, what defines space, the relationship between flatness and illusionistic space, the Albertian window (its possibilities and limitations), Neoclassical contributions to modernist flatness (from Jacques Louis David to Picasso), the importance of pictorial tension, representation and abstraction, compositional strategies (organizing pictorial information, including the Renaissance pyramid, the Baroque spiral, the Neoclassical frieze, symmetry and asymmetry, photography and the arrival of cropping, Eastern approaches and the influence of Ukiyo-e on the development of modernism, the Constructivist diagonal, Futurist motion, the Bauhaus grid, the Pollock factor and its effect on post-modern representational approaches), Cézanne, Picasso, and pictorial relativism, Duchamp and ready-made imagery, Warhol and the ubiquity of popular culture, and communications in a global environment.

At this stage, students for whom the sketchbook had been an afterthought realize that they cannot plan, much less execute, the final project without thumbnail sketches and preliminary drawings. Nor can the narrative component be understood in a contemporary context without having read and discussed Marshall McLuhan and, to a lesser degree, Jean Baudrillard. McLuhan's theories on the media and global communications, and Baudrillard's observations on "hyperreality" anticipated and explained today's digital environment. No contemporary artist can work without understanding the ways in which technological, economic, and social changes altered the artistic and communications landscape.

Assignment 7

The final project occupies the students through the end of the semester. They must plan and execute a drawing of a party with either an obvious or clearly implied narrative. The finished piece cannot be smaller than 18" × 24", and the substrate must be appropriate to the medium and technique. The scene includes at least five figures within a believable, undistorted space. It depicts metal and glass objects as well as drapery and furniture. The lighting conforms to the time of day or night when the party takes place. The compositional scheme informs the narrative and serves as more than a formal arrangement. Although the final illustration is a product of the student's imagination, it must be based on direct observation of objects, interiors, and models. No photographic or computer-generated sources are allowed. Students are encouraged, however, to look at precedents ranging from paintings and films to graphic novels, and television still shots.

This complex piece cannot be executed without thumbnail sketches and preliminary studies of objects, interiors, and models. The students are required to consult with the instructor throughout each stage of the project. They must show all studies and sketches as they plan the final image. Throughout the process, they will explain their approach as they are questioned on specific visual, narrative, and formal points.

The student is expected to approach the assignment with professionalism. As the instructor assumes the role of client, agent, or art director, the student will be asked to justify the work on aesthetic, communicative, and practical grounds. Where and how will the piece be published? Who is the audience? Will it be part of an article? How will it fit in the layout? What size will it be? These and other questions stress the practical side of the business and allow the student to think in terms appropriate to a highly competitive and time-sensitive industry.

The finished piece is presented in a formal critique where all students participate in evaluating it as artists, businesspeople, and consumers.

The final project demands that the student incorporate newly acquired skills and a story to produce coherent communication that speaks to a contemporary audience. Students are asked to defend the traditional skills by which the communication and message was constructed. Could it not have been made more easily through photographic and digital means? Is a hand-drawn image even relevant? Why should anyone spend a semester learning to see when ready-made images are everywhere? Those students who make an honest effort to address these questions verbally and in their work will better understand their reasons for entering the field and will approach future projects with convictions tempered by critical thinking. They also begin to see their work within the larger context of art.

COURSE TITLE: HISTORY OF ILLUSTRATION

INSTRUCTOR: Dan Nadel

SCHOOL: Parsons School of Design

FREQUENCY: One semester, once a week

CREDITS: Three

goals and objectives

This class will explore the illustration medium through fifteen thematic lectures that will address crucial ideas, movements, and personalities in illustration while relating these topics to their social, political, and artistic contexts. These lectures will not attempt a chronological march through time, but will rather trace the boundaries of the medium, creating a sketch of the past and present of illustration. And because this is a history of a commercial medium (and one without an established canon), most classes will also feature a guest speaker—usually a practitioner—whose experience or depth of knowledge will complement that week's lecture. The objective for this class is for students to understand the history and medium of commercial image-making and the context in which it has been practiced.

The class will consist of a one-hour lecture, a twenty-minute break, and either a one-hour discussion section or a guest speaker. Discussion is essential both in sections and with the guest lecturers.

52

grading

Attendance, class participation, and weekly assignments/ notebook: 50 percent. Your weekly assignments will not be graded, but failing to turn them in on any given week counts against your total grade. If you turn in all the weekly assignments and attend and participate in class, then you will fulfill this requirement. You notebooks will be checked in the discussion sections and looked at more closely during the mid-term and final review. **Final assignment:** 50 percent

description of classes

Weekly Assignments

You are to keep a scrapbook of illustration. Every week, you need to fill five pages of your notebook with found images. These images can come from anywhere. The only requirement is that they be some kind of illustration: magazine, animation, Web, newspaper, packaging, and so on.

You are to write two hundred words on one item every week. This text needs to be typed and turned in weekly. Give your impressions of the image

and how you think it relates to the history as we've discussed it in the previous class. Though not all of you will be asked, all of you should be ready to present that one image and discuss its relationship to the previous week's class.

Your notebooks must be turned in for a mid-term review and then for a final review.

Final Assignments

You will choose one item from your semester-long scrapbook and, in consultation with the instructor, create a visual essay describing its history. This essay is to be ten pages long and must trace the path of this image through history. You are to use writing, drawing, typography, and any other artistic means to describe the history. But there must be a legible and well-developed written component of the project of at least eight hundred words. You will be graded on the depth and accuracy of your research, the originality of your approach, and the success of its execution. The final product should be handed in on 8.5" × 11" sheets of paper only. Printouts only—no original art, please (it will not be returned).

Week 1: What is Illustration?

We'll look at a few drawings from multiple perspectives in order to establish how we might discuss the medium.

Week 2: Nineteenth-Century Caricature and Illustration

Illustration came into its own as a medium with the boom in magazine and newspaper publishing in the nineteenth century. We'll examine the circumstances and artists involved.

Week 3: The Heroic Tradition and Popular Romanticism at the Turn of the Twentieth Century

A look at Howard Pyle, the Brandywine School and its proponents throughout the 20th century. Speaker: Brad Holland.

Week 4: Humor Illustration, the Comic Strip, and Popular Drawing

Comic strips rose with illustration. We'll survey the best of the medium as well as humorous illustration in magazines. Speaker: Arnold Roth.

Week 5: The Art of Political Subversion in 1920s and 1930s Germany and France

Artists such as George Grosz and Karl Arnold rebelled against their political system in the pages of magazines. We'll look at the varieties of subversive illustration. Speaker: Peter Kuper.

Week 6: Animation Explosion

Studios such as Walt Disney, Fleischer Brothers, and UPA borrowed from and in turn influenced illustration. We'll watch clips and discuss the different styles in play.

Week 7: Post–World War II Existential and Psychoanalytic Illustration

Artists such as William Steig and Boris Artzybasheff brought a new level of thematic depth to the medium. We'll discuss their responses to the terrible events around them. Speaker: Marshall Arisman.

Week 8: Saul Steinberg and the Birth of Conceptual Illustration

Saul Steinberg, as part of a wave of European illustration that hit America in the 1950s, helped formulate what we now call Conceptual Illustration, the dominant mode of editorial illustration. Speaker: R.O. Blechman.

Week 9: The Illustrator as Journalist

Artists such as Robert Weaver, Julian Allen, and Alan E. Cober helped reshape illustration into an expressive, journalistic medium. Speaker: Peter Arkle.

Week 10: Pushpin Studios and the Flowering of Pop-Illustration in the 1960s

Pushpin Studios, psychedelia, underground and pop comics became part of the cultural revolution of the 1960s. We'll look at all of these media and watch part of *Yellow Submarine*. Speaker: Steven Guarnaccia.

54

Week 11: Children's Books

A look at the history of illustrated children's books including Dr. Seuss and Maurice Sendak. Speaker: Leonard Marcus.

Week 12: Punk and Post-Modernism

Punk rock not only changed music—it reshaped visual culture. We'll look at punk drawings and graphics and their evolution into post-modern illustration. Speaker: Gary Panter.

Week 13: Covers

The uses and abuses of illustration in packaging books and records from Jim Flora to Edward Gorey to Coop. Speaker: Irwin Chusid.

Week 14: The Graphic Novel

One of the primary outlets for illustrators today is the graphic novel. We'll look at its origins, progress, and contemporary status. Speaker: David Heatley.

Week 15: Wrap Up

We'll tie all these historical strands together and look at some contemporary illustrators of note.

COURSE TITLE: ETCHING AND MONOPRINT AS ILLUSTRATION/ILLUSTRATING BOOKS WITH PRINTS

INSTRUCTOR: Bruce Waldman

SCHOOL: School of Visual Arts

FREQUENCY: One semester, once a week

CREDITS: Two

goals and objectives

This course will introduce students to numerous basic etching and monoprint techniques, including hard ground, soft ground, aquatint, and color printing.

Once students become familiar with functioning in a print shop, they will learn to use prints as a viable technique for fine illustration. The emphasis will be on experimentation and personal expression. We will discuss the early relationship of printmaking to illustration, and will study and discuss specific illustrators who use printmaking as a final technique for answering illustration problems.

printmaking techniques

Etchings are images that are burned into metal. This is done by taking a zinc or copper metal plate and covering it with a liquid substance called "hard ground" (hard ground is applied to a metal plate with a brush, and is made up of beeswax, solvents, and other chemicals). When the ground dries, the artist draws through it with a thin metal tool called an "etching needle," which works similar to scratchboard. Where the artist has drawn, the plate is exposed, and then the plate is submerged in a bath of nitric acid, which eats into the metal, engraving the image permanently. Then ink is applied to the plate, wiped off the surface, remaining only in the etched lines, and run through an etching press with a damp piece of printing paper on it. Usually the artist can print from ten up to fifty copies of the print before the plate begins to wear down. Mono means one, and unlike other printmaking processes, you only get one image from a monoprint. It is basically a painting on paper. Monoprint is a painting, applied to a piece of plexiglass with printing inks, and then run through an etching press with a damp piece of printing paper on it.

description of classes

Week 1

We will discuss the general goals of the class.

We will also discuss the historical merging of printmaking with illustration in the late 1800s and early 1900s. I'll show samples of Old World and modern artists and illustrators who used printmaking as a final technique for solving illustration problems.

Weeks 2 and 3

We will explore the use of hard ground as a basic technique, referring to the works of Dürer and Rembrandt.

Weeks 4 and 5

We will explore the use of aquatint as a basic technique, referring to the works of Goya.

Weeks 6–8

We will explore the use of soft ground as a basic technique, exploring the works of modern printmakers and illustrators.

Weeks 9–11

We will explore ways to apply color to an etching plate, including hand-applied color, three-plate color registration, and viscosity color printing.

Weeks 12–15

We will explore the art of monoprint, as both a black-and-white, and a full-color image. Students will use the techniques that they have learned to conceptualize, develop, and illustrate a series of images on one subject, done in a consistent manner using printmaking as a final technique.

COURSE TITLE: DIGITAL ILLUSTRATION

INSTRUCTOR: Federico Jordán

SCHOOL: Universidad Autónoma de Nuevo León

FREQUENCY: One semester, once a week

CREDITS: Three

Editor's note: In Mexico, as in many Latin American countries, the illustrator's education depends on the curricular plans for graphic design, on the visual arts student's will, and on other disciplines since there is no efficient structure in the illustrator's labor field allowing him or her to have a specific education plan.

goals and objectives

Students will experience the production and direction of art process on functional images and by watching and analyzing the work of other illustrators and their own work; they will understand illustration as an interdisciplinary activity.

The course is meant to generate the experiences that will build the foundation for the learning of future designers in the field of illustration in the short term offered by the curricular program of the School of Visual Arts in the University of Nuevo León.

It is also meant to generate and share eloquent ideas through illustration images that reach the right message to the public in general.

The course is held every Friday for four hours. Assignments are delivered by e-mail. The program has also a forum and a gallery to discuss topics related to the subject. The program changes from term to term according to my personal experiences as illustrator and educator.

week by week

Week 1

Introduction

We have a group analysis regarding the essence of illustration. Later, we analyze illustrators as Jose Guadalupe Posada and Norman Rockwell in relation to empathy.

Assignment 1
- Reading and discussion in the Internet forum.
- Presentation of six drawings: a self-portrait, an observation drawing, an imagination (fantasy) drawing, a portrait of a family member or colleague, a drawing of a tree, and a drawing of a mountain. Digitization and sending of portrait via e-mail during the week.
- Analysis of two illustrators: one from current times, the second from past times.

Week 2

Lecture: Playing through drawing
Presentation and discussion of two illustrators' works.
Presentation of students' self-portraits; students critique their own work.

In-Class Exercises

- Drawing of an animal: Every ten minutes, a student adds an unbelievable characteristic to the sketch of an animal and explains why. Everybody draws the new characteristic for the same drawing. This is a way to generate sketches and ideas for their projects.
- Drawing of music: Draw the feelings generated by a tune heard a moment before.
- Drawing of poetry: Draw the feelings generated by the reading of a poem.
- Continuous drawing: Each student decides the form and way to represent two simple elements on paper. Every ten seconds, they add something to the drawing and then pass it to their neighbor. The exercise reaches an end when the sketchbook is back to the owner. The direction of the drawing is analyzed.

Assignment 2

- Correction of self-portrait based on the student's self-criticism.
- Study and research of digital formats and characteristics of bitmaps and vector graphics.
- Analysis of the work of two illustrators.

Week 3

Lecture: Illustration as part of a whole.
Presentation and discussion of works by the two illustrators from Assignment 2.
Students present slideshows of their revised self-portraits.
Discussion and explanation of types of format and technicalities of bitmaps and vector graphics.
Discussion of changes generated by technology in the history of illustration. View several examples in books.

Assignment 3

- Drawing of a *cadavre exquise*. Specifications about size and characteristics will be posted on the Internet forum.
- Visit to the incunabular books in our university and discussion afterwards.
- Analysis of the work of two illustrators.

Week 4

Lecture: Phyllotaxis.
Presentation of the work of two illustrators from Assignment 3.
Delivery of the *cadavre exquise* work in CD and reading of a text related to composition.

The last three hours of class, exit to the garden and talk about the illustration as being a part of a whole. Quick analysis of students' drawing of the tree, talk about phyllotaxis, and watching and drawing the structure and composition of the plants.

Assignment 4
- Reading assignment on phyllotaxis.
- Find a word at random in the dictionary and draw a graphic representation. Specifications about size and characteristics will be posted on Internet forum.
- Analysis of the work of two illustrators.

Week 5
Lecture: Illustration as part of a whole.
Presentation and discussion of the work of two illustrators.
Presentation of URL for the *cadavre exquise*. Only the students who met the technical specifications will be included.
Presentation and discussion of dictionary words.
Discussion about rectangular composition formats and analysis of the composition of two art works and two books.

Assignment 5
- Final work for the dictionary word; revisions based on discussion in class. Presentation of corrected sketches in the discussion Internet forum.
- Analysis of the work of two illustrators. Analyze the composition of a work and its interaction with its original context.

Week 6
Lecture: Art direction and illustration.
Presentation and discussion of the work of the two suggested illustrators, including some remarks about composition and functional analysis.
Presentation and public discussion of final art.
Presentation of recording of interviews with illustrators on their opinions and their work process when they receive art direction. The address for the interviews is *www.fjordan.com/more/voces*.
A guest art director will be invited to write an assignment. Text will be read in class and discussed.

Assignment 6
- Groups of students will get together and do interviews related to the topic of art direction or interdisciplinary work on any discipline related to the solution of problems.
- Students will prepare sketches for art director's assignment.
- Analysis of works and recordings of interviewed illustrators, regarding the topic of art direction and illustration.

Week 7

Discussion about the interviews and the working methods of each illustrator regarding art direction.

The guest art director will talk with the students and critique their work.

Assignment 7

- Final art for Assignment 6, #2, based on the new direction received from the art director or presentation of new sketches. The work will be delivered one day before next class session.
- In groups, the students select two illustrators and analyze their work.

Week 8

Presentation of work of the two illustrators and suggestion of discussion in the classroom.

Another discussion with the art director on the final art criticism on the Internet presentation.

Assignment 8

- Drawing of two postcards with a selected image. Research an art director of a publication who might be interested in that image.
- Six free drawings in sketchbook.
- Reading about federal law on copyright.
- In groups, the students select two illustrators and analyze their work.

Week 9

Lecture: Copyright.

We start a session related to Mexican authorship and international copyright laws and review of contracts.

Students present the work of two illustrators and direct the discussion.

Assignment 9

- Students direct art of other students and at same time, make illustration of other students. They also practice how to negotiate agreements.
- In groups, the students select two illustrators and analyze their work.

Week 10

Lecture: Industry.

We perceive the industry of illustration as an economic sector that produces and trades an asset: the image. We analyze the trends of our field and the inter-industries affecting the field in the last ten years. We discuss the field of illustration in Mexico regarding other countries.

Review Assignment 9.

Assignment 10

- In groups, the students select two illustrators and analyze their work.

Week 11

Lecture: Structure.
Students create a structure 1.60 meters high in thirty minutes. The materials will be a sheet of bond paper, scissors, and adhesive tape.
Review Assignment 10.

Assignment 11

- In groups, the students select two illustrators and analyze their work.
- The students create their next assignment: a project with a productive end for our art school.

Week 12

Lecture: Promotion.
Students present proposals for Assignment 11.
Discuss the issues related to the promotion of the illustrator in Mexico and other countries.

Assignment 12

- In groups, the students select two illustrators and analyze their work.
- Students design a national-level promotions plan, which they will develop during the next weeks.
- Final art for Assignment 11 due next class.

Week 13

Lecture: Information graphics.
Students present Assignment 12.

Assignment 13

- Students prepare a portfolio with the project developer in the workshop.
- In groups, the students select two illustrators and analyze their work.

Week 14

Lecture: Promotion.

Assignment 14

- Final art for Assignment 13 due next class.
- Discussions on illustration promotion. Promotional pieces are key to getting assignments. This is a critique of different approaches.

Week 15

Conclusion.
Students deliver completely finished layout book.

COURSE TITLE: HUMOROUS AND SATIRICAL
ILLUSTRATION FOR PUBLICATION
INSTRUCTOR: Chris Gash
SCHOOL: Montclair State University
FREQUENCY: One semester, once a week
CREDITS: Three

goals and objectives

Humor is very subjective, as is taste in art. Combine the two and the lines are increasingly blurred between what is good and what is not so good. This semester through discussion, examples, and projects, we will explore the humorous image and its place in the world of illustration.

A great artist once said that a good idea could take a bad drawing much further than a nice drawing can carry a lousy idea. Please don't think that means that bad art is ever acceptable, but rather just how important a strong concept is in your illustration. I trust you are all competent in your craft, but you will be given assignments this semester that require thinking before drawing. I want to see you solve problems your own way. Your style will be determined as much by how you think as by how you draw or paint, and in this class, by your sense of humor.

Your assignments will be challenging, but try to have fun with them. That is one of the keys to creating art that is fun and funny.

grading policy

You are allowed three absences per semester. For each succeeding absence, half of a grade point will be deducted from your grade. Three late arrivals will equal one absence. If you finish the semester with five absences in total, your final grade will drop one letter grade—from A to B, B to C, and so on. Extended absences with legitimate cause will be discussed and dealt with accordingly.

supplies

These are a few basics. If you have some proficiency in other media, I encourage you to use it.

- 8.5" × 11" sketchbook
- Watercolor set and various brushes: #10, #6, #4
- Pencils and erasers

- Technical pens: #0, #1, #2, #3
- Black and colored inks
- 11" × 14" vellum or trace
- Colored pencils
- X-acto knife, white artist's tape, rulers, triangle

recommended reading

I do not have required reading for this class. However, I do recommend the following books, from which the handouts were made:

The Education of an Illustrator, edited by Steven Heller and Marshall Arisman
Understanding Comics, by Scott McCloud
The Complete Book of Humorous Art, by Bob Staake
The Business of Illustration, by Steven Heller and Teresa Fernandes
The Graphic Artists Guild Handbook of Pricing and Ethical Guidelines, 11th Edition,
 by The Graphic Artists Guild, Inc

description of classes

Week 1

Discuss class requirements, grading, and review the materials list.
Briefly discuss illustration and humor.

Objectives: To get the students out and looking at illustration as well as
finding some insight as to what styles appeal to them.
Homework: Go to the newsstand and find an example of humorous illustration to discuss in next class.

Week 2

Discuss the illustrations the students bring in.
Distribute and review briefs for the pedagogical corpse and the novelty
 package assignments.
Brief talk in class about *Mad* magazine, Wacky Packages, Garbage Pail Kids,
 comic advertisements, and other gag art as it relates to the novelty package
 assignment.
Objectives: The pedagogical corpse assignment is designed to give the students one project without limitations, as well as to develop their narrative abilities.

Assignment 1: The Pedagogical Corpse

This is a semester-long project passed between students from week to week.
Knowing only the panels that immediately precede your own, you will add
three new panels to the ongoing narrative. Have fun with this. I want to see
how far you can take the story in three panels and how far you can take it from
the apparent direction it had when you received it.

Assignment 2: Novelty Package

You will receive a novelty item such as a joy buzzer or whoopee cushion. You must illustrate a 4" × 4" card top for the item and present the completed package in two weeks, but you *cannot* use the novelty item itself in the illustration.
Homework: Three to five sketches for Assignment 2 due next week.

Week 3

Class critique of Assignment 2. One-on-one time spent with students on their sketches. Work on final art in class.

Demonstration given on proper presentation, mounting, and flapping of art.
Objectives: For the novelty package, the fact that the students cannot use the item in the illustration will hopefully get them thinking about the joke versus the punchline, the cause and effect relationships of their items. It is an opportunity to distort and exaggerate facial expression and gesture.
Homework: Final art for Assignment 2 due next week.

Week 4

Class critiques Assignment 2.

Presentation to the students of numerous examples of boxed gags. Discuss examples of those that work and those that don't, as well as the range of styles in which they are illustrated.

Assignment brief and objects handed out for Assignment 3. Work on sketches in class.

Assignment 3: Gag Gift Box

You will receive one object (thimble, egg timer, magnifying glass, etc.) and create a boxed gag gift using this item. You must write a joke and illustrate the front of your box. Use language that leads us to more than one interpretation. Your illustration should support the double entendre on the cover, alluding to something else entirely being inside the box. The item inside is the punchline.
Homework: Three to five sketches for Assignment 3 due next week.

Week 5

Demonstration given on watercolor and colored ink techniques. A short, in-class concept exercise given.

Class critiques of Assignment 3 sketches. One-on-one time with each student to review his or her ideas and choose one for the finished piece. Work on final art in class.
Objectives: To understand the mechanics of a joke, to think about how to make something funny that isn't inherently so, and to set up a joke and support it with an illustration. This assignment requires the students to think both verbally and visually, and to ponder the relationship between the two.
Homework: Final art for Assignment 3 due next week.

Week 6

Class critique of Assignment 3.
Discussion and examples of the use of scale and contrast in humorous illustration.
Distribute and review brief for Assignment 4.
Distribute handout on scale in design and illustration for recommended reading.

Assignment 4: Magazine Spread

Students will receive a light-hearted, humorous article on the daily struggles of exceptionally tall people—the bumps on the head, clothes that don't fit, awkward dates, and leg cramps in cars and on airplanes. The illustration for the opening spread of this article runs across the top of the two pages, approximately 16" wide × 5" deep.

Homework: Two to three sketches for Assignment 4 due next week.

Week 7

Class critique of Assignment 4 sketches. One-on-time spent with students to tighten sketches and choose the best solution. Work on final art in class. Demonstration given on gouache techniques.

Objectives: To emphasize the use of scale and contrast in humorous art. The extreme horizontal orientation of the art for an article about extreme height requires consideration of the proportion of other elements in relation to the subject, cropping, contrast, and exaggeration.

Homework: Final art for Assignment 4 due next week.

65

Week 8

Class critique of Assignment 4.
Guest speaker visits class to discuss humorous art for kids.
Distribute and review brief for Assignment 5.

Assignment 5: Kids' Joke Book Cover

Each student will be given a children's joke book. For the cover art, you will choose three jokes from the book and create one illustration that somehow logically includes all three. For example, if this was an adult joke book, you might show a street scene where a woman is walking into a bar holding a poodle and a salami, a priest and a rabbi strolling down the sidewalk, and a chicken about to step off the curb to cross the road. Keep in mind who your audience is.

Homework: Two to three sketches for Assignment 5 due next week.

Week 9

Class critique of Assignment 5 sketches. One-on-time spent with students to work through sketches and choose one for their finished piece. Work on final art in class.
Discussion and examples of humor and art for children. Handout on designing and illustrating for children.
Demonstration given on various inking techniques and tools.

Objectives: To better understand how to create a humorous image for children, and to get students out and looking at artwork for kids. The assignment requires students to logically combine the disparate visual aspects of three jokes into one illustration, a problem to be solved in almost any conceptual or humorous illustration.

Homework: Finished art for Assignment 5 due next week.

Week 10

Class critique of the kids' joke book cover art.
Distribute brief and business article for Assignment 6 (no examples are shown, no discussion of the article).

Assignment 6: Playing Off the Straight Man

What strange bedfellows humorous illustration and business magazines make. Humor and business stories almost seem antithetical, but often times the role of humorous illustration is to help out an utterly dry or boring article. Each student will receive an article on small cap funds, the S&P 500, and so on. Your assignment is to read the article and, "do something, you know, fun and uh, funny." This project is a full page and a spot.

Homework: Two to three sketches for Assignment 6 due next week.

Week 11

Class talks about humorous illustration and boring articles, with numerous examples shown and discussed.
Class critiques Assignment 6 sketches. One-on-one time spent with students to choose their best sketches. Work on final art in class.
Handout given on illustrating business articles for recommended reading.

Objectives: To emphasize the difference between humorously illustrating something that's already funny versus something dry. This assignment has minimal limitations, and students should take advantage of this.

Homework: Finished art for Assignment 6 due next week.

Week 12

Class critiques Assignment 6.
Distribute and review briefs on Assignments 7 and 8. Distribute handout on the illustrator as author.

Assignment 7: Illustrator Report

Research illustrators, choose one for a report: One to two pages (typed, single-spaced) with at least three samples of the artist's work.

Assignment 8: The Back Page

Write and illustrate a humor piece for the back page of a magazine. You will choose a magazine and develop a concept for its back page. You will write the

description of classes

Week 1

Introduction to dimensional illustration.

Assignment 1

Students create a composition using the first initial of their first names, recreating it on at least three levels and using only white materials. Removing the use of color forces students to focus on the highlight and shadow patterns which define the image.

Homework: Assignment 1 sketches due next class.

Week 2

Critique Assignment 1 sketches.
Work on final art for Assignment 1 in class.
Homework: Assignment 1 final art due next class.

Week 3

Critique Assignment 1.
Start roughs for Assignment 2 in class.

Assignment 2

Students to find and comment on works of dimensional illustration produced decades ago. Color comps and tight final drawings are completed in addition to selection of materials to complete the finished illustration.

Homework: Assignment 2 color comps.

Week 4

Critique color comps.
Start Assignment 2 tight final drawings in class.
Homework: Assignment 2 drawings.

Week 5

Lecture: Photographing dimensional illustration.
Work on finished art in class.
Homework: Assignment 2 final art due next class.

Week 6

Critique Assignment 2.

Assignment 3

Students photograph their finished work and submit the digital image to the instructor via e-mail for evaluation.

Week 7

Critique Assignment 3.
Start roughs for Assignment 4.

Assignment 4

Students select from a list of five titles, each open to a wide range of interpretations. Write a communication objective based on their selected title and produce rough conceptual drawings.
Homework: Assignment 4 color comps due next class.

Week 8

Critique color comp.
Start tight final drawings in class.

Week 9

Work on finished art in class.
Homework: Assignment 4 final art due next class.

Week 10

Critique Assignment 4.

70

Week 11

Individual critique.

COURSE TITLE: ART AND ACTIVISM
INSTRUCTOR: Peter Kuper
SCHOOL: Parsons School of Design
FREQUENCY: One semester, once a week
CREDITS: Three

goals and objectives

The course will explore the application of art from posters to comics to illustration and beyond as a way of addressing social and political concerns and communicating these issues to others. Guest artists are frequently invited.

Students will investigate, document, and create work based upon a passion for their chosen subjects while exploring venues for publishing and disseminating this kind of personal and political work.

At conclusion of the course, students will have learned how to develop and apply their skills in the creation of effective political art, and learn of the specific venues for this type of work as a financially viable career.

All students will be expected to give a brief talk on an artist of their choosing, with examples. There will be short weekly assignments as well as a semester-long project. Each assignment will be evaluated in the group classroom setting, and students are expected to participate in critiques. Students must keep a sketchbook and develop thumbnails, and an outline of their semester-long project that will be periodically evaluated throughout the semester.

71

reading and resources

Understanding Comics, by Scott McCleod
Art of the Masses
German expressionists
Blood Song, by Eric Drooker
Flood! by Eric Drooker
Sue Coe (various titles)
Jules Feiffer (various titles)
Simplicissimus Dover
Maus, by Art Spiegelman
In the Shadow of No Towers, by Art Spiegelman
Peace Signs the anti-war movement illustrated
Freedom Fries, by Steve Brodner
Ralph Steadman (various titles)
Sticks and Stones, by Peter Kuper
The Jungle, by Upton Sinclair adapted by Peter Kuper

Web sites

http://visualresistance.org
http://anotherposterforpeace.org

materials and supplies

Though no specific supplies will be required, students will be introduced to an array of techniques and materials including stencils, collage, and scratchboard.

description of classes

Week 1

Explore students' abilities and subjects of interest, which will dictate focus of class.
Discuss individuals' potential directions from illustrating existing text to
 reportage to posters, comics, and so on. Show examples, including a
 PowerPoint presentation and various books on the subject.
Discuss importance of sketchbook.

Assignment 1

Pick a song with social/political content (students' choice) and illustrate it with single or multiple images. Song title and lyrics may be incorporated, but not required. Introduce semester-long project idea for students to contemplate.

Week 2

Critique with speaker Seth Tobocman.
World War III illustrated, and the process of self-publishing and distributing.

Assignment 2

Begin semester-long project on topic of students' choosing done as a comic, reportage, illustration series, etc.

Week 3

Discuss process of a long-term project.
Guest speaker Ryan Inzana (a newcomer in the field) discusses the difficulties and
 new approaches to entering the field of political illustration and cartooning.
World War III continued.
Show documentary on magazine history.
Address student issues on process of self-publication. Examples: *Raw*, *Bad
 News*, Xeric grant, and so on. Students will address issues in producing their
 long-term project.

Week 4

Critique and discussion.
Examine how best to convey one's topic from irony to head-on attack; the
 application of image with text to complement or counterbalance subject.
 Examples include Sue Coe, Tom Tomorrow, Seth Tobocman, Eric Drooker,
 and Micah Wright.

Assignment 3

Political poster on chosen topic.

Week 5

Guest lecturers Martin Kozlowski and Tom Kerr.

PowerPoint show on history of political illustration with discussion of political illustration group INX found on the Web (*inxart.com*).

Assignment 4

Illustration on topic of the week.

Week 6

Critique illustrations.

Discuss how to succeed in addressing subject with conceptual and artistic clarity. Discuss development of individual projects.

Week 7

Critique Assignment 2.

Political illustration guest speaker Sue Coe. Examine conceptual illustration and venues for social/political art.

Assignment 5

New York Times illustration, if possible from *Times* op-ed art director Brian Rea, with opportunity for publication.

Week 8

Critique project development.

Political comic strips guest speaker Ward Sutton, cartoonist for *Village Voice*. Discuss career and outlets for political strips. Examples include Tom Tomorrow, Tom Toles, and others.

Homework: One-page comic on topic of the week or continue on project.

Week 9

Critique project development.

Guest speaker David Rees. Examine political art from various fields from fine art to *Mad* magazine, and discuss the merits of different approaches to successfully communicating concepts. Examine political humorists (Bill Hicks, David Cross, et al.) and how they verbally attack their subjects.

Assignment 6

Finding humor in serious themes. Students choose the medium.

Week 10

Critique work.

Guest speaker Jules Feiffer. Using children's books, plays, cartooning to convey political topics to an audience and reach people in their formative years.

Assignment 7

Create a work that is aimed at children that is not condescending, aimed at teaching or examining a social/political topic.

Week 11

Critique Assignment 7. Examine development of Assignment 2.
View film *Comic Book Confidential Part I*. Discuss comics as a political tool.
 Examine Spiegelman's *Maus*, *In the Shadow of No Towers*, *Raw*.
Homework: Continue work on long-term project.

Week 12

Critique development.
View film *Comic Book Confidential Part II*. Examine adaptations from other
 texts. PowerPoint show of examples from Classics Illustrated to Sue Coe's
 Malcolm X to film adaptations and animation (*Ghost World*, *American
 Splendor*, *Stripped*).

Assignment 8

Adaptation of another author's text for a long-term illustration project.

Week 13

Critique project progress.
Caricature and political illustrations. Guest speaker Steve Brodner.

Week 14

Critique final project, examine adjustments, and wrap-up to be completed by
 next and final class.
Discuss animation and its application to social/political topics. Guest speaker
 Bill Plympton.

Week 15

Critique final project.
Discuss venues for students' projects and various approaches to marketing and
 disseminating their work.

**COURSE TITLE: A CARTOONING WORKSHOP—
PEN, BRUSH, AND INK**

INSTRUCTOR: Sal Amendola

SCHOOL: School of Visual Arts

FREQUENCY: One semester, once a week

CREDITS: Three

goals and objectives

The hope is that students will develop drawing skills as well as technical, pro-
duction, and reproduction knowledge, through the creation of drawings and
illustrations, using traditional and "exotic" ink and black-and-white media.
Black-and-white media (especially the "line-cut" medium) also remain the
most promising source for early professional assignments.

"Inking" is the creation of a sense of light, form, depth of space—even the
impression of color—through the use of black-and-white media on two-dimen-
sional surfaces. From the basic traditional tools of black waterproof India ink, and
pens and brushes, we go on to shading film ("Zip-a-Tones") and "duo-shade"
boards; scratchboard; textured papers and boards; Wolf pencil, grease pencil, dry-
brush; stipple, toothbrush spatter, razor blade scraping; opaque and transparent
black-and-white watercolors; acetate overlays; and production methods. We will
study pretty much every tool and every technique available to every artist.

75

primary supplies

Pens: Assorted drawing pen nibs and pen holders ("points" and "handles"),
the Gillott® #170, #290, #303, or Hunt nibs, if possible.

Brushes: One for ink, the other for white paint: #4 or #5, Series 7, Winsor &
Newton® sable watercolor "rounds." Get synthetic-hair equivalents. They are
cheaper now and don't entail the killing of Russian rodents.

Ink: Waterproof black India ink. Pelikan® is as good as any. Higgins® is now
one of the worst.

White paint: Pro-White® or Graphic White® are good.

14" × 17" Pads: Two- or three-ply Bristol ("kid, vellum, plate, hot, cold,
rough, medium, high"). Most artists use "kid." Strathmore® is best.

Containers for water: One to rinse out the ink brush, another to rinse out
the white paint brush, and the third for clean water.

Paper towels: Bounty® is best, but others will suffice.

Pencils: Whatever you feel comfortable using. Avoid too-hard pencils that
leave pen-spattering "trenches" or unwanted white lines within brush strokes

on the working surface; or too-soft pencils that can easily leave ink-repelling graphite smudges on the working surface.

Erasure: Kneaded eraser is my preference.

For Measurements: A 24″ T-square, a 18″ ruler, and a 16″ (long angle) triangle.

Masking tape.

secondary supplies

The following are optional supplies. They will be shown and demonstrated. You may choose to explore their possibilities as you go along:

- X-acto® knife.
- Rubber cement.
- Proportional scale.
- Assorted shading films/student packet Duo-Shade® boards and developers, two #6 "round" watercolor brushes.
- Scratchboard, scratchboard "knives" and holders.
- Pad of acetate (try to get "frosted" or "treated" acetate).
- Circle compass-ruling pen set/French curves.

For non-line-cut graded art: One black, two "warm" grays, and two "cool" grays of the same values (lightness/darkness) of the following:

- **Markers:** Chartpak® markers, 3-way tip
- **Paints:** Tempera, gouache, or watercolor (e.g., for watercolors: one lamp black, one Chinese white, and a set of Gama® or Designer® grays
- **Brushes:** A watercolor "round" brush (#5 or #6) and a wide, "flat" watercolor brush (useful for laying in large areas), and a palette, for mixing and holding paints.

Do not use black waterproof India ink for wash drawings!

description of classes

Week 1

Demonstration of traditional tools and supplies.

Week 2

Demonstration of scaling procedures.

Week 3

Demonstration of pantograph, T-square, triangle, and ruler for various grid techniques.

Week 4

Transfer-drawing of one photo. Work on three ink technique drawings of that one drawing in class.

Week 5
Display and explain copies and originals of professional works.

Week 6
Value ranges: contrast, light source, line, weight, quality, and direction.
The effect of lights on local values.

Week 7
Textures: feathering, stippling, shadows (shading), edges (hard, soft), halation,
and hatching/crosshatching.
Shading film (Duo-Shade® boards).

Week 8
Dot/line patterns: direction(s), weight, spacing, and the relationship to perspective and to shape-size in which they are applied or placed.

Week 9
Surfaces: Utilizing moiré patterns, dry brush, scratchboard, Coquille, and other textured boards.

Week 10
Pencils: Grease, wolf, ebony.
Toothbrush-spatter.
Razor blade scraping/scoring.

77

Week 11
Acetate overlays.
Working with photographs.

Week 12
Black-and-white media/color relationships.
Black, grays, and white to suggest color.

Week 13
Photocopy machines as tools.
Paste-ups for corrections and in making mechanicals for reproduction or
limited-color reproduction.

Week 14
Applications of tonal media (black and white).

Week 15
Understandings of cropping, folds, and register marks.

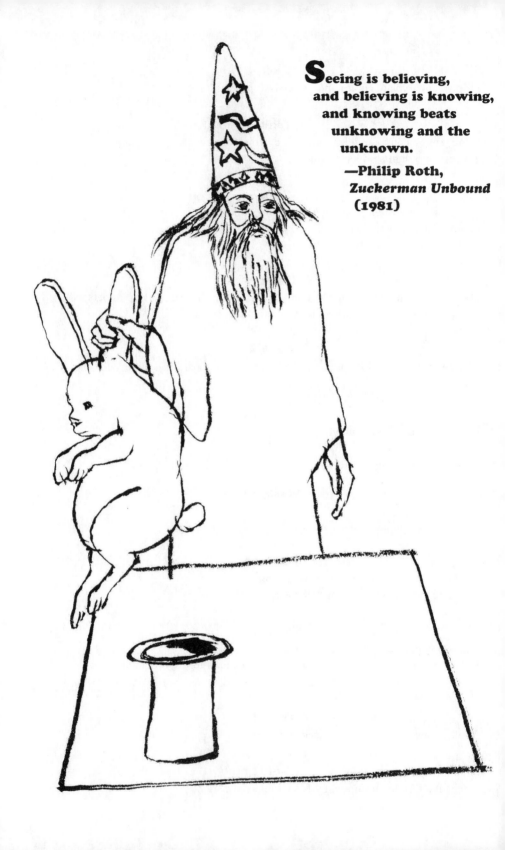

Seeing is believing,
and believing is knowing,
and knowing beats
unknowing and the
unknown.
—Philip Roth,
Zuckerman Unbound
(1981)

junior

COURSE TITLE: ILLUSTRATION II
INSTRUCTOR: Kevin McCloskey
SCHOOL: Kutztown University of Pennsylvania
FREQUENCY: One semester, once a week
CREDITS: Four

79

goals and objectives

Illustration II deals with business practices and a survey of various types of illustration including editorial, CD covers, portrait, advertising, institutional, how-to, book covers, and cartooning. Upon completion of this course, the student will be able to:

- Define various fields of illustration.
- Evaluate one's competencies and interests in the various areas.
- Describe and solve problems encountered within each field of illustration.

Media can be traditional or digital. In either case, sketches are mandatory. The instructor is under no obligation to accept work not seen in progress.

resources

The Graphic Artist's Guild's Handbook: Pricing and Ethical Guidelines. Eleventh edition, 2004, Graphic Artist's Guild, New York.
Mary Cox, ed., *2006 Artist's & Graphic Designer's Market*, Writer's Digest Books.
Business and Legal Forms for Illustrators by Tad Crawford. Third edition, 2004, Allworth Press, New York.

description of classes

Illustration business practices and professional ethics are introduced throughout the class as appropriate. These discussions occur during the first twenty minutes of class and during critiques. We use case studies and examples from *The Graphic Artist's Guild's Handbook: Pricing and Ethical Guidelines.* Topics include maintaining records for tax purposes, model releases, respecting copyright of reference material, and protecting your own intellectual property. We talk about promotion strategies, including entering juried illustration annuals and making a Web portfolio. Each student prepares an itemized invoice for an illustration.

To stimulate the art director/illustrator dialog during assignments, the "art director shuffle" is introduced at the sketch stage. Rough sketches are due the next week after a new project is assigned. The number of roughs varies by project but is never less than three.

We put the roughs in 9" × 12" envelopes, shuffle, and pass them out again. Students are asked to look at their classmates' roughs as an art director might. They make written notations, positive and negative, on the margins of the sketch. Students then meet briefly with the classmates who have their sketches. The artist must consider the art direction seriously, even if he or she decides to pursue the original version of the sketch.

Weeks 1 and 2

Editorial Illustration. The general term "editorial illustration" is not the same as editorial cartooning. Editorial illustration is artwork for any story in printed matter (usually a magazine or newspaper, but also Web) that relates to the text. It does not include artwork that is part of a publication's advertisements. The smallest editorial art is called spot illustration.

Assignment 1

We start small with a spot. From a handout page with several brief stories, choose one story and bring three roughs to the next class. Bring photo reference to class if needed. Since these spots are small, make the roughs full size or larger. If you prefer to find your own story, you may do so only if you bring the story and three roughs to the next class.

Weeks 3 and 4

Cartoon. We will look at the work of modern masters of this subset of illustration, including Gary Larson, Bill Watterson, Lynda Barry, and others.

Assignment 2

A caricature, editorial cartoon, or a multi-panel comic strip. This should be India ink density on Bristol board. To encourage publication, it is suggested that you send a copy to the Keystone school newspaper. If the newspaper prints it, assignment gets an automatic "A" as long as it was completed on time.

Mini-comic by Shannon Collins

Weeks 5 and 6

Portrait. We will look at portraits by Paul Davis, C.F. Payne, Julian Allen, and others.

Assignment 3

Your portrait is to be of a historical figure, or sports or entertainment personality. This can be informal, but it may not be a caricature. Please do not draw God, your pet, or a loved one, as it can be hard to distance yourself from your attachment to the subject at critique time. Vertical format, finish not larger than 18" × 24". Color. May include type or hand lettering.

Weeks 7 and 8

Advertising. Advertising traditionally pays well, but the sketch approval process can be more cumbersome than a deadline-driven editorial assignment. Sketches may have to go through an agency art director and also get client approval.

Assignment 4

The theme is any small local business. Its full-color illustrated ad will appear in the program for the Reading Royals hockey team. The tie-in with hockey is optional. You are welcome to come up with a concept or write a headline and body copy, but your grade is primarily based on the artwork. **Alternative Advertisement**: A 16" × 18" concert poster, horizontal or vertical, full color. Use the names of two real bands, which can be local. Typography and details such as venue and time should be appropriate for the bands.

Week 9

Assignment 5: Tattoo Flash Design

Tattoo parlors call their sample designs "flash." Students are asked to invent or find a person who lives in two very different worlds: biker/lawyer; bartender/science fiction writer; wrestler/judge are some examples. Design a tattoo for that unique individual. Make a full-color rendering for the tattoo artist to copy. Color pencil or watercolor might be appropriate.

Week 10

Assignment 6: How-to Drawing

Three or more clear illustrations showing how to do something, how to open a particular computer and add RAM, how to check your car's oil, make an origami crane, prune a tree, and so on. This is an opportunity to display specialized knowledge you may have from another class or your own work experiences.

Weeks 11 and 12

Assignment 7: Book Cover

Work with a mass-market paperback, an existing book of your choice. Show the class the present cover. Explain how and why your artwork will differ from the actual cover. Work proportionately to the existing cover art. Consider the cover as a cross between a small poster and a point-of-purchase illustration. Cover style should entice the reader to take a closer look and be appropriate for the author, genre, and particular book's audience.

Weeks 13 and 14

Assignment 8: CD Art

Bring in a music or spoken-word audio CD (and reference photos if you need them). If you are in a band or have friends in a local band, do a CD cover for that group. You can do wrap-around art as long as the front image is strong and can stand alone. Print art to size and place it in a clean CD case. The CD cover serves much the same purpose as a book cover; see above.

Week 15

Final critique.

conclusions

Sometimes this schedule of projects becomes overwhelming. Students frequently remind the instructor that illustration is not their only class. In some instances, it helps to allow students a choice on the final project, to do either the CD cover or the book cover. This way the final cover project can be given more time—three to four weeks. These two projects then have a common critique. Though this class is made up largely of illustration majors, most of the students will probably become art directors or graphic designers. For these students, the class can serve as an opportunity to learn to work with illustrators.

COURSE TITLE: ILLUSTRATION III

INSTRUCTOR: Randy Chavez

SCHOOL: California College of the Arts

FREQUENCY: Two semesters, once a week

CREDITS: Six

goals and objectives

We will review the principles of composition and design with an even emphasis on developing concepts. These components will be applied to create finished illustrations that are structurally and conceptually sound. Demonstrations will be set up in order to extend the student's experiential base in the use of watercolors, inks, acrylics, and various mixed media and techniques.

Critical thinking and problem solving are stressed in order to create readable illustrations, developed methodically with a keen emphasis on discipline and craftsmanship.

format

Class time will consist of critiques, lectures and discussions, demonstrations, and in-class exercises. Guest lecturers will be invited. Notebooks are encouraged. There is a required book, *The Annual of the New York Society of Illustration*.

evaluation

- Demonstration of your passion for the field of illustration.
- Relevance, differentiation, and originality of concepts.
- Craftsmanship. The quality, involvement, and comprehensiveness of your preliminary work and finishes. Using tools and techniques competently, and presenting work in a professional manner.
- Communication skills. Sharing your knowledge, experiences, and opinions both through your work and in classroom discussions.
- Attendance.
- Following direction and meeting deadlines.

grading

All preliminary work is due as assigned and accounts for 50 percent of each project's grade.

Each project's total grade is computed according to factors such as: the sound application of principles, the level of experimentation, the level of energy and expressiveness, and the quality of problem solving.

description of classes: first half— working from light to dark

Week 1: Introduction

Handouts: syllabus, materials list, and reading list.
Lecture: "First there is a mountain," "Ceterus Paribus." Hand out "Your success as an illustrator depends. . . ."
Lecture: "How to create a readable picture."
Homework: Read handouts on composition; buy supplies.

Week 2: Readability and Values

Announce portfolio review.
Quiz on readability.
Lecture: "Using Value to Create Focus and Depth" (Jungle Book, animation; Van Alsburg, drawings; Rockwell; Parrish).
In-class assignment: Assignment 1.

Assignment 1 85
Filing cabinet cartoon: This half-hour, in-class exercise is for the student to demonstrate the understanding of values as a means of creating focus and depth. A single cartoon panel (without shading, contour line only, about 6" × 8") is given to every student. The student reads and "illuminates" the caption of the cartoon. Using a regular #2 pencil, a value structure is executed that provides contrast in a way that turns the form of every element, while providing focus and depth to support the text.
Homework: With image from the in-class assignment, use value studies to create a readable picture. Do a contour drawing of an interior space, usually a studio or living space. The student should compose this drawing with many overlapping elements to create a sense of depth with line only. The student is then instructed to photocopy the contour drawing and with a graphite pencil or pencils, do three value compositions: 1) Dark super foreground to light super background; 2) Light super foreground progressing to dark background; and 3) Using value in either or any way, but providing contrast to some smaller or insignificant object in the room so that it becomes the focal point of the picture. Due in two weeks.

Week 3: Introduction to Watercolor

Lecture: Intro to watercolor.
Demo and lecture: "How to set up your watercolor studio."

Discussion: Materials: paper, brushes, and so on. Demo on stretching watercolor paper.
In-class assignment: Begin Assignment 2.
Homework: Finish watercolor properties chart. Due in two weeks.

Assignment 2
Watercolor properties chart (color matrix, lifting, staining, and translucency).

Week 4: Critique and Composition

Portfolio review.
Critique Assignment 1.
Lecture: Defining composition.
Handout: "Depth, line, picture area, value."
Lecture: Picture area/manipulating elements in picture area to create emotional state (Klimt, Rivera, Gustavson, et al.).
In-class assignment: Begin Assignment 3.

Assignment 3: "Composing Billy"
Billy is a silly egg-shaped character I use to get the student to move away from "layout a." By moving Billy around a picture plane on the chalkboard, I can demonstrate how the emotional response of the viewer can be manipulated—that is, extreme closeup creates intimacy (resulting in either a nurturing or repulsive reaction from the viewer); each possibility (far away, small, bottom of picture plane, top of picture plane, bird's-eye view, ant's-eye view, turning figure on its axis, leaving it partially cropped) has its own "psychic pull." This segues into the importance of creating many compositional thumbnails in addition to conceptual ones.

Week 5: Watercolor Swatches

Critique Assignment 2.
Discussion: Watercolor in illustration (Sargent to Santori).
Demo: watercolor (gradations, wet-in-wet effects, etc.).
In-class assignment: Begin Assignment 4.
Homework: Finish watercolor swatches. Due in two weeks.

Assignment 4
Watercolor swatches.

Week 6: Critique Preliminary Work

Lecture: Three stages of picture making: Immersion, preliminary work, beauty.
Handout: "Specifications for preliminary work."
Lecture: How to build an illustration (Kazuhiko Sano).
Lecture: The use of reference, creating conceptual and compositional thumbnails.

In-class assignment: Begin Assignment 5. Ask students to bring reference and props for "concept party" assignment for next class.
Homework: All preliminary roughs for Assignment 5. Due in two weeks.

Assignment 5: Product Illustration

With the product illustration assignment, I am more intent on providing an engaging assignment than I am on creating a hardcore commercial art exercise. I'd rather give them a talk on the exigencies of a commercial assignment and show them preliminary sketches to completion.

The assignment itself (i.e., Celestial Seasoning teabox) would address typography and layout but only in a cursory manner. The emphasis is always on picture-making constructs that reinforce and are in the service of concept.

Another "product" assignment might be music CD cover art in which the content of the CD is "distilled" into a readable image that is strong enough to pull the customer across a sales floor. Here again, the chief intent is to provide an engaging assignment that is so compelling that the artists will immerse themselves completely.

Week 7: Facets and Friskettes

Critique Assignment 3.
Discussion: "Concept party" (bring in and share reference).
Demo: facets and friskettes.

Discussion: Drawing transfer techniques.
In-class assignment: Begin Assignment 6.

Assignment 6

Painting faceted elements with watercolor.

Week 8: Composing in Color

Critique Assignment 4 preliminary roughs.
Lecture: Color composition/creating color roughs.
Homework: Produce finished illustration for Assignment 5. Due in two weeks.

Week 9: Inks and Dyes

Lecture: Inks and dyes, concentrated watercolor (Rackham, Santori, Steadman, Colon).
Discussion: Pen and inks (Charles Santori technique).
In-class assignment: Begin Assignment 7.

Assignment 7

This assignment returns students to traditional rendering methods. Create illustrations with crowquills and watercolor.

Week 10: Critique

Critique finishes for Assignment 5.

Assignment 8
Book illustration: Render a scene or moment from a book.
Homework: All preliminary roughs for Assignment 8. Due in two weeks.

Week 11: Concepts and Storytelling

Lecture: Book illustration (Maurice Sendak trilogy). Examples of book illustration.
Lecture: How to construct a picture book.
In-class assignment: Watch film of Sondheim's *Into the Woods*.

Week 12: Critique

Critique preliminary work for Assignment 8.
Homework: Finish Assignment 8. Due in two weeks.

Week 13: How Light Reveals Form

Individual midpoint review.
Lecture and handout: How light reveals form/The physics of light (Caravaggio).
Discussion: Perspective review and how to collect photo reference.
Demo and handout: "Painting the head in watercolor."

Week 14: Critique

Critique Assignment 8.
Lecture: Integrating secondary elements.
Homework: Final art for Assignment 9 due in two weeks.

Assignment 9
Portrait assignment: Render a character from life.

description of classes: second half— working from dark to light

Week 15: Acrylics
Individual midpoint review (continued).
Lecture: Intro to acrylics.
Demo: Basic acrylic technique.
In-class assignment: Preparing surface and painting.

Week 16: Critique
Critique Assignment 9.
Homework: Preliminary roughs for Assignment 10 due in two weeks.

Assignment 10
Editorial illustration: Using allegory, metaphor, and symbolism to express an editorial idea.

Week 17: Dark to Light Using Monochromatic Underpainting
Lecture: Grisaille technique (Caravaggio, Da Vinci, Ingres, Parrish, et al.)
Discussion: personal technique and instructor's portfolio.
In-class assignment: Using grisaille with acrylics.

Week 18: Critique
Critique preliminary roughs for Assignment 10.
Homework: Finish Assignment 10. Due in two weeks.

Week 19: Experimenting with Acrylics
Lecture and Demo: Building textures, mixing media.

Week 20: Illustration Critique
Critique Assignment 10.
Homework: Preliminary roughs for Assignment 11.

Assignment 11
Second editorial illustration.

89

Week 21: High Tech Meets Low Tech
Discussion: Secret Knowledge–Hockney; the use of optics and digital methods (Photoshop, Illustrator, photo images, etc.); how to stage light and shoot reference and model building.

Week 22: Illustration Critique
Critique preliminary roughs for Assignment 11.
Homework: Finish second editorial assignment. Due in two weeks.

Week 23: Field Trip, Guest Lecturer, or Presentations
Gallery hop, guest illustrator, or students reporting on step-by-step procedures of top illustrators.

Week 24: Illustration Critique
Critique Assignment 11.
Lecture: The poster.

Assignment 12
The poster: Using lettering, design an illustrated poster for advertising an event or idea.
Homework: Preliminary work for Assignment 12 due in two weeks.

Week 25: Acrylics, Continued

Lecture and demo: Adjuvants and additives, the alchemy of acrylics.
Guest speaker: Representative from Liquitex.
Homework: Students bring scratchboard and tools for Class 27.

Week 26: Critique

Critique preliminary work for Assignment 12.
Discussion: Contemporary and historical posters.
Homework: Finishes for Assignment 12 due last class.

Week 27: Scratchboard

Lecture and demo: Scratchboard; Scratchboard examples (Summers, et al.).
Handouts for scratchboard.

Week 28: Oil Wash Technique

Lecture and demo: Oil wash technique (Lane Smith, Ariel Pang, C.F. Payne).

Week 29: Work Day

Open studio.

Week 30: Critique

Critique poster.
Final comments.

COURSE TITLE: ILLUSTRATION III/IV

INSTRUCTOR: Tom Garrett

SCHOOL: Minneapolis College of Art and Design

FREQUENCY: One semester, once a week

CREDITS: Three

goals and objectives

Projects cover creative problem solving and risk taking, professional ethics, practices, production, and technology. Students will be working on a range of assignments that will include illustrating for specific audiences as well as developing innovative images for their portfolios. One of the assignments will require them to create a series of illustrations documenting a specific place or event.

This advanced class is intended to develop a more self-directed and inspired illustration student through a concentration of process, communication, technical skills, craft, and professionalism. Students will be introduced to a variety of media and encouraged to work with a sketchbook to broaden their concepts. Demonstrations on acrylic painting, colored pencil, scratchboard, watercolor, inks and dyes, Photoshop, and paper and photo collage will be provided. Students will create Web-ready spot images as well as large-scale images.

description of classes

Week 1

Introduce goals and class rules and discuss the different methods of the sketch process, including e-mail-ready sketches.

Inform students about a digital portfolio due at the end of the semester.

Before starting new project, students to take a field trip to the Minneapolis Institute of the Arts to see the posters of Swiss designer and illustrator Niklaus Troxler.

Project 1: Aid Relief

Create a poster to help the victims of 2004 tsunami tragedy. The poster should be for one of the following charitable organizations: Oxfam America, the Red Cross, CARE USA, or UNICEF.

Specifics: Full-color, 24" × 18", landscape format.

Objectives: Students will develop research skills and learn to create images on a larger scale.

Deadline: Pencils due in one week, finished art critiqued in two weeks.

Week 2

PowerPoint lecture on contemporary illustration and a new emphasis on drawing. Sketches reviewed for Project 1: Aid relief poster.

Week 3

Workshop on dyes, inks, and colored pencils.
 Critique aid relief poster. Student work evaluated on creativity, research, process, technical achievement, and presentation. After critique, Project 2 assigned.

Project 2: Lucky

Create an illustration using the headline "Lucky."
Specifics: Color image, 11" × 17".
Objectives: To develop concepts into clear sketches and to show students individual styles and working methods.
Process: Students are to create at least twenty different thumbnail sketches and meet with the instructor before starting a more finished pencil sketch.
Deadline: Pencils due in one week, finished art critiqued in two weeks.

Week 4

Critique pencil sketches for "Lucky."
Students are to bring materials to class to work on their finished illustrations.

Week 5

Guest illustrators Mark Todd and Esther Watson to present their work. Critique "Lucky" illustration.

Week 6

Day project "Spots" assigned.

Project 3: Spots

Create a series of spot illustrations for GEICO insurance's Web site. Select three of the following subjects to illustrate:

 • Person carrying goldfish bowl.
 • Person skateboarding with cast on foot.
 • Bird in a cage with a cast on its foot.
 • Dog or cat driving a car.
 • Person flattened under large monthly bill.
 • House floating in water, representing flood insurance.
 • Gecko animal on motorcycle.
 • Gecko animal carrying an umbrella.
 • Boat in water.
 • Person on motorcycle with autumn leaves falling.

Specifics: Full color. Three illustrations. Images can be irregular. Square image at least 8" × 8". Students are to work with a new medium for each illustration.

Objectives: To work quickly and to work with a variety of media.
Deadline: Finished art critiqued at the end of class.

Week 7

Workshop on watercolor papers and techniques.
Project 4 assigned.

Project 4: Drive

Love it or hate it, the automobile has been a part of American culture for almost a century. The project is for the students to illustrate one aspect of our relationship with this machine. Illustrate one of the following headlines dealing with the car:

- Traffic
- Commute
- Scenic drive
- Drive-in restaurant
- Road trip
- The race
- Road rage

Specifics: Full color. 7" × 17" (portrait format)
Schedule:

- Students to create at least fifteen thumbnail sketches.
- After your best concept has been approved, develop your ideas through larger pencil sketches exploring composition and other design issues.

Objectives: To help students develop their concepts, to improve their use of color media and to successfully compose their images within an unusually long format.
Deadline: Pencils due in one week, finished art critiqued in two weeks.

Week 8

PowerPoint lecture on the art of collage in illustration.
Review finished pencils for "drive." Students to work on finished art after critique.

Week 9

Critique "drive."
PowerPoint lecture on the art of the portrait.
Assign Project 5: Pet Pals.

Project 5: Pet Pals

Create a celebrity portrait that includes a famous person with his or her pet. The pet need not be the celebrity's actual furry, feathered or reptile friend, but one that you think shows the same characteristics of its master. Select one of the following celebrities from the list to illustrate:

- Condoleeza Rice
- Hilary Swank
- Clint Eastwood
- Donald Rumsfeld
- Stevie Wonder
- Donald Trump
- Martha Stewart
- Arnold Schwarzenegger
- Loretta Lynn

- Prince
- Ellen DeGeneres
- Nora Jones
- Yoko Ono
- Alicia Keys
- Bono
- Oprah
- Usher

Specifics: One full-color illustration, at least 14" × 14".
Objectives: To develop color media and to illustrate a convincing portrait.
Deadline: Pencils due in one week, finished art critiqued in two weeks.

Week 10
Review finished pencils for "pet pals."
Workshop on Photoshop techniques.
Students to work on finished art after critique.

Week 11
Critique Project 5: Pet pals.
Assign Project 6: The hunt. Minneapolis has a good selection of Asian and Latin markets in the Whittier neighborhood. This project has two parts. The first part is a scavenger hunt in which students expand their research skills by collecting things from this neighborhood. The second part is to create illustrations that depict the rich culture of the community.

Project 6 (part one): The Hunt
Go to the Whittier neighborhood in Minneapolis, specifically Nicollet Avenue from 24th to 29th Streets, and bring back to class the following items that you find on the street or cheaply purchase from shops in the area:

- Something shiny.
- Something old.
- Something organic.
- Something with Spanish written on it.
- At least five take-out menus from restaurants in the area.
- Something bought from an Asian market under $1.00.
- Something with polka dots.
- Any other found materials that you find fascinating.

Week 12
Assign Project 6: Eat Street

Project 6: Eat Street

Create a series of illustrations based on "Eat Street." Make sure that you include some of the things you discovered on the scavenger hunt. Your illustrations could depict eating in one of the restaurants, the street life or the culture.

Specifics: Two full-color illustrations. Double-page spread. 17" × 8.5" (landscape format)

Objectives: To expand research and documentation skills, and to create a series of images based on a specific place.

Deadline: Pencils due in one week, finished art critiqued in two weeks.

Week 13

Workshop on acrylic painting and demonstration on painting of different surfaces like plywood board, canvas, and paper.
Review finished pencils for "Eat Street."
Students to work on finished art after critique.

Week 14

Critique Project 6: Eat Street.
Assign final project.

Project 7: Disappearing Acts

Students to illustrate something that is either extinct or close to extinction. Topics could be birds, plants, animals, machines, or even cultural elements such as the drive-in movie theatre.

Specifics: Three illustrations of any size. Final illustrations must be printed out and bound in some manner.

Objectives: To learn to work in sequence, observing a consistent style and tone.

Deadline: Pencils due in one week, finished art critiqued in two weeks.

Week 15

Review finished pencils for "Disappearing Acts."
Students to work on finished art after critique.

Week 16

Final class.
Critique "Disappearing Acts."
Students to submit a CD with digital images of all their assignments from this semester.

COURSE TITLE: ILLUSTRATION V

INSTRUCTOR: Robert Hunt

SCHOOL: University of California, Davis, Academy of Art

FREQUENCY: One semester, twice a week

CREDITS: Three

goals and objectives

The goal of this class is to introduce students to professional issues and practices in the "real world" of illustration, and to investigate problem solving from the point of view of the artist, client, and audience. I try to give assignments that are interesting but often out of the student's "comfort zone," which are critiqued from a somewhat pragmatic point of view. The goal is to help the students learn to make illustrations which function the way they want, and which will be "read" by the audience the way that they intend.

recommended readings

I bring in several of my own books each week (mainly art books), which I pass around during critiques. Hopefully some books will inspire further interest. Among the many books I bring in to show my class is my dog-eared copy of *Great Illustrators of Our Time*. I think the different responses to the same questions are quite revealing and helpful to the students.

I also bring excerpts from *The Magic Pen of Joseph Clement Coll*, *Nicolai Fechin*, Robert Henri's *The Art Spirit*, Dali's *The Secrets of Magic Craftsmanship*, *The Philosophy of Andy Warhol*, several books by Burt Silverman, and a few Steven Heller books. I usually bring in two or three per class so the list is about sixty books. I loan some of them out to the more interested students.

description of classes

Week 1

Class 1: Introduction, overview.

Assignment 1

An illustration portrait of a parent or guardian created entirely from memory.
This is the most unstructured assignment I give; the idea is to encourage the student to draw from inner resources to create an image.
Class 2: Critique Assignment 1. Emphasis on unique approach of unique subject.

Assignment 2
Ozymandias: Make an interpretation of the classic Shelley poem based on the political climate of today. Thumbnails due next class.

Week 2
Class 1: Critique Assignment 2 (emphasis: problem solving), create revised
 thumbnails for next class.
Class 2: Critique revised thumbnails.

Week 3
Class 1: In-class demo on drawing, final art for Assignment 2 due next class.
Class 2: Critique final art for Assignment 2.

Assignment 3
Calendar assignment based on the Japanese Hotel Barman's Association.
Make a calendar image that is built around the name of a mixed drink (i.e., "Black Russian")

Week 4
Class 1: Slide presentation on reference photography.

Assignment 4
Create an illustration for the cover of a "modern classic" novel. Students pick
 from a short list of five books, which I provide. They must read the book.
Class 2: Critique Assignment 3 thumbnails.

Week 5
Class 1: Guest speaker.

Assignment 5
Create an illustration for limited-edition Converse athletic shoe.
Class 2: Critique Assignment 3 sketches.

Week 6
Class 1: Critique of thumbnails for Assignment 4.
Class 2: Critique finished Assignment 3 and Assignment 5 thumbnails.

Week 7
Class 1: Return of guest speaker, who critiques finishes for Assignment 5.
Class 2: Final drawing for book cover due, critique.

Week 8
Class 1: Assignment 6 in class.

Assignment 6
Illustration based on an editorial content, with a two-day turnaround to finish.
Class 2: Critique Assignment 6.

Week 9
Class 1: Critique finishes for Assignment 4, business lecture, and in-class workday.
Class 2: Look for children's book manuscript.

Assignment 7
Create a 32-page children's picture book (a collaborative project). Finished book to be distributed on CD.

Week 10
Class 1: Choose and assign page break for Assignment 7.
Class 2: Assignment 8 thumbnails in class.

Assignment 8
"Heaven and hell": Detailing the dichotomy between these two metaphoric locales.

Week 11
Class 1: Finishes for Assignment 8 due.
Class 2: Drawings for Assignment 7 due, make book dummy.

98

Week 12
Class 1: Revised drawings for Assignment 7 due, individual student meetings to discuss future plan.
Class 2: Class studio workday, further individual student meetings.

Week 13
Class 1: Final class critique of Assignment 7.
Class 2: Class visit to studio, last-minute critiques.

class projects

Any of the above assignments are subject to change. Some past assignments include:

- Recreation of Roy Horn (of Siegfried and Roy) being attacked by tiger in Las Vegas.
- Editorial magazine illustration on identity theft.
- Book cover conceived as part of a series (a concept that works for a title but that could be expanded to additional titles by the same author)—that is, *Slaughterhouse 5* must be able to make a cover for another Vonnegut book while keeping artistic continuity.

- Illustrating an emotion.
- Illustration for calendar based on Beatles music.
- Illustration: "What's on your ipod?"
- Design for a snowboard deck.
- Make up a holiday and create a greeting card for it.
- Illustration for a header for a "webzine" (*salon.com*) advice column.

conclusions

My hope is that students leave my class with a better work ethic, sense of professionalism, and perspective on their future in illustration. My hope is that they learn that their true value in the marketplace is rooted both in their individuality and their ability to adapt their unique vision to solve real problems.

COURSE TITLE: ILLUSTRATION SEMINAR

INSTRUCTOR: C.F. Payne

SCHOOL: Columbus College of Art and Design

FREQUENCY: One semester, one class a month
for three days

CREDITS: One and one-half

goals and objectives

As an overall concept, this class was created to offer CCAD students practical assignments relevant to the actual contemporary conditions and environments they will soon enter, all the while reinforcing fundamental skills of craftsmanship, design, and problem solving. As this class is a piece of the final chapter of the CCAD illustration, an additional mission is to help the students complete their portfolio for their life after graduation.

There are times when I divide the students into two or three groups, depending on the strengths and weaknesses of each student. I then deliver the assignments to each group, depending on its intended goal. By doing this, I am neither slowing any one student down nor pressing a student beyond his or her capabilities.

This Illustration Seminar has more structure, with specific assignments to challenge, teach, or reaffirm students' fundamental skills learned in foundations and sophomore classes. The assignments will also expose their strengths or weaknesses that can be addressed in future assignments. Each assignment is designed with "real-world" function in mind, thus allowing students to potentially utilize the art they create as a portfolio piece.

recommended reading

My Adventures as an Illustrator, by Norman Rockwell
The Business of Illustration, by Steven Heller and Teresa Fernandes
The Art Spirit, by Robert Henri
The Painted Word, by Tom Wolfe

description of classes

Each student is required to develop a notebook of illustration tear sheets. Each notebook must contain at least three images of fifteen illustrators and three images of five graphic designers. By the second class, each student must choose

one illustrator and collect fifteen images of that artist and write a critical essay on the artist and his or her work. It is strongly encouraged that the students refrain from collecting the works of artists they admire and seek new artists who may open their eyes to new ideas. Encouraging the students to review and collect the works of graphic designers allows them to see the function of the applied arts and how the illustrator collaboratively works with a designer.

Thursday Class

Reviews and critiques of the finished art assignments produced by the students. Upon finishing the critiques and a short meal break, we begin the next assignment. Each assignment starts with a lecture that has some meaning to the assignment, with either a demonstration or presentation.

Friday Class

Students are beginning their assignments. Some assignments require in-class exercises. If an exercise is not required, students begin an idea or concept development by drawing on tracing paper with pencil in class. Ideas are discussed either as a class or in private.

Saturday Class

Before sending the students off on their assignments, ideas are finalized and discussed, as well as reference development, design and prefinish work required before completing the assignment.

sample assignments

1. **Atmospheric drawing**. Here the student will complete five fully developed and rendered drawings from life. Three drawings will be outside drawings and two will be interior, or vice versa. Either way, the total number of drawings is five.

The purpose of the assignment is to reaffirm the observational drawing skills of the students, putting into application their understanding of perspective, space relationships, light, form, shadow, composition, and communication.

2. **Self-portrait.** This assignment requires the students to create a self-portrait, with him- or herself in the mid-ground and an object of their choosing in the foreground with an atmospheric background.

The self-portrait assignment is designed to have the student demonstrate an ability to capture likeness and to have an understanding of perspective, composition, the unity of light, shadow, and form in creating a complete narrative picture.

3. **New York Times Book Review**. This assignment is to develop or strengthen the students' ability to handle likeness as well as compose in a required format, as established by the publication.

4. **The Conversation**. The students are required to illustrate a conversation with two people in their proper surroundings. This assignment seeks to develop the students' ability to capture a narrative quality in their work by creating a piece of art that allows the viewer to imagine the content of the conversation.

5. **Opposites**. In this assignment, each student chooses an opposite—that is, black and white, tall and short, fat and thin, or life and death. Each student will create an image that illustrates both words in a single concept. As a warm-up, I divide the students into three groups and give each group a single word—red, green, or blue. The students then have thirty minutes to come up with thirty separate ideas from their assigned word. In class, all students then participate in reviewing and discussing each student's ideas, offering their own suggestions on how varying ideas can either be developed or improved.

6. **Reference development**. To teach the students about developing, creating and researching reference for an illustration, I bring in camera equipment, files, and books to show students the variety of ways an artist has to work to develop reference for a picture. I shoot photos of each student using a variety of lighting effects and costumes. From these photos, the student chooses a character from literature and creates a portrait. Sometimes we have the students use their own photos, and sometimes we have the students swap the photos.

conclusions

When I first began teaching at CCAD, I tried requiring the students to read *The Art Spirit* by Robert Henri. Unfortunately, I found that requiring the notebook collection of illustration with the critical essay and the required reading was just too much for the students, with all the other required assignments they have in their other classes. Requiring too much in one class seemed to only ensure that my class would be the one that suffered, with the students not giving their art assignments enough time. In the end, I found the notebook collection to be too good of a learning tool to let go. So now, all I can do is recommend to the students a few books to read at their own pace and choice.

COURSE TITLE: SYNERGISM IN ILLUSTRATION
INSTRUCTOR: Mike Hodges
SCHOOL: Ringling School of Art and Design
FREQUENCY: One semester, twice weekly
CREDITS: Three

goals and objectives

A studio elective that explores a variety of problem-solving methods that creatively use analogy and metaphor in order to communicate visual ideas. Slide presentations and discussions provide a historical context as well as an overview of contemporary issues and approaches. Projects are balanced between instructor-provided assignments and student-generated directions.

Student accomplishments shall have an awareness of the methods and directions related to the course topic via an overview of collected works and an understanding of the creative techniques associated with synergistic thinking and problem solving.

- Experience in developing self-directed projects.
- Experimental explorations.
- Significant utilization of a "personal vision" in all works.

103

description of classes

Each class begins with slide presentations of historical and contemporary synergistic work.

Week 1

Introduction to course.
Discussion on historical perspective.
Homework: thumbnail ideas for Assignment 1.

Assignment 1: Splice of Life
You are to select a topic that you find interesting and develop a synergistic image that is appropriate for your choice. A) Monster or creature, B) Inventor, C) Deity, D) Contraption or gadget.

Week 2

Slide presentations.
Review homework.
Work on Assignment 1 in class.
Homework: tight pencil sketches for Assignment 1.

Week 3

Slide presentations.
Review homework.
Work on Assignment 1 in class.
Homework: work on Assignment 1.

Week 4

Slide presentations.
Work on Assignment 1 in class.
Homework: Final art for Assignment 1.

Week 5

Slide presentation.
Critique of finished art for Assignment 1.
Work on Assignment 2 in class.
Homework: thumbnail ideas for Assignment 2.

Assignment 2: Interactions
Select one of the sub-topics that you find interesting from the following categories and using a synergistic direction, develop an image that brings a specific point of view to the issue. Think local, regional, national, and international when trying to develop your ideas:

- Social themes: Compassion, conflict, or ambivalence
- Political themes: Negotiation, confrontation, or manipulation
- Business themes: Cooperation, growth, or insight.

Week 6

Slide presentations.
Review homework.
Work on Assignment 2 in class.
Homework: tight pencil sketches for Assignment 2.

Week 7

Slide presentations.
Review homework.
Work on Assignment 2 in class.
Homework: work on Assignment 2.

Week 8

Slide presentations.
Work on Assignment 2 in class.
Homework: Final art for on Assignment 2.

Week 9

Slide presentation.
Critique of finished artwork.
Work on Assignment 3 in class.
Homework: thumbnail ideas for Assignment 3.

Assignment 3: Coexistence
The topic for this assignment is "coexistence." It is the title of an international traveling exhibition that was sponsored by the Museum on the Seam for Dialogue, Understanding and Coexistence, which is located in Jerusalem. This outdoor poster exhibition will be displayed locally. You are to create an image that you feel communicates an interesting (and synergistic) idea of coexistence. Read the description of the show and the curator's comments and then visit the Web site to view the posters as well as read the additional quotes by some well-known writers and thinkers (*www.coexistence.art.museum/eng/exhibition/traveling.htm*).

Week 10

Slide presentations.
Review homework.
Work on Assignment 3 in class.
Homework: tight pencil sketches for Assignment 3.

Week 11

Slide presentations.
Review homework.
Work on Assignment 3 in class.
Homework: Final art for on Assignment 3.

Week 12

Slide presentations.
Critique of finished artwork.
Work on Assignment 4 in class.
Homework: thumbnail ideas for Assignment 4.

Assignment 4: Editorial
You are to select an article from the newspaper, a magazine, or the Internet, on any topic that interests you and create an image that involves a synergistic approach. You should keep in mind that you are illustrating the writer's viewpoint, not just using the topic as a springboard for your own opinion or expression.

Week 13

Slide presentations.
Review homework.

Work on Assignment 4 in class.
Homework: tight pencil sketches for Assignment 4.

Week 14

Slide presentations.
Review homework.
Work on Assignment 4 in class.
Homework: Final art for Assignment 4.

Week 15

Slide presentations.
Critique of finished artwork.

COURSE TITLE: ILLUSTRATION METHODS
INSTRUCTOR: Mark J. Tocchet
SCHOOL: University of the Arts, College of Art & Design
FREQUENCY: Two 15-week semesters, once a week
CREDITS: Three per semester

goals and objectives

Through a planned series of lectures and assignments on basic pictorial problems as they relate to illustration, students build a repertoire of illustration skills, aptitudes, and techniques. Achieved, practical, and real-life illustration assignments begin with students solving these problems by using their picture-making experience from past assignments. They will develop theme, drawing, value, composition, color, texture, mood, and style within the illustration. Emphasis is on finding and developing the artist within the illustrator—that is, illustration as a reflection of the artist's orientation to the world. Ultimately, personal style and authentic technique evolve. This, together with lectures on the history and business of illustration, including target marketing, field trips, guest lecturers, and individual critiques and evaluations, all combine to prepare students for the future fourth-year program, illustration in general, and earning a living as an artist after leaving school.

course requirements

Attendance and punctuality are expected. If a student is more than ten minutes late or has irregular attendance on any one day, that student will be marked half-absent for that class. Department policy allows only three absences per semester, with the fourth resulting in a failing grade. It is the student's responsibility to make up all material covered and work missed due to absences.

Class assignments are due in a state of quality and completeness on the date designated. At such time, they are reviewed and graded. Classroom participation is noted.

It is hoped that the preceding policy and standards will give students the professional skills and attitudes needed to survive in the real world of illustration they find after graduation.

supplies and reading

Discussed as individually needed/applicable.

description of classes

Week 1
Introduction: Goals and objectives of the class.
Discussion: Illustration today as a profession.

Assignment 1: The Power of Light
In a series of assignments, students develop and create two personal images in two different techniques, using light and value composition as the main vehicles to explore and reveal a part of themselves. Write brief intent statement (to improve content/viewpoint development).

Week 2
Review sketches for Assignment 1.
Discussion: Illustration as personal viewpoint (finding yourself, experimentation); direction and focus in third year.

Week 3
Critique Assignment 1 final art.
Discussion: The process of making an illustration—reference and creative research; starting a picture file; materials and techniques; thumbnail image development.

Assignment 2: Self-Portrait/Multiple Personalities
In a series of assignments, students develop and execute a self-portrait value study; a traditional color scheme skin tone self-portrait based on a color study lecture and demonstration; and an expressive, personal approach to a themed self-portrait. Write brief intent statement.

Week 4
Review sketches for assignment.
Discussion: Value–value patterns; capturing light; proportion scale.

Week 5
Critique Assignment 2 final art.
Discussion: Allowing for bleed in artwork; silhouetted illustration; paper, board, canvas and other supports for artwork; history of illustration.

Focus Assignment
Individual student presentations to class of selected Golden Age master illustrators, outstanding contemporary illustrators, and artists of their own choosing. Students are encouraged to see what's out there and relate it to their own work.

Week 6
Discussion: The portrait; landscapes and aerial perspective.

Assignment 3: Landscape/Color Explorations
In a series of assignments, students develop and execute: three color theory landscape studies; a black-and-white full-value landscape study; and a full-color finished art landscape using aerial perspective, creating mood related to a theme and expressing a personal approach to space and color. Write brief intent statement.

Week 7
Review sketches for Assignment 3.
Discussion: Color theory, composition.
In-class color theory assignment.

Week 8
Critique Assignment 3 final art.
Discussion: Working with themes and in series; history of illustration.
Mid-semester evaluations.

Week 9
Focus assignment presentations.
Discussion: The computer (with scanning and preparing files for print and e-mail attachment), opaque projector, light box and photo copier; surrealism and illustration.

Week 10
Focus assignment presentations.
Discussion: Color theory II (mix any color in three simple steps).
In-class color theory assignment.

Week 11
Discussion: Making one believable image from multiple reference sources.

Assignment 4: One Image from Multiple Reference Sources
Students create, develop, and finish one whole, believable picture by utilizing multiple, completely separate reference sources. Image theme is based on understanding famous quotes and their meaning in a larger context (relating its human commonality/universal truth to something in their own lives). When thinking of the finished art, students are asked to move beyond what they already know and ask, "What materials/techniques/application would best say this for me?"

Week 12

Review sketches for Assignment 4.
Discussion: Photography and models as reference.

Week 13

Critique Assignment 4 final art.
Discussion: Digital, 35mm, and Polaroid cameras and film for reference.

Week 14

Focus assignment presentations.
Discussion: Using past assignments as reference.

Week 15

Focus assignment presentations.
Discussion: Creative identity; concepts, themes, and universal truths.
Individual final evaluations.

spring semester

Week 1

Past assignments—analyzing results.

Assignment 1: Music CD Packaging Cover Illustration

Students develop and create an illustration for an artist whose work contains
themes that interest them and that they relate to on a personal level. Artwork
should be a visual representation of the music's theme, capturing the mood and
atmosphere of the work. At the same time, it must have visual impact and
readability in its condensed state.

Week 2

Class site visits a music store to familiarize itself with the genres. Students play
music selections and discuss their research and thumbnail ideas in class.
Discussion: The boldness of beginning—commitment, passion, faith,
and integrity.

Week 3

Review sketches for Assignment 1.
Discussion: Finding the "link"—conceptualizing and problem solving on
your terms.

Week 4

Critique final art for Assignment 4 (finished illustration—quality digital print of
image to size, displayed in a CD jewel-case).

Discussion: Working from a manuscript; reading an art director; book covers and type.

Assignment 2: Hardcover Book Jacket Illustration

Students begin this assignment by immersing themselves in the topic by reading, visualizing, asking questions, and doing research; finding personal interests and viewpoints to explore; being sensitive to the use of typography on book covers; thinking beyond what has already been done; trying to communicate something personal and unique and yet broad enough to be the cover image for the specific book; asking—what universal themes does the author visit time and again? Use light and shadow, color, mood and space, drawing and gesture, composition, viewpoint and perspective, along with subject matter and theme to achieve their goals in thumbnail sketches

Students discuss their research and thumbnail ideas in class presentations.

Week 5

Site visit to a bookstore to look at contemporary covers for the author and genre, making notes to refer to; discuss ideas.

Discussion: Setting up a studio; portfolio reproduction and presentation.

Week 6

Review sketches for Assignment 2.

Discussion: Target marketing.

111

Assignment 3: Target Marketing Presentations

Students spend four weeks researching and documenting the illustration, graphic and other art industries for artists, artwork and potential markets, genres, and clients, with an eye to their own work, aspirations, and goals. Write brief intent statement.

Week 7

Critique final art for Assignment 2 (finished illustration and quality digital print of image to size).

Discussion: Self-promotion and advertising.

Week 8

Discussion: Web sites; voice and e-mail; promotional cards; four-color process printing.

Mid-semester evaluations.

Week 9

One-Day In-Class Assignment

Students come to class with all necessary supplies, peruse more than fifty different assignments posted, and follow this schedule:

8:30–9:00	Assignments chosen, process analysis, art direction
9:00–9:45	Thumbnail/conceptual stage (must get approval before continuing)
9:45–10:15	Reference stage
10:15–11:00	Sketch stage (must get approval before continuing)
11:00–2:30	Finished art stage
2:30–3:30	Class critique

Week 10

Discussion: Trade directories.

Assignment 4
Students create two self-generated target market illustrations based on each student's individual target marketing research and presentation.

Week 11

Review sketches for Assignment 4.
Work in class.
Discussion: Copyright.

Week 12

Work in class on Assignment 4.
Discussion: Contracts, pricing and negotiating.

Week 13

Work in class on Assignment 4.
Discussion: The interview; business relationships.

Week 14

Critique final art for Assignment 4.
Discussion: Developing a successful attitude; visualizing success.

Week 15

Last thoughts for the year.
Individual evaluations.

COURSE TITLE: DESIGN METHODS

INSTRUCTOR: Brian Biggs

SCHOOL: University of the Arts, College of Art & Design

FREQUENCY: 6 hour class, once a week, for one fifteen-week semester

CREDITS: Three

goals and objectives

Within the context of design/illustration projects, an understanding of how artwork is reproduced in commercial print media. Emphasis is on the relationship between electronic media and production techniques. Specific programs utilized include Adobe InDesign, Adobe Illustrator, and Adobe Photoshop.

recommended reading

The Business of Illustration, by Steven Heller & Teresa Fernandes, Watson-Guptill Publications.

Inside the Business of Illustration, by Steven Heller and Marshall Arisman, Allworth Press.

Graphic Artist's Guild Pricing & Ethical Guidelines, Graphic Artist's Guild, Inc., Northlight Books.

Designing with Illustration, by Steven Heller and Karen Pomeroy, Van Nostrand Reinhold.

MTIV: Process, Inspiration and Practice for the New Media Designer, by Hillman Curtis, Pearson Education.

The Big Book of Logos, by David E. Carter, Collins Design.

Production for the Graphic Designer, by James Craig, Watson-Guptill Publications.

Unspecial Effects for Graphic Designers, by Bob Gill, Graphis Press.

The Mac is not a Typewriter, by Robin Williams, Peachpit Press.

The Shape of Content, by Ben Shahn, Harvard University Press.

The Graphic Design Reader, by Steven Heller, Allworth Press.

Design Literacy, Second Edition, by Steven Heller, Allworth Press.

Fresh Dialogue One: New Voices in Graphic Design, Princeton Architectural Press & AIGA, New York.

Fresh Dialogue Four: New Voices in Graphic Design, Princeton Architectural Press & AIGA, New York.

The Theater Posters of James McMullan, by Bernard Gersten, Penguin Publishers.

Communication Arts, Print, Step-by-Step, How.

description of classes

Week 1

Introduction to course.

Survey of logotypes (famous and not so famous, symbols, usage, etc).

First assignment to design a logo is given.

Week 2

Sketches for logotype project.

Introduction to Adobe Illustrator.

Discussion of vectors versus pixels.

Week 3

Work on logotype in computer lab.

Poster assignment introduced.

Week 4

Logotype assignment due; class critique.

Discussion of posters in second half of class.

Week 5

Shakespeare poster assignment.

Research due with discussion of thumbnails and ideas.

Introduction to Adobe InDesign, and discussion of scanning and resolution.

Week 6

Sketches due for posters.

Complete layout for poster in class in InDesign, drop in sketches.

Week 7

Final posters due.

Critique in class.

Book cover assignment given in second half of class.

Discussion and survey of book covers.

Week 8

Research and thumbnail sketches due.

Introduction to bleeds, crops, and registration in InDesign.

Week 9

Finished sketches for book covers due. Introduction to saving project files for reproduction (discussion of file types: PDF, TIFF, EPS, etc.).

Week 10
Final book covers due. Class critique.
CD cover assignment given and discussed.
Illustrator/art director combinations are drawn.

Week 11
Briefs describing assignment are given to illustrators from art directors.
Research and thumbnail sketches proceed in class.

Week 12
Final sketches from illustrator due.
Presentations made to art directors.
Revisions and layouts worked on in class.

Week 13
Final illustrations due for art directors. See assignment.
Final layouts prepared in computer lab.

Week 14
Final CD projects due at beginning of class. Class critique.

Week 15
Final critiques: All final art revisions due.

class projects

Weeks 1–4: Logotype Assignment
Create a logotype for a company. Student must make up the company (sometimes wide open, sometimes limited to particular kinds of companies like coffee shops, florists, and airlines). Logotypes are deceptively simple and get the students quickly to the dirty work of breaking down big ideas (like companies) into easily readable, quickly identified shapes and symbols. This project also introduces many of the students to working with vectors in Adobe Illustrator and how this process is different from working with traditional media, as well as different from moving pixels around in Photoshop. The final projects must be created in Illustrator and saved as EPS files.

Weeks 4–7: Shakespeare Theater Poster
Choose *and read* any play by William Shakespeare, and create a poster advertising the production. Size and format are given, as well as certain typographic requirements such as date, location, and production company. Students are encouraged to reconsider the setting and time-period for the play and create

their poster accordingly. In addition, they are encouraged to experiment with ways of making images for the poster that are different from the drawing/painting they already do.

This project covers scanning images and understanding resolution. The correct use of RGB and CMYK is also discussed.

Weeks 7–10: Book Cover

Taking the skills learned on the poster assignment, the more complicated process of creating a book cover is tackled. Titles, authors, and synopses for six books are presented (based on real books but with new titles and fictitious authors so that the students aren't easily influenced by what was already done for the book with a quick *Amazon.com* search) and are randomly handed out. The students must research the subject of the book and present that research along with their sketches.

From a production standpoint, students learn about the page layout application as a design tool and what file formats are correct for printing. Specifically, what is CMYK, and why they should flatten their layered Photoshop files and save them as TIFFs before importing them into their InDesign layout. File types are thoroughly discussed, and the students are introduced to the concept of printer's marks and the bleeding of images on a layout.

Weeks 10–15: CD Cover

You will design and art direct an illustrator in the creation of a cover for a compact disc of your choice. You will be teamed up with another student from this class who will act as your illustrator on the project and who will have to take your concept and idea in order to make his or her art. Additionally, you will be an illustrator for another student's design and will try to convey the concept for that work. The point of this unusual twist is to introduce to you the role of the art director in the process of creating design and illustration, and to further stress the importance of "concept" in creating such work.

In this project, the students are introduced to the specific roles of the art director and the illustrator. All students choose a CD to design in the role of art director. They must write a brief, describing the music and the performer, and what is to be expected from the illustrator in creating an image for the cover. This brief is then given to another student who acts as the illustrator for the assignment. In addition, the art director is an illustrator for another art director, and so on. Ultimately, it's the art director who is responsible for the work being done on time, and done well. If the illustrator for the project is falling behind, it is up to the art director to solve this and get the piece done on deadline, or keep the client (the instructor) informed as to the problem. Since the art director has no control over which student he or she will be working with, it is important for the idea of the design to be stressed over the look of the illustra-

tion. Often, a disco illustrator ends up with the assignment to illustrate a punk-rock CD cover. If the brief gets the art director's idea across sufficiently, the illustrator can step out of his or her "typical" style and do something appropriate for the CD.

The art director is responsible for making sure that the illustrator has heard the music and understands the desired market and feel for the cover. The art director discusses sketches directly with the illustrator, and they are expected to stay in touch throughout the process, even outside of class.

COURSE TITLE: PEN, INK, AND SCRATCHBOARD
INSTRUCTOR: Nicholas Jainschigg
SCHOOL: Rhode Island School of Design
FREQUENCY: One semester, once a week
CREDITS: Three

goals and objectives

To introduce students to the medium of pen and ink as an expressive and versatile means of communication.

Pen and ink is one of the simplest of all artistic media to learn. Like chess, however, mastery requires a large dose of talent, and a lifetime of study and dedication. Naturally, this class will be unable to provide these ingredients. What it will provide is discussion of the use of pen-and-ink drawing in various times and cultures, an introduction to the materials and methods of pen-and-ink drawing in the present day, including: nibs and holders of various types; inks of traditional and modern acrylic formulation; scratchboard cutters of various types, both commercial and improvised, as well as how to sharpen and maintain them; papers and boards of various types, including clay coat boards and medical illustration boards for scratchboard. In addition, some discussion of digital media will take place, especially how it can be used to emulate pen and ink in both raster and vector formats, as well as how pen-and-ink techniques can be used to create interesting and small-size HTML documents for the Web.

description of classes

Week 1: Introduction

The first class will consist of a discussion of pen-and-ink work from various times and cultures up through the present, including work in visually related media, such as woodcut, lithography, and engraving. Discussion will concentrate on the creation of form through line (Beardsley, Hirschfeld, Hokusai) or tone (F. Booth, Tinkelman) as well as the combination of the two (Vierge, C.D. Gibson, and almost everybody else). Attention will be paid to the proliferation of pen-and-ink work in the 19th and earlier 20th centuries and how it was driven by the technical considerations of reproduction (interesting parallel to ukiyo-e printing in Japan, as well as the artistic pen-and-ink work of those influenced by it, such as Van Gogh and Toulouse-Lautrec).

The basic equipment of modern pen and ink will be discussed: the quill, holder, and ink. Proper preparation (vinegar bath), handling for right and left

handers (gotta avoid those wet lines...), bottle holders, the merits of soft and hard nibs, waterproof versus non-waterproof inks, and so on. In addition, methods of transferring preliminary work to the board will be discussed (blue line and why it works, graphite trace, etc.) as well as tips like the use of photo technicians' cotton gloves and bridges to keep a clean surface.

Assignment 1: Prepare and Become Acquainted With the Materials

Purchase and prepare a range of nibs and papers, and at least one bottle of India ink. Exercises in line and tone after Arthur Guptill's classic book will be assigned and discussed in the following class.

Week 2: Pen-and-Ink Handwriting

It will be noticed when the previous week's assignments are put on the board that even in the case of the simplest academic assignment, the personality of the artist is revealed. Pen and ink shows personality in the same way as hand-writing: some loose and free, some tight and controlled, some scrawling, some flowing. One of the goals of the class will be to discover and develop the personality described by the line work. Extensive photocopies of classic and modern pen-and-ink work will be handed out and discussed as regards expressiveness and execution.

Assignment 2: Copying as Study

The assignment is to copy an example of pen-and-ink work that the student admires. The copy may be executed by tracing, grid transfer, freehand drawing, or even working over a photocopy, although this is discouraged on the grounds that photocopy paper is too fibrous and thin to allow for good control. The point of the exercise is to demonstrate that unlike many other media, pen and ink is instantly usable. There is no breaking-in period where the hand and mind must become used to the action of the brush, chisel, or kiln. On the contrary, anyone of even moderate dexterity is capable of making the marks that go into a pen-and-ink drawing. The difficult part of pen and ink is knowing where and how to put the lines. This is to a large extent determined by the temperament of the artist. However, discipline and practice, and a study of other artists' effects, can go a long way to developing this style.

Week 3: Tone

The effects achievable through pen and ink break down roughly into line and tone. Of the two, tone is perhaps the easier to master. Intrinsic to the mastery of tone is an understanding of values. The 1–10 value system will be discussed, the use of red glass and commercial value finders, as well as the concept of the "break" as it relates to the tonality of a picture. Pen and ink, unlike continuous-tone media, cannot easily create a smooth gradation across the entire value spectrum. At some point, the tonality will experience a visual "break,"

usually close to the pale gray or near-black tone. This break must be dealt with to produce an effective image, although there are as many ways of dealing with it as there are pen-and-ink artists. Examples of different tonally based artists will be shown and discussed, notably Murray Tinkelman, Gustave Dore, Franklin Booth, Brad Holland, J.M. Flagg, C.D. Gibson, and Bernie Wrightson.

Assignment 3: Family Values

Students will choose an image to do three value breakdowns. The first will be a pure black and white, the second will add two grays, and the third will be a complete tonal rendering. During this process, the virtue and clarity inherent in the simplest possible value breakdown will hopefully become clear to them.

Week 4: Directionality

What should become apparent to the class from looking at this week's assignments is the importance of line direction, as well as tone, in conveying the solidity and structure of objects. Different linear directions within the same tonal range can be used to accentuate texture, form, or movement. Different artists handle this phenomenon in different ways, and the quality of grouped lines and hatching versus crosshatching versus pointillism will be analyzed as it relates to the expressiveness of the drawing.

Assignment 4: Which Way?

The value of repetition in pen and ink cannot be overstated. It is more a thought process than a medium, and reworking often bears immediate fruit. This assignment is yet another breakdown of the same drawing, this time using the value breakdown to allow for meticulous planning of the directionality of the lines.

Week 5: The Line

Relatively few illustrators have made careers entirely by line work—Beardsley, Hirschfeld, Steinberg, a few others, often Japanese. The line is simultaneously the most elegant and the least controllable of expressive means. Its simplicity leaves no room for error. Absolute mastery of line seems restricted to an elect few, but a greater understanding of how the line works is beneficial to all artists. Discussion of the line as border, as divider, as direction, as graph, etc.; line as symbol, line as shape.

Assignment 5: One-Line Autobiography

To focus their attention on the emotive quality of lines, students will be asked to compose an autobiography in one line. The line can be of any length and must express, somehow, aspects of the students' lives as they grew and how they came to be here.

Week 6: Putting It Together

Students will by now have an understanding for both styles of work, line and tone, and a deep appreciation for the value of a mixed technique. Different examples of mixed, or classical pen and ink will be presented, showing how line work can be used to extend the visible range of the tonal drawing further into light and dark than would otherwise be possible.

Assignment 6: The Self-Portrait

Faces are hard to draw, and harder in pen and ink. The way the lines flow naturally around the features leads to some very ugly intersections if not carefully managed. By working from features they know, hopefully the students will not only be able to concentrate on the technical aspects of the craft, but also reinforce their understanding of how their inkwork reflects their personalities.

Week 7: Scratchboard

After looking at the self-portraits and analyzing them for technique and expressiveness and how these two things are inextricably linked, we will begin discussion of the mechanical aspects of scratchboard: materials, tools, and so on. Because of the wide disparity in brand quality and pricing, brand name recommendations are necessary here as they are not in pure pen and ink. Some discussion of woodcut and wood-engraving as antecedents to scratchboard, as well as stylistic exemplars such as Fritz Eichenberg, Barry Moser, M.C. Escher, and Lynd Ward.

Assignment 7: The Same, Only Different

Again, self-portrait. The easiest mistake to fall into with scratchboard is "going negative," or attempting to draw with the same reflexes as one would with pen or pencil. The results of this are often undesirable. To avoid this, the students will, essentially, copy the self-portrait of the previous week, but with the added benefit of having done it before as well as the ability to exploit the increased control of scratchboard. This will also expose them to the very different character imparted to the work by this medium.

Week 8: Precision

The engraved quality of line is something that has been exploited by many scratchboard illustrators. It is used to evoke history, charm, rusticity, as well as officialdom and repression. Examples of quality scratchboard work from mid-century advertising as well as current examples by people like Douglas Smith will be discussed, and photocopies of step-by-step working methods distributed. Also historic examples of steel as well as wood engraving will be shown.

Assignment 8: Make Big Bucks . . .

or anything else official. The commemorative stamp or bill. Students will be encouraged to look at the engraving of both United States and foreign

currency and stamps, and to adapt some of those techniques to issue a commemorative document of their own devising.

Week 9: Freedom of Expression

Despite their stark quality, pen, ink, and scratchboard can be quite free, not to say explosive. The work of Ralph Steadman comes to mind, as well as the elegies for the Spanish Republic, which, although executed in oil, strongly resemble ink work. Some of the illustrations by Picasso, Ben Shahn, Jose Munoz, and Gary Panter fall into this category. Use of bamboo pens, spatter techniques, and other "experimental" techniques will be discussed.

Weeks 10–15

Assignments: A variety of different assignments will be given toward the end of the semester, seeking both to explore the standard ways pen and ink is used in the illustration market today, as well as seeking to get the students to explore and expand the expressive means at their disposal.

COURSE TITLE: EDITORIAL ILLUSTRATION
INSTRUCTOR: Dugald Stermer
SCHOOL: California College of the Arts
FREQUENCY: One semester, twice a week
CREDITS: Three

goals and objectives

Premise

Editorial illustration occurs as the result of an illustrator being commissioned to augment the written word with an image, communicating to the reader an idea, emotion, or action, occasionally incorporating a likeness; in short, a visual statement. From about the middle of the nineteenth century to the early 1960s, illustration was primarily employed to visually duplicate the action described in the text; this is rarely true at present. Currently, the illustrator is asked to present a point of view intersecting, overlapping, or even parallel to the copy. And often we are asked to create an image or series of images that present information impossible to convey in words. It is these areas that we will explore in class.

123

Promise

The instructor will endeavor to attend every class and participate fully; each student is expected to do no less. Four unexcused absences are the maximum allowable. More than that and the student may be dropped from the class, withdrawn or, if the third absence occurs after the withdraw deadline, the student may receive a C- at best. There will be no fewer than ten assignments, given almost weekly, and each will require well-considered sketches and a fully realized finished piece. Each step will be discussed and analyzed, with full involvement of all present. Actual hands-on work will also be carried on during class. As attendance is mandatory, so is the completion of all assignments. An incomplete grade will only be given under the direst of circumstances. Please be prompt.

Procedure

Assignments will be presented in a manner as much like that found in the publishing field as possible; in fact, most of them will be actual commissions as given to the instructor and other professionals. The work will vary from magazine to newspaper to book jackets, from portraiture to fiction to journalism, and from interpretive to explanatory.

Criteria

Personal style will not be much of an issue, unless it gets in the way of communication; neither will be media. Relative drawing and painting skills will, in this class at least, only be issues when they are required to create a likeness, object, action, or scene. What counts most is whether your solution is well thought out and executed in a way that accurately conveys an intelligible response to the text. Does it attract, involve, or repel the reader? Does it entertain? Does it assist the reader in comprehending the message? And, best of all, does it communicate something extra not contained in the text? For the most part, we are in the realm of ideas.

Bring your tools to class, including your brain.

COURSE TITLE: CONCEPT DRAWING

INSTRUCTOR: Robert Meganck

SCHOOL: Virginia Commonwealth University

FREQUENCY: One semester, twice a week

CREDITS: Three

goals and objectives

This course introduces students to principles of idea generation and the practice of concept drawing as a means to illustrate content. Additionally, the coursework enables students to develop their visual thinking and problem-solving abilities, and to study and explore the use of drawing as a tool to communicate concepts and develop an idea from thumbnail sketches through to the final illustration.

required reading

The Art of Looking Sideways, by Alan Fletcher (Phaidon Press, 2001)

description of classes

Level A Projects

Similar to a traditional editorial assignment. Students are given an article to read and interpret. With the exception of process critiques, these assignments are executed outside of class time. A typical Level A project would be:

- Students are given a real editorial assignment, one that I have already solved. They are given the same text and given the same constraints that I was given.
- Generally, the project would start with the distribution of the author's text and support material. The students are then taken through the process of analysis, thumbnail concept development and evaluation, reference research, final sketch evaluation, final illustration, and critique.

Level B Projects

Students are given a simple concept and are given one class period to produce a concept sketch and one class period to complete the final illustration. With the exception of finding reference material, all project work must be completed during the normal class time. A typical Level B assignment would be:

- Students are given a list of oxymorons and asked to illustrate one.
- Students are given a list of phobias and asked to illustrate one.
- Students are asked to illustrate the phrase "If you think everything is going well, you obviously don't know what is going on."
- Students are given copies of a few different rock/pop/folk songs and asked to illustrate one.

Level C Projects

During a single class period, students are asked to use drawing to communicate a simple concept. Typical Level C assignments would be:

- Communicate the idea of "identity."
- Imagine the roof of the class has been removed; draw the classroom from a bird's-eye view.
- Students are given five minutes to study a still life, which is then covered up. They are then asked to draw it from memory. Toward the end of class, the still life is uncovered and they are then asked to compare their drawing to the actual objects.
- Students are given a list of objects (baseball glove, ballet slipper, the dashboards of their cars, etc.) and asked to draw each from memory.

Week 1
Class 1: Course introduction; introduce Project A1.
Class 2: Complete Project C1 during class.

Week 2
Class 3: Critique Project C1.
Class 4: Critique concept sketches for Project A1.

Week 3
Class 5: Introduce Project B1, begin concept sketches; complete during class.
Class 6: Critique concept sketches for Project B1.

Week 4
Class 7: Process review of Project A1.
Class 8: Complete final illustration for Project B1 during class.

Week 5
Class 9: Final critique for Project B1.
Class 10: Final critique for Project A1; introduce Project A2.

Week 6
Class 11: Complete Project C2 during class.
Class 12: Critique Project C2.

Week 7

Class 13: Critique concept sketches for Project A2.
Class 14: Introduce Project B2, begin concept sketches; complete during class.

Week 8

Class 15: Critique concept sketches for Project B2.
Class 16: Process review for Project A2.

Week 9

Class 17: Reading day.
Class 18: Complete Project C3 during class.

Week 10

Class 19: Final illustration for Project B2; complete during class.
Class 20: Final critique for Project B2.

Week 11

Class 21: Final critique for Project A2; introduce Project A3.
Class 22: Introduce Project B3; begin concept sketches; complete during class.

Week 12

Class 23: Critique concept sketches for Project B3.
Class 24: Critique concept sketches for Project A3.

Week 13

Class 25: Complete Project B3 during class period.
Class 26: Final critique for Project B3.

Week 14

Class 27: Process critique for Project A3.
Class 28: Complete Project C4 during class.

Week 15

Class 29: Final critique for Project C4.
Class 30: Final critique for Project A3.

Week 16

Class 31: Make up day.
Class 32: Portfolio review.

conclusions

By the end of the semester, students should have developed the ability to analyze content, conceptualize an idea, and communicate a concept through oral and visual presentations.

COURSE TITLE: VISUAL COMMUNICATION OR IMAGE
 AND NARRATIVE
INSTRUCTORS: Carole Potter and Michael O'Shaughnessy
SCHOOL: Liverpool School of Art and Design
FREQUENCY: One semester, once a week
CREDITS: Three

goals and objectives

This module develops an image-based approach to answering static and/or time-based briefs. Students will learn to develop a variety of approaches toward designing static and/or moving imagery, to explore a range of visual and conceptual approaches to expressing ideas and organizing information, to develop use of appropriate tools in designing static and/or moving imagery, and to examine image and narrative within the broader context of art and design.

After completing this course, students should be able to formulate a range of responses in the production of static and/or moving imagery, sustain a coherent approach to the development of visual material over a sequence of images, demonstrate relevant technical skills, apply research and study skills. This course's research is centered around contemporary animation and illustration practice. Students will be exposed to current examples and exponents of digital media and software tools that are relevant to the production of digital imagery and animation. They will learn how these tools relate to professional art and design practices. They will also be required to do written analysis; generate, visualize, and present ideas; and convey their personal visual language and conceptual approaches to graphic arts.

course requirements

This is a practical studio-based module supported by a program of tutorials, seminars, field-study visits, and contextual lectures. Students can choose from project briefs related to graphic design, motion graphics, typography, and interactive design. They must undertake a brief with a strong emphasis on generating their own researched content.

The final assessment for this module is 100 percent coursework by portfolio submission comprising finished project work, research and development work, PDP progress file, and critical evaluation. Written feedback is given after assessment. Ongoing informal feedback will be available via seminar and project critique.

references

Franz Masereel

Andre Klimowski

The Folio Society

Edward Hopper

Far from Heaven, by Todd Haynes

The Man Who Wasn't There, by the Coen Brothers.

Borelli, L. *Fashion illustration now*, Thames & Hudson, 2000.

Faber, Liz and Walters, Helen. *Animation Unlimited : Innovative Short Films Since 1940*. Laurence King, 2004.

Eggers, Dave and Ware, Chris, eds. McSweeney's Quarterly Concern 13. *An Assorted Sampler of North American Comic Drawings, Strips and Illustrated Stories*. Hamish Hamilton, 2004.

Hanson, Matt. *The End of Celluloid: Film Futures in the Digital Age*. Rotovision, 2004.

Noble, I. *Picture Perfect: Fusions of Illustration & Design*, RotoVision, 2003.

Heller, Steven. *Handwritten : Expressive Lettering in the Digital Age*. London: Thames & Hudson, 2004.

Powers, A. *Front Cover: Great Book Jacket and Cover Design*, London: Mitchell Beazley, 2001.

Ware, Chris. *The Acme Novelty Date Book 1986–1995*. Drawn & Quarterly, 2003.

Wiedemann, Julius (ed.) *Animation Now!* Taschen, 2004.

Zeegen, Lawrence. *The Fundamentals of Illustration* / AVA, 2005.

129

description of classes

All projects are supported by contextual lectures each week.

Project 1: Storytelling

Retell a traditional story. Angela Carter is an author who explores and retells children's stories. Your interpretation does not have to be aimed at children.

Using the Brothers Grimm, Hans Christian Anderson, and Norse myths from Asgard as starting points, change the context. Over what period of time is your story played out?

Produce a linear sequence (pictures without words). Employ filmic devices to help construct your sequence (long shots, close ups, close sequence). The tradition of the illustrated book dates back hundreds of years. In 15th-century Flanders, cities such as Bruges and Ghent became famous for their production of illustrated manuscripts. The most famous of these was Bruges artist Simon Benning, who was renowned for miniature detailed scenes of the Life of the Virgin Mary. This work was filmic, and its design sequential. Chris Ware is a recent exponent of this tradition.

Media: Black and white.

Project 2: Book Cover

This project allows you to experiment and explore narratives in Literature. Select one of the following genres below and produce an A3 presentation. These may involve narratives/character design. Explore the relationship between autographs and hand-drawn type. Consider the iconography of signs and symbols in relation to the following genres:

- Modern ghost stories
- American crime
- The American Western
- Scary Stories (Ghost stories for children)
- Short stories: An anthology of modern British writing
- Gay fiction

A book cover template is supplied if you need a formal construct to help you. Your logo is a simple character letterform—A, B, or C. Your design must show an awareness of text/body copy and barcode. Decide who your audience is.

This project introduces you to the relationship between craft and technology. Throughout this project, there will be a series of I.T. workshops, exploring the relationship between vector-based drawing systems and autographic language. Your final solution must be accompanied by a digital printout.

Media: Full color.

Project 3: Teaching Illustration

- *How to buy a house*: Financial institutions often employ witty and clever concepts to communicate very daunting and mundane practices.
- *How to get to a party*: The London Underground map makes the complicated logistics of a rail network clear and easy to understand. Something we have all done at one time or another is to make maps for people. Create a simple navigation system that shows us how to get from A to B.
- *How to steal a car or be a pickpocket*: Describe and illustrate a process. It may be something conventional or unconventional.

Consider the following:

Diagrams and maps don't have to use technical drawing devices but are often hand-drawn and autographic.

If your design employs paper engineering, it's important to produce a prototype. That means you must submit flat artwork and a paper-engineered prototype that explains how the imagery is played out on the surface.

Media: Full color.

COURSE TITLE: THE PORTRAIT AS ILLUSTRATION
INSTRUCTOR: John A. Parks
SCHOOL: School of Visual Arts
FREQUENCY: One semester, once a week
CREDITS: Two

goals and objectives

This course is designed to introduce the student to the wide variety of ways in which the portrait can be used as illustration.

The objectives of the course are two-fold. First, students will be trained to become knowledgeable and intimate with the human head, its features, and its movement. Working from a live model, they will be involved in intensive study of the form. They will also do considerable work on color and light as they relate to the flesh, looking at a variety of ways to create light and verisimilitude. Second, students will complete a range of assignments in which the portrait is used as an illustration. These will include everything from enhanced realist images for editorial assignments to more adventurous caricature to quite decorative approaches. The narrative possibilities of expression and posture will be explored. Each week, students will be exposed to a broad range of examples from both illustration and the fine arts.

The course is taught as a workshop with a live model and continuous feedback from the instructor. Homework assignments are due weekly.

131

description of classes

Week 1. Introduction

The class begins with a look at the anatomy of the human head through diagrams, a skull, and the presence of the live model. Examples of master drawing from Michelangelo to Rubens are shown. After the basic structures have been described, students begin to paint from the model using a limited palette. Doing a tonal painting, they are asked to describe the head as completely and clearly as possible.

Homework: Make a miniature self-portrait—no larger than two inches square. The portrait should contain as much detail as possible. The idea here is to experience compression and get a sense of what pushing the image will do.

Week 2. Color and Flesh

Painting flesh in full color is one of the more challenging aspects of portraiture. The class begins with a detailed discussion of the behavior of color across the

form as it takes on and loses light. Students are introduced to the notion of the alternation of color temperature—the primary means by which light is secured on form. Examples are shown, including Rubens, Chardin, Sargent, and Wyeth. Using the live model illuminated by a single light source, students begin to paint in full color. Attention is paid to strategies that can be used on the palette to support this enterprise. Technique is kept as simple as possible.

Homework: Make a self-portrait illuminated from an unusual angle. Use the ideas covered in class to make the light as palpable as possible.

Week 3. Color and Flesh Continued

Focus is maintained on the project from the previous week. Students are encouraged to be more exacting and accurate with the color. Given the complexity of the challenge, it is to be expected that students will need time to take full control of it. Some aids include making the students aware of the most saturated instance of an impression of the local color and making them aware that induced color in the shadow tends to be a muted version complementary of the local color.

Homework: Illustrate a portrait of a disgraced politician for a magazine article. Exaggerate or skew the color in order to reinforce the sense of the piece.

Week 4. Getting to Know the Features

Now that students are starting to create form and light, they begin a series of assignments in which they make close-up paintings of individual features at larger than a life-size scale. This first week, they paint the nose and the mouth, attempting to get maximum "pop" in the form. Enlarged photographs are used to demonstrate the details more clearly. Examples of clearly rendered features are shown from the work of several artists, including Ingres and Chuck Close.

Homework: Illustrate a magazine article on the stages of depression. This should take the form of three views of the same face becoming progressively sadder. This is the first of several assignments that will deal with facial expression.

Week 5. Getting to Know the Features II

Continuing the previous week's focus, students turn their attention to the human eye. There is a detailed discussion of the structure of the eye along with diagrams and enlarged photographs. Students make a double-lifesize painting of an eye and eye socket.

Homework: Make an illustration for a book jacket entitled "The Healing Power of Laughter," showing someone laughing cheerfully.

Week 6. Getting to Know the Features III

In this last week, to focus on the features the students will paint an ear and a chin at double lifesize. Diagrams and enlarged photographs of the ear will be used to demonstrate the structure, and there will be a discussion of the handling of the ear in portraiture.

Homework: Make an illustration for the packaging of a candy bar whose brand name is "Farm Boy." Students should research and refine an image of a wholesome all-American farm boy and present his image in a circular format. Color should be attractive.

Week 7. Lighting

Discussion will take place about the lighting of the head. What does the lighting do in terms of changing the nature and import of the image? Some lighting exaggerates and dramatizes the sense of form, while other lighting is flattering, or eerie, or uncomfortable, and so on. Examples of dramatically lit portraits will be shown, including Caravaggio and Degas. Students then paint the model illuminated by a primary light source accompanied by a "key light." This painting is done in two stages, beginning with a monochrome underpainting.

Homework: Make an illustration for a short story entitled "Revelation," showing a powerful light source blazing down on a face with an appropriate expression.

Week 8. Lighting II

Students continue the painting of the week before, working on top of their monochrome underpainting. There is a discussion of various technical ways of working over an underpainting, from glazing to open "scumbled" layering. As the painting progresses, students are encouraged to hone in on the form.

Homework: Hair. Illustrate an article on women's hairstyles, showing four different scalps with their hairdos.

133

Week 9. Hands

Hands are often incorporated in portraiture and obviously have great use in contributing to expression and meaning in both fine art and illustration. The class will begin with a discussion of the anatomy of the hand and a breakdown of ways in which to simplify the drawing of the hand. Examples of the hand in portraiture will be looked at, ranging from Rembrandt to Lucien Freud. Students will work from a model posed with the hands touching the face.

Homework: A literary portrait. Students will execute a portrait of Victor Hugo. They will try and emulate an "old master" style with dramatic and portentous lighting befitting the vision of the writer.

Week 10. Hands II

Students will continue their work on hands, securing the form more accurately and exploring the color differences between hands and face. By this time, students should be gaining some confidence in their ability to secure the color and form of flesh. As this improves, various technical changes can be tried— shifting to sable brushes for close work, using fan brushes for smoother finishes, and so on.

Homework: Double-portrait. Make a double-portrait to illustrate an article on presidential debates. Both protagonists should be shown interacting forcibly.

Week 12. Dramatizing the Portrait

Discussion will take place on various ways of dramatizing the portrait—theatrical lighting, colored lighting, exaggerated expression, and demonstrative posing. Examples will be shown from Balthus, Daumier, Goya, and so on. Students will paint the model under intensely colored lighting with the idea of making the form as dramatic and entertaining as possible.

Homework: 3D caricature. Students will make a caricature of a famous entertainment figure and render it in three dimensions, using the principles discussed in class.

Week 13. Caricature from Life

Discussion will take place of various strategies for caricature. Using examples of the work of many caricaturists students will be exposed to the range of approaches to exaggeration and editing that are possible. Working from life the students will make a fully rendered caricature of the model.

Homework: Expressionist portrait. Students will make three very energetic and highly distorted portraits of a famous politician using decorative or non-natural color.

134

Week 14. The Total Picture

The wider possibilities of pose and gesture will be discussed, along with a broad range of examples. Consideration will also be given to the use of props and backgrounds for portraiture as illustration. The model will be posed in costume, taking a theatrical gesture and surrounded by appropriate props. Students will paint "the whole story."

Homework: A series of four portraits reduced to flat color and a few simplified shapes to illustrate an article on "Sixties Rock and Roll." The idea here is to get a decorative retro look.

Week 15. The Total Picture II

Students will continue the project from the week before after looking at further examples. They will bring the painting to a finish in which consistent light, a good likeness, and a sense of narrative are all up and running. The day will end with a brief review of the material covered.

COURSE TITLE: POSTER DESIGN
INSTRUCTOR: Seymour Chwast
SCHOOL: School of Visual Arts
FREQUENCY: One semester, once a week
CREDITS: Three

goals and objectives

The purpose of the class is to develop design skills through the knowledge of process. Typography is more important than illustrations. An image is not always necessary. Typography can be very expressive and could replace an image, but it functions in many other ways and offers many graphic possibilities. Choice of fonts, positions, size, and color should never be arbitrary but should be considered as a critical part of the design and message. The message has to be more accessible and readable on a poster (unless obfuscation is the point) since it is usually viewed while passing by.

description of classes

Students design eight proscribed posters for the semester. The student learns the principles of design as in any graphic design class. The poster is one application of those principles. Images as well as typography—in most cases—should reflect the message. Students should be more inventive than finding a photo and plunking down type.

All the posters are on the theme of New York. As a group, they cover a wide area within the theme but tend to be for cultural institutions. Stereotypic symbols of the city cannot be avoided but should be applied in creative and imaginative ways.

projects

Weeks 1–2
"The Bronx Zoo: Go on Safari without leaving home."
Having a sense of place and zoo animals is helpful.

Weeks 3–4
"Union Square Farmers Market."
Focus on fruit, vegetables, and baked goods, and announce the bounty that is the market.

Weeks 5–6

"Mostly Mozart" concerts at Lincoln Center.
Promote these famous annual concerts in type and image.

Weeks 7–8

"The Nude and the City," museum exhibition.
A poster for two art exhibits in New York. The image of the nude must be
idealized and classical, not a pinup.

Weeks 9–10

"New York, World Capital," travel poster.
Only positive images of the city are allowed.

Weeks 11–12

"Coney Island Cyclones," baseball team.
Baseball imagery evokes so many memories. The national pastime is a perfect
theme for posters.

Weeks 13–14

"The Subway: 100 Years."

Explore historic subway imagery and create a documentary of the underground.

Weeks 15–16

"Building the Big Apple," architecture.
Anything from a skyline to an architectural detail is permissible. This is an
opportunity to celebrate the grandeur of behemoths.

All the posters are presented as laser prints; each is 11" × 17" and collected in a
single container/portfolio/package that students design.

COURSE TITLE: SEQUENTIAL IMAGING

INSTRUCTOR: George Pratt

SCHOOL: Virginia Commonwealth University

FREQUENCY: One semester, once a week

CREDITS: Three

goals and objectives

This is a course in sequential imagery as applied to books, graphic novels, and film storyboarding. Assignments will incorporate applicable references to the history of art and contemporary developments.

This course introduces the students to principles of sequential imaging. Using drawing as the basic means of communication and idea generation, they learn to manipulate time and emotional content through multiple images.

A. To develop an understanding of the use of sequential images and their application to various disciplines.

B. To study the manipulation of time and motion through sequencing.

recommended reading

Comics & Sequential Art, by Will Eisner.
Graphic Storytelling, by Will Eisner.
Shop Talk, by Will Eisner.
Understanding Comics, by Scott McCloud.
Panels, by Durwin Talon.
The City, by Frans Masareel.
Maus, by Art Spiegelman.
Enemy Ace: War Idyll, by George Pratt.
Wolverine: Netsuke, by George Pratt.

description of classes

The course is broken into three 5-week sections for the semester.

Section One: Weeks 1-5

The first section is comprised of lectures and discussion. Students will be introduced to various forms of sequential imaging and narrative, from cave paintings of the prehistoric hunt, the Sistine Chapel, basic A-to-B diagrams such as simple model kit instructions, and children's books, to more complex film and graphic novel solutions.

Students will see the films (live action and animated) of numerous directors, past and present, to learn how each director's personal choices in filming and editing dictate the style and mood of the content. Students will be introduced to cinematic storytelling devices, such as jump cuts, establishing shots, bird's-eye view, worm's-eye view, the use of the point of view of the camera, as well as motion, on screen, and the motion of the camera. Students will also learn the basic principles of animation and motion.

Students will read various graphic novels to assess the methods and techniques employed by their authors/creators.

Throughout these processes, students will be reminded of the importance of content, how the choices of the creators of each discipline are in service to the content or the story. A wonderful tool to drive this point home is the "extra" content on DVDs. Within the audio commentary, directors discuss reasons for deleting scenes that often were fairly elaborate but didn't, in the end, serve the intent of the story. Another benefit of these "extras" is the scene-to-storyboard comparison. Here, students can see how scenes were originally envisioned and then eventually executed.

Drawing from my own library of graphic novels and original art, I show students examples of various artists' breakdowns and layouts, comparing these with the finished books. It is interesting to note how many changes may have to be made before a scene is completed. Choices are driven by service to the content.

138

Students do simple breakdowns to visualize basic sequential concepts such as movement, rhythm, timing, and so on. What is most important in this class is not any refinement or particular polish a drawing may have, but rather how well the student can communicate with basic thumbnail pictures. This also deflects any lengthy discussions that can result over differing personal opinions about drawing styles. Finish will come later, but until then it is deemed secondary to the direct communication of the story or concept.

Students are also required to write a sequence, visualizing with words rather than pictures.

During this first section, students will be given several short stories (Jack London, Ernest Hemingway, Ray Bradbury, Roald Dahl, Charles Beaumont, Jack Finney, Stephen King, et al.), which they will read and discuss. From these selections, students will choose one story to break down into a sequential narrative, though they will not begin their breakdowns until the second section of the semester.

Section Two: Weeks 6–10

Section Two is a study of the process of refinement. Students now begin work on the breakdowns of their chosen short story. They will "thumbnail" the entire short story in a "stream of consciousness" fashion. This first run-through is not an analytical procedure, but rather it is an emotional, rhythmic, or beat-

oriented exercise. The point is to get the story down on paper, even in the most elementary fashion. The student begins to get a feeling for the emotional movement of the story. An exercise that aids in this process is storyboarding sequences from existing movies. Step-by-step freezing of scenes via DVD allows students time to sketch out the storyboard. First, the static frame of the movie camera, and then re-edit scenes to take advantage of the more fluid panel shapes and storytelling devices inherent in graphic novels, underlining the unique visual and structural strengths of both disciplines.

Critiques are essential in the second section. Here, students will be pressed to put into words what they were trying to accomplish and what is and is not working. This is where analysis takes place, in concert with the more spontaneous emotional, intuitive side of creativity. Students continue to refine their thumbnails through revision and critique, always in service to the story.

Throughout Section Two, students will investigate films and graphic novels in order to steep themselves in the respective histories of these powerful media.

Section Three: Weeks 11–15

The final section of this course is when students begin working on the finished project. They add polish to the tale, lavishing stylistic choices in their drawing, adding color and other pictorial embellishments. Often due to the length of the stories, it is possible that only a few pages of the entire work may be brought to full completion.

outcomes

Sequential imaging can be a very broad subject of study for a single-semester class, hence the focus on storytelling and the various disciplines applicable.

Through viewings of films and readings of graphic novels and interpretations of works from art history, students are introduced to the concepts of sequential imaging. Utilizing various short stories as narrative material, students break the essential elements of the stories into various sequential scenes or movements. Through the use of panel size shape and arrangement, as well as rhythm, repetition, and time, students realize the concepts of the sequential narrative.

COURSE TITLE: IMAGINARY WORLDS

INSTRUCTOR: Nora Krug

SCHOOL: Muthesius Kunsthochschule

FREQUENCY: Sixteen weeks, once a week

CREDITS: Three

goals and objectives

The goal of the class is for the students to be able to both stimulate their own creative thinking and ability to come up with a variety of solutions, and to be able to successfully communicate them to the viewer.

recommended readings

Ascending Peculiarity: Edward Gorey on Edward Gorey, by Edward Gorey, Karen Wilkin

Cabinet of Natural Curiosities, by Albertus Seba

Dali: The Paintings, by Gilles Neret, Robert Descharnes

Giraffes? Giraffes! by Dr. Doris Haggis-on-Whey

Henry Darger: Disasters of War, by Henry Darger, Kiyoko Lerner, Klaus Biesenbac

Invisible Cities, by Italo Calvino

Joseph Cornell, by Kynaston McShine

M.C. Escher: Life and Work, by J.L. Locher

Nat Tate, by William Boyd

Paris Out of Hand, by Karen Elizabeth Gordon, Barbara Hodgson, Nick Bantock

Roadside Japan, by Kyoichi Tsuzuki

Secrets in a Box, by Joseph Cornell

The Book of Imaginary Beings, by Jorge Luis Borges

You Are Here, by Katharine Harmon

recommended DVDs

Alice, by Jan Svankmajer

The Brothers Quay Collection: Ten Astonishing Short Films, 1984–1993, by Brothers Quay

The Collected Shorts of Jan Svankmajer, by Kimstim Collection

description of classes
semester project: imaginary world

Each student will come up with an idea for an imaginary country that he or she will then visually describe in the form of a bound book or object. The imaginary country could exist in the future, in the past, on another continent or planet, in space, below the ground, in another dimension, visibly, invisibly, physically, purely emotionally, subconsciously, secretly, or in any other conceivable form. Students will have to consider issues such as:
- What does the place and its creatures look like?
- How do they live?
- What do they eat?
- What rules do or don't they follow?
- Where do they come from?
- What do they desire?

The final product could be an illustrated lexicon, a visual diary, a scientific log or investigation book, a Bible, a cook book, a schoolbook for children, an illustrated historic report, a set of cards, a collector's case with drawings, objects, and other alleged pieces of evidence, or any other project that defines some aspect of the country. All projects must at least include introductory text. Students should consider the possibility of including additional explanatory or other text. The final product should give a deep insight into the world described. 141

Week 1
Introduction
Flash presentations: Choose from a list of descriptions of imaginary worlds from the arts, film, and literature, which will form the basis of 15-minute Flash presentations given throughout the beginning of the semester. I will also show examples of books on imaginary worlds.

Assignment (due next week)
Select an action that you perform every morning before going to school, and visually document it on five pages with text as precisely as you can, thinking about its different facets. Choose a situation or place that is familiar to you, but visually document it in an unfamiliar, personal, and unexpected way. The goal of this assignment is for you to describe in a conceivable way a world that you have a clear notion of but that is unknown to the viewer, and how to decide which aspects you want to focus on and which ones you want to leave out.

Week 2
Presentation and group critique of the previous week's assignment:
- What was hard?
- What was easy?

- Does the outcome communicate well?
- Does it give an insight into your personal life?
- Did you discover something new about the described action?

Three Flash presentations, followed by discussions about the presentations.

Assignment (due next week)

I will give out a list with descriptions of animals from the *Book of Beasts*, a translation from a Latin bestiary from the 12th century. Choose one description and imagine the world around the animal. Create a five-panel depiction of aspects of its life:

- What does its habitat look like?
- What does it eat?
- How does it behave?
- How does it communicate?

Week 3

Presentation and group critique of previous week's assignment:

- Is there continuity between the chosen character or animal and the imagined environment and actions?
- Are the solutions inventive or predictable?

142

Three Flash presentations, followed by discussions about the presentations.

Assignment (due next week)

Define your idea for the semester project in one paragraph:

- What's the concept of your imaginary world?
- When and where does it exist?
- What does life look like there?
- How will you document it?
- What form will the final product take?

Week 4

Presentation and discussion of the project ideas:

- Are the ideas inventive?
- Are they complex enough to be turned into a semester project?
- Do they include a variety of aspects?
- How can they be pushed even further?

Three Flash presentations, followed by discussions about the presentations.

Assignment (due next week)

Make a dummy or prototype for your semester project that includes a layout with thumbnails for all spreads.

Week 5

Presentation and discussion of semester project dummies and prototypes:

- Is there a storyline, and in what way does it develop?
- Is there a coherence and continuity throughout the whole project?
- What aspects could be developed further?
- Are any important aspects missing?
- What's the relationship between text and image?

Assignment (due by Week 8)

Make first sketches, drawings and designs for your imaginary world.

- How do you best visually express what your imaginary world will be about?
- How do you picture the environment and creatures in your mind, and how can you communicate what you imagine in your drawings or objects?

Think about what medium you want to use:

- What medium will best suit the world you want to invent?
- Will you use more than one medium?
- Is there a medium that you have never used that you would like to introduce yourself to?

Week 6

Last six Flash presentations, followed by discussions about the presentations.

Assignments (due next week)

Write a first outline of the introduction and other text for the semester project:

- How can you describe your imaginary world in only an introductory paragraph without giving away too much?
- How much text do you want to use in your project?
- Will the text be descriptive, personal, poetic, associative, rhyming, or encoded?
- Will it stand alone or be a graphic part of the drawings or objects?
- When and where is text absolutely necessary?

Organize the text and other material into appropriate sections (i.e., if your project is a book, determine the chapters):

- What and how many aspects of the imaginary world will you cover?
- Which aspects do you want to mention first?
- Which ideas are most important and essential in order to understand the project?

Week 7

Presentation and critique of first finished drawings and designs:

- Do the drawings and designs represent the general idea?
- Are they represented in a personal way?
- Does the style represent the mood of the project?
- If not, why and how can it be changed in order to do so?
- Can the drawings and designs be developed further?
- Do they look finished?
- Do they look *too* finished?
- How do you decide when they are finished?

Discuss what medium you will use:

- Does the chosen medium represent the mood of the project?
- How comfortable are you technically with the medium you chose?
- Can you imagine using the same medium in different ways throughout the project?
- Can you imagine using different media to represent different ideas in the project?

Read your first outline of the text to the class and discuss the layout and design of the type or hand-lettering:

- Is the text easy to understand?
- Is it *too* easy?
- Is it personal and inventive enough?
- Is there enough text to convey the idea?
- Is there too much text?
- Would the project work without text?
- If yes, would you consider leaving it out?
- Does the chosen font or hand lettering suit the idea and mood of the project?
- How will it relate to the drawings and objects?

Assignment (due next week)

Make drawings or sketches for the complete first section of your semester project.

Week 8

Presentation and critique of the designs/illustrations/sketches of the first section of your semester project:

- Do the illustrations, designs, or sketches convey the idea and mood of the project?
- Are they visually consistent?
- Do they look too similar?
- Are they visually challenging?
- Do they lead the viewer further into the subject of the project?
- Are you comfortable with the medium?
- Could you have used the medium in a more interesting, challenging way?

Assignment (due next week)

Determine what the final product will look like. Research different ways of assembling or binding your material. Make thumbnails to present next week:

- How will it be bound or assembled?
- What kind of materials will you use?
- Will books have a case?
- How will the project be displayed?

Week 9

Presentation and critique of the visual aspect of the final product:

- Is the binding and overall visual aspect of the final product consistent with the way the illustrations, font, or objects look?
- Does it represent the idea and genre?

Assignment (due by Week 12)

Make drawings or sketches for the complete second section of your semester project.

Week 10

Presentation and critique of the designs/illustrations/sketches of the second section of the project:

- Does the visual aspect of the designs/illustrations/sketches in the second section relate to the visual aspect in the first section?
- Is there a development?
- How does the visual aspect represent the specific section?

Assignment (due next week)

Source paper and other materials you want to use. Prepare the newest version of the text for next week. Think about how text will be laid out on the page, what font or fonts you want to use, and, if it's hand-written, what it will look like. Create sample sheets of what the type or hand-lettering will look like:

- How does a font convey emotion?
- Which font most represents your idea?
- How big or small will your font be?
- Will it change throughout the project?
- How will it change?
- What color will it be?

Week 11

Presentation and critique of the newest version of the text:

- Is it well written?
- Does it convey the idea and mood of the project?

Present designs/sketches for the type or hand-lettering:

- Does the font or hand-lettering represent the idea, context, and mood of the project?
- Is there a conceptual consistency throughout the project?
- What's the relationship between the visual aspect of the type and the visual aspect of the drawings or objects?

Assignment (due next week)

Make drawings or sketches for the complete third section of your semester project.

Week 12

Presentation and critique of the designs/illustrations/sketches of the third section of the semester project:

- Does the visual aspect of the designs/illustrations/sketches in the third section relate to the visual aspect in the first and second sections?
- Is there a development? How does the visual aspect represent the specific section? Did you improve your use of the medium?

Assignment (due next week)

Prepare a finished dummy of the semester project, including the final text and visual materials. Come prepared with all the materials necessary to work in class.

Week 13

Work on your projects in class and meet individually with me to review the finished dummy:

- Does it feel like a finished product?
- Is it coherent?
- Should anything be added or deleted?
- Was the idea rendered the way you imagined?

Assignment (due next week)

Complete the project—that is, if it's a book, bind it or have it bound.

Week 14

Final presentations of the semester project, critique, and class discussion:

- Is the world described in an inventive and personal way?
- Is the way you portrayed your imaginary world conceivable to the other students?
- Did you experience anything new or unexpected while working on the project?
- Are you satisfied with the outcome?
- Why was this an effective assignment?
- What have you achieved?
- Could you imagine further developing your project?
- Can you imagine ways to apply what you learned to other problems?

COURSE TITLE: IMAGE AND IMAGINATION
INSTRUCTOR: Nick Jainschigg
SCHOOL: Rhode Island School of Design
FREQUENCY: One semester, once a week
CREDITS: Three

goals and objectives

To acquaint students with the tools and methods for producing "realistic" illustrations of events, scenes and concepts that cannot be photographed or even directly observed.

Even today, with enormous technological advances in imaging, photography, and data acquisition, there are things that simply cannot be photographed. Whether separated from us by time, size, or other impenetrable barriers, to visualize these things we need illustration. This course will deal with the skills and tools needed to produce such illustrations in a dynamic, engaging, and "realistic" fashion. While these images will be as accurate as possible to the known facts, they will not be "cold." Taking as our model the standards of *National Geographic* magazine, which has a policy of using photography wherever possible, yet which still maintains its reputation as one of the world's premier venues for illustration, we will be producing images that will engage the viewer both intellectually and emotionally.

147

grading criteria

To get the most out of class, it is recommended that the student attend all classes, on time, and remain until dismissed. You will be called upon to draw or paint accurately; meaning with proportion, perspective, and where appropriate, color, all handled clearly, with appropriate referencing and practice studies. Refresher sessions, demonstrations, and examples will all be part of the class, but the quality of the resulting artwork is paramount and grading will be highly dependent on this.

description of classes

The semester will be broken down into four long assignments. This will provide time for sketches, revisions, research, and final painting. Subjects covered throughout will be methods and sources for research, finding human models, making and finding inanimate models, the sketch as a research tool and as a presentation tool, color, composition, and materials and techniques.

Weeks 1–4: First Barrier—Time

Our first assignment will be based on an excellent article from *Atlantic Monthly* magazine, which examines in great detail the current knowledge and hypotheses regarding the indigenous peoples of the Americas during the years prior to 1492. As a subject, it is broad enough to provide a range of approaches (necessary so that we don't poach one another's research materials), yet focused enough to allow our research to help each other.

Class will commence with a discussion of the sketch as a research tool: how the choice of subject and angle influence information gathering. Obviously, a crowd scene may require more work than a simpler subject, and a view of a city will require different research than a more intimate, domestic scene. After reading the article, students will produce one or two sketches showing their first rough ideas. These will be discussed and examined for clarity, focus, informational content, possible pitfalls, and also, of course, beauty, impact, and elegance.

Revisions will be required on an ongoing basis until the final comp (composition) sketch.

A trip to the library for an introduction to the facilities and capabilities will occur within the first weeks. The references will fall into two categories—humans and artifacts. Reference for human characters will be discussed: finding models of appropriate race, age, and sex; model release forms; photography kit for data collection; lighting and "snap" photography; combining models; and asking people to pose—what ways work and don't get you arrested. Artifacts are the furniture of life, ranging from the stuff of daily life (tools, clothing) to more dramatic elements (weapons, religious artifacts). Also important is architecture, both as a historical fact, and, even as it's used today, to provide a stage for the action of daily life.

Discussion will concern such things as permissible extrapolation of missing or damaged parts, removal of age-related wear, how to make architecture seem to "live," with reference to the perspectivists and visualizers of the past and present architectural field, and the methods they use to make buildings appealing and lively. We will discuss the perspective methods of deriving a 3D view from an elevation drawing or a floor-plan. The use of 3D modeling software will also be discussed.

Finally, methods of integrating people with an imagined environment will be discussed: sight lines, horizon lines, layering, scale, and atmosphere will all be examined. Additionally, I will demonstrate the use of acrylic, oil, and gouache both together and separately as I use them to produce detailed illustrations.

Final comp (presentation) sketches will be shown and discussed, and class must approve final image before finish is commenced. Students will have two weeks to execute the finished piece, ample time considering that all compositional and color elements have been worked out in advance.

Weeks 5–8: Second Barrier—Space

Some things are just placed so that it's really hard to see them, such as behind or inside something else. Examples of illustrations that solve this problem are

148

medical illustrations and automotive cutaways. They share similar concerns of relating objects together in a three-dimensional space that must be comprehensible and yet invisible in key areas.

"Ghosting" and other methods for maintaining relational data while still discarding opaque surfaces will be examined, as well as other situations where the same difficulties appear. The use of symbols within the illustration will be discussed, along with the edge of where symbol shades over to caption.

The assignment will be to choose a mechanism, whether organic or mechanical, and display its underlying structure in a way that illuminates its internal relationships to the viewer while still being engaging and beautiful. Examples might include the anatomy of a weather system or of a pond, the functioning of a coffee maker or of a Wacom computer drawing tablet.

Weeks 9–12: Third Barrier—Scale

Some subjects are difficult to relate to a human understanding because they are of such scale, whether great or small, that our organs of sense no longer function as we would expect, despite the finest technical amplification. Examples of these things might be atomic or quark interaction, and the massive tendrils of galaxies that have been deduced from examination of the far ends of the electromagnetic spectrum. How do you go about depicting these invisible things? What metaphors can best encompass them? How can they be made engaging to viewers, yet not insult their intelligence?

The relationship between illustrations and diagrams will be discussed—the benefits and limitations of each, and where they can be complementary. Composition of abstract elements and the generation of interest and tension in the absence of human motivation. How does the element of abstraction limit or enhance our ability to encode information into a painting?

Weeks 13–15: Self-Generated

Since it is practically a given that any student taking this class will have at least one image of this sort that he or she has always wanted to paint (often involving dinosaurs), it would be a pity to waste this enthusiasm. The final assignment is to produce an illustration of a subject that meets the criteria for this class.

There are a number of challenges presented by the self-directed project, among them over-ambition and a scattering of class focus. To minimize the possibility of disaster, students will be required to submit, two weeks before the project commences, a written description of the intended project containing references, citations, and other supporting material. This serves as an impetus to research and a check on overly optimistic projections of the final piece. Additionally, the students will each present their work to the class on a weekly basis, allowing for a cross-pollination of ideas and approaches, and ensuring that students are both prepared and working to appropriate levels. I would hope that the extra requirement of regularly explaining the background information and the working process will help the students to more concretely realize the connections between research, understanding, and visualization.

COURSE TITLE: BOOK ILLUSTRATION
INSTRUCTOR: Julie Lieberman
SCHOOL: Savannah College of Art and Design
FREQUENCY: One trimester, twice a week
CREDITS: Five

goals and objectives

This course develops students' skills in interpreting a manuscript or story and creating a visual image. Students explore the application of various materials and techniques. Emphasis is placed on unique solutions and perspectives to expand students' imagination and develop a personal viewpoint.

The following course goals articulate the general objectives and purpose: The objective of this course is to help the student create a personal style through conceptual and technical approaches to problem solving within the context of the printed book. An understanding of visual communication skills necessary to be successful in a commercial market will also be emphasized.

The following outcomes indicate competencies and measurable skills that students develop as a result of completing this course: interpretation of manuscripts in the form of illustrations for book covers, sequential story telling, and the integration of word and image. Students will be able to effectively design and execute illustrations with interesting compositions, color relationships, and strong conceptual ideas.

description of classes

The assignment is to create one book: illustrated cover, title page, twelve interior illustrations, three double-page spreads, and a series of images for your choice.

Week 1

Introduction to illustrated books.

Week 2

Slide lecture on different approaches to book illustration. Breakdown of written material due next week.

Week 3

Discussion of topics. Lecture on composition and integration of text and image/storyboards.

Week 4

Work in class on thumbnail sketches for storyboard and for book cover, title page, and six interior illustrations.

Week 5

Critique storyboards. Begin working on revisions for storyboard (due next week).

Week 6

Work in class on preliminary sketches for book cover and title page.

Week 7

Critique final sketch for book cover and title page. Begin working on interior book illustrations.

Week 8

Work in class.

Week 9

Critique on final sketches of interior book illustrations.

Week 10

Bring in materials to begin working on final technique. Begin working on finished illustration for book cover and title page.

Week 11

Finish book cover; title page due. Work in class.

Week 12

Book cover and title page finish due, critique. Begin working on finishes for interior illustrations.

Week 13

Typography lecture; scan cover and title page and apply type for next class.

Week 14

Typography added to cover and title page on computer due. Work in class on interior finishes.

Week 15

Book binding demo. Work in class.

Week 16

Critique on three double-page spread illustrations. Begin combining finished sketches and double pages into book form on computer.

Week 17

All revisions due.

Week 18

All work on computer/all original illustrations due.

Week 19

Prints of final images including text due. Book binding workshop.

Week 20

Final presentation of reproduced book.

Field Trip(s): Campus printing/Coastal Reprographics; Murray Tinkleman lecture on Maxfield Parrish.

COURSE TITLE: POP-UP BOOKS I

INSTRUCTOR: Bill Finewood

SCHOOL: Rochester Institute of Technology

FREQUENCY: Winter quarter (ten weeks), once a week

CREDITS: Three

goals and objectives

This course deals with constructing and illustrating pop-up and mechanical books. Students will study planning, preparation, engineering, and illustration for production of pop-ups. The course is divided into a preliminary section of learning basic mechanisms and a second section, which allows students to apply knowledge learned in the first section to the illustration and production of a working spread.

This course offers an opportunity to students seeking to complement and combine skills learned in Dimensional Illustration and Book Illustration, and provides a beneficial blending of precision and creativity. In today's market, there is continuous demand for pop-up books with a variety of themes, not only for juveniles but many directed toward adults as well.

153

The objectives of this course include the opportunity for students to gain an understanding of the basic mechanisms of pop-ups and to plan the organization of a series of mechanisms for a desired effect. It will require students to work with more precision and accuracy, and apply improved skills of craftsmanship. The underlying goal, as an illustration course, is to engage students in a step-by-step process leading to a unique application of technology and creativity which will surprise and delight readers.

required reading

The Elements of Pop-Up: A Pop-Up Book for Aspiring Paper Engineers, David A. Carter, James Diaz, Little Simon, 1999.

recommended reading

Paper Engineering for Pop-Up Books and Cards, Mark Hiner, Parkwest Publications, 1986.

The Pop-Up Book: Step-By-Step Instructions for Creating over 100 Original Paper Projects, Paul Jackson, Paul Forrester, Owlet, 1994.

Paper Magic: Pop-Up Paper Craft, Masahiro Chatani, Japan Publications, 1988.

description of classes

Week 1

Intro to pop-ups lecture.
Demonstrate basic mechanisms.

Assignment 1

Duplicate approximately thirty mechanisms found in the assigned text, which will teach the methods of producing working structures, using only white Bristol board while practicing precision and craftsmanship so the mechanisms work properly. Drawing tools and accuracy are a must.

Week 2

Demonstrate basic mechanisms.
Work on Assignment 1 mechanisms in class.

Week 3

Complete Assignment 1 mechanisms in class.

Assignment 2

Plan, illustrate, and produce one pop-up book spread that includes any ten of the mechanisms learned in the first assignment.

For next week: Begin doing rough sketches, and start thinking about making a dummy spread. Devise and write communication objective. Settle on a single topic. Think about the imagery, moment in time, point of view, the mechanisms used to produce the desired effect, and illustrative style with regard to the subject.

Week 4

Communication objective due.
Critique of rough layouts due.
Dummy spreads due next week.

Week 5

Critique of dummy spreads.
Make revisions and start working on the final selection and arrangement of ten mechanisms in class.

Week 6

Work on final mechanisms in class.
Working model due next week.

Week 7

Critique working model.
Make revisions and begin working on color comps for illustrations in class.
Finished illustrations due next week.

Week 8

Critique finished illustrations.
Make revisions, scan art, make prints, ready for mounting, cut, and assemble.
Finished spread due next class.

Week 9

Critique finished spread.

Week 10

Revisions due.
Individual critique.

COURSE TITLE: SKETCHBOOK WAREHOUSE
INSTRUCTOR: George Bates
SCHOOL: Parsons School of Design
FREQUENCY: One semester, once a week
CREDITS: Three

goals and objectives

The sketchbook is a place for uncompromised expression and mistakes. It is also a place for the comprehensive exploration of ideas, techniques, skills, and process. Allowing for mistakes to happen while pursuing these goals either consciously or not can only lead to learning and development, and in turn usually surprising successes. These successes can ultimately become part of a process for effective visual communication.

The sketchbook is ultimately a personal decision. On the first day of class, students are asked how they want to use this class. The only mandatory requirement is that the work ultimately has to be presented in a sketchbook somehow. The goal of this class is to begin to bridge the gap that exists between the drawing/painting classes and the concept classes in addition to the gap that exists between personal and commissioned work.

recommended readings

The Transfiguration of the Commonplace, by Arthur C. Danto
The Mission of Art, by Alex Grey
On Style, by Susan Sontag

description of classes

Weekly themes: Each week, students are given the option to use a theme to be the genesis for exploring ideas, techniques, aesthetics, and process. This theme will be open to interpretation in their sketchbooks. The themes will be broad enough to allow for personal exploration but will demand conceptual problem solving. However, if the students are more interested in being self-directed they can choose to ignore the theme and pursue their particular approach to weekly homework.

Some samples of weekly themes:
- The promise
- The mistake
- The conundrum

- Terra incognita
- The garden
- The real hero

The objective is to exercise all of the skills which lead to successful visual communication in a setting where the students naturally feel comfortable and importantly, there is much less pressure than in their concept class. One of the problems of teaching illustration is that students are capable of doing good work in drawing and painting classes, and work that is not done for a particular assignment (personal work), but often cannot translate that work into something with strict objectives, like a professional assignment. Often the work in concepts classes is artless black line with badly filled-in gouache—this even from students who generally draw and paint well.

The projects help the students become comfortable in developing their process, to be able to apply it to very specific commercial and editorial concerns. Essentially, these projects, and especially the discussion in class, help the students to tap into their natural affinity for certain media and modes of problem solving under the guise of being encouraged to be self-indulgent.

A piece with crows called Tomorrow—A Day for the Crows; The Garden/*Jake Messing*

Week 1

Introduction to course.
Lecture on the use and importance of sketchbooks in art and illustration, accompanied by examples of a wide variety of sketchbook approaches.
Homework: Project 1.

Week 2

Critique Project 1.

View samples from students' other classes and favorite pieces: The first couple of weeks are usually about addressing drawing and painting skills.

After looking at their work from their other classes, the discussion turns to what they are doing well and how to best use it to their advantage in this class.

Homework: Project 2.

Week 3

Critique Project 2.

Homework: Project 3.

Week 4

Critique Project 3.

Homework: Project 4.

Week 5

Critique Project 4.

Homework: Project 5.

At this point, the discussion turns to the topic of sketches for works that are to be published. Some of the students are usually doing work that far surpasses what they are turning in for their concept classes. Often this is because they are not doing any formal sketch and are using their intuition to guide their work.

Since art directors and teachers often require a sketch, possible solutions are discussed, such as:

- Do the final piece and make a separate sketch based on the work, and turn that in.
- Submit the piece as the sketch, and be prepared to make changes if necessary.
- Work on the piece until enough of the idea is comprehensible, and finish it according to the final art direction.

Week 6

Critique Project 5.

Homework: Project 6.

Week 7

Critique Project 6.

Sketch jam (draw live jazz musicians).

Homework: Project 7.

159

Drawing/collage of sad woman holding an open book; sketchbook page/Yelena Balikova

Week 8

Critique Project 7.
Homework: Project 8.

Week 9

Critique Project 8.
Homework: Project 9.

Week 10

Critique Project 9.
Homework: Project 10.

Week 11

Critique Project 10.
Guest speaker: Virtually anyone working professionally is a good candidate for a guest speaker. Everyone in the creative professions has something akin to a sketchbook, even if it is a place to simply write down ideas. It is important for the students to see how this filters into their process.
Homework: Project 11.

Week 12

160

Critique Project 11.
In-class sketchbook assignment: At this point in the class, often the sketchbook becomes a comprehensive work of art in itself and students have a tendency to start to regard it as a place where they can no longer experiment and make mistakes. They are each given materials that they have not been using or would never use, and asked to complete a theme in the class time allotted. Examples:

- If students were using their sketchbooks to explore collage mixed media, they would be given a stamp alphabet, one black stamp pad, and one red pad, and asked to interpret the theme "The Banquet," using no references to food.
- If students were using their sketchbooks to explore portrait painting, they would be given paper samples and asked to interpret the theme "Absolute Royalty," using no imagery of monarchs.

Homework: Project 12.

Week 13

Critique Project 12.

Final Assignment: Design a poster for the "orchestra underground" performance at Carnegie Hall using existing art from your sketchbook.

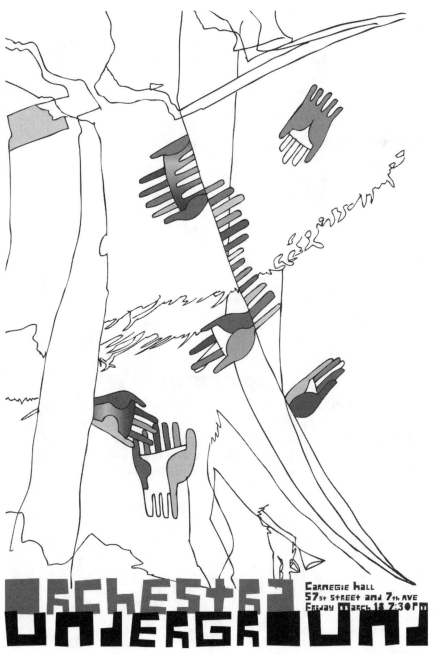

Line drawing called Orchestra Underground; *Orchestra Underground poster/Eun Hye Min*

Requirements:

- All art must be preexisting work from your sketchbook.
- Computer type is allowed, but hand lettering is preferred.
- Any size; keep in mind that this is a poster, therefore it has to call attention to itself, so final size does matter.
- Any media.
- Complete more than one option.
- Please try not to use straight violin or orchestra imagery (boring).

Information that has to appear on the poster:
Orchestra Underground
Carnegie Hall
57th Street and 7th Avenue

Week 14
Critique homework.
Gallery visit.

Week 15
Critique homework.
Final review.

conclusion

Completion of this course will give the students an understanding of their sketchbooks as a personal image/idea library which can be used to generate income from the sale and re-use of this pre-existing library. This library serves to further the students' understanding of process in addition to the ongoing development of conceptual, design, drawing, and painting skills.

COURSE TITLE: DESIGN 380: ILLUSTRATION

INSTRUCTOR: Richard Ross

SCHOOL: State University of New York, Buffalo

FREQUENCY: One semester, twice a week

CREDITS: Three

goals and objectives

This course is designed as an introduction to two different marketplaces (editorial, publishing) in the illustration field. A thorough introduction to materials and techniques will accompany each of the seven different media covered in the course. Classroom sessions will include critiques, lectures, demonstrations, videotapes, guest illustrators, and in-class assignments. Lecture material will involve in-depth discussions of copyright, promotion, pricing, and portfolio presentation, as well as historical trends and influences in the field of contemporary illustration.

course requirements

Course assignments will include the following media and fields of illustration:

163

- Editorial newspaper: Graphite pencils
- Editorial newspaper: Pen and ink
- Editorial newspaper: Scratchboard
- Anthropomorphics: Colored pencils
- Short fiction: Colored pencils
- Book cover: Pastels
- Personality portrait: Watercolors
- Interior magazine series: Oils
- Earth Day poster: Mixed media
- Editorial magazine: Free media

In addition, there will be regular in-class exercises in: color mixing, conceptual problem solving, perspective drawing, as well as drawing and painting from models and still-life materials. There will also be assigned readings and a final reaction paper.

Illustration Sketchbook

Students are required to keep a sketchbook for this class. It is a place for cultivating the habit of collecting thoughts and ideas, outside source material, and examples of other illustrators' and artists' work for reference as students begin to work on illustration assignments. They should use their sketchbooks for note taking, recording ideas when working on projects, and storing examples of illustrators' and fine artists' work. The sketchbook is collected during mid-term and with the students' portfolios at the end of the semester.

Attendance

The term is fifteen weeks, and time moves quickly. Attendance is critical for understanding course material and for keeping pace with class projects. It is the student's responsibility to see me before the next class session in order to get the next assignment, review sketches, or to hand in a project. All absences will be counted, no matter what the reasoning or excuse. Students will be allowed three absences without penalty.

Critiques

Participation in class critiques is required. Critiques are a time for students to critically evaluate their work and that of their classmates. Participation in class critiques is required. Missing a critique is similar to missing a meeting with a client in the professional field. Work is expected to be complete and ready for presentation at the time the critique is scheduled to begin. If, for some reason, the work is not finished for a critique, it is still required that students attend the critique.

Grading Policies

Grading criteria are as follows:

- Application of principles discussed in class to illustration problems.
- Aesthetics/quality of formal aspects of illustrations.
- Innovation/strength and uniqueness of ideas.
- Craft/aesthetics of the presentation.
- Punctuality/meeting of deadlines/class participation.

A grade of incomplete is greatly discouraged and will be given out only in the case of protracted, serious illness.

Assignments are due at the time the critique is scheduled. Work that is not ready for presentation when the critique begins will not be critiqued and will be marked as late. Late assignments are downgraded half of a letter grade for each class the assignment is late. All assignments can be reworked for a second grading. The final grade will be an average between the original assignment and the re-do. Mid-term grades will be given by the ninth week of the semester.

required reading

The Story of a Shipwrecked Sailor, by Gabriel Garcia Marquez
Perspective Drawing Handbook, by Joseph D'Amelio
The Art Spirit, by Robert Henri

description of classes

Week 1

Class 1: Review of course syllabus; slide presentation of illustration work from a graduate of the program.
Homework: Read the first chapter in *Art & Visual Perception* by Rudolph Arnheim.

Class 2: Presentation of instructor's personal illustration work followed by a question-and-answer session.
Homework: Generate four sketch ideas for an editorial article in the *New York Times*, entitled "The Salinger Papers." Review first four chapters in *Perspective Drawing Handbook* by Joseph D'Amelio.

Week 2

Class 1: In-class lecture on visual analogy and metaphor in the illustration, graphic design, and fine art fields; review of four sketches for the *New York Times* editorial article, "The Salinger Papers"; review of first four chapters in *Perspective Drawing Handbook* by Joseph D'Amelio.

Assignment 1: Editorial Newspaper
Students are given an editorial article from the *New York Times*, entitled "Gardeners of the World, Unite!"
Homework: Generate four sketch ideas.

Class 2: Review of four sketch ideas for Assignment 1; in-class revision of final sketch. Approval of sketch by instructor; review of materials handout for graphite pencils; review of chapters 3 and 4 in *Perspective Drawing Handbook* by Joseph D'Amelio.
Homework: Execution of finished artwork for Assignment 1; completion of technical exercise of graphite pencils; review of chapters 5–8 in *Perspective Drawing Handbook* by Joseph D'Amelio.

Week 3

Class 1: Critique of graphite pencil assignment; Students watch first half of videotape from the Society of Illustrators on Guy Billout; Review of chapters 4–6 in *Perspective Drawing Handbook* by Joseph D'Amelio.
Homework: Generate four sketch ideas for each article of Assignment 2.

Assignment 2: Pen and Ink
Students are given two editorial articles from the *New York Times*, entitled "Science, Lies, Ultimate Truth" and "My Father Was a Minor League Player."

Class 2: Review of eight sketch ideas for Assignment 2: pen and ink. In-class revision of final sketch for one of the articles. Approval of sketch by instructor. Review of materials handout for pen and ink. Review of chapters 7–8 in *Perspective Drawing Handbook* by Joseph D'Amelio.
Homework: Execution of finished artwork for graphite pencil. Assignment 2: pen and ink. Completion of technical exercise for pen and ink. Review of chapters 8–13 in *Perspective Drawing Handbook* by Joseph D'Amelio.

Week 4

Class 1: Critique Assignment 2; tear sheets from the annual *American Illustration* are put up on the classroom walls. Students select four favorite pieces and are asked to present them to the class; second half of videotape

from The Society of Illustrators on Guy Billout is presented; review of chapters 8–13 in *Perspective Drawing Handbook* by Joseph D'Amelio.
Homework: Generate four sketch ideas for each article for Assignment 3.

Assignment 3: Editorial Newspaper/Scratchboard

Students are given two editorial articles from the *New York Times* entitled, "Out of Uniform, Into Service" and "Movies Don't Cause Crime."

Class 2: Review of eight sketch ideas for Assignment 3; in-class revision of final sketch. Approval of sketch by instructor; review of materials handout for scratchboard. Instructor demonstration of use of scratchboard materials; tear sheets from the annual *American Illustration* are put up on the classroom walls; students select four favorite pieces and are asked to present them to the class.
Homework: Execution of finished artwork for Assignment 3: scratchboard. Completion of technical exercise for scratchboard.

Week 5

Class 1: Critique of scratchboard assignment. Tear sheets from the latest Society of Illustrators annual are put up on the classroom walls. Students select four favorite pieces and are asked to present them to the class. Students work on drawing a still-life in colored pencils to learn different principles about color.
Homework: They bring to the next class a total of nine sketch ideas.

Assignment 4: Anthropomorphics

Students are asked to choose a combination of animals and objects, and anthropomorphize them by combining them with a human figure in an environment. In their sketches, they take a combination of animals/objects and put each of them in three different environments.

Class 2: Review of nine sketch ideas for Assignment 4: Anthropomorphics. In-class revision of final sketch. Approval of sketch by instructor. Review of materials handout for colored pencils. Instructor demonstration of use of materials. Students watch videotape from the Society of Illustrators on C.F. Payne.
Homework: Completion of color exercise for colored pencils. Execution of finished artwork for Assignment 4: Anthropomorphics.

Week 6

Class 1: Critique of anthropomorphics assignment. Tear sheets from the latest Communication Arts illustration annual are put up on the classroom walls. Students select four favorite pieces and are asked to present them to the class. In-depth business discussion on pricing guidelines for editorial illustration.
Homework: Four sketches ideas for Assignment 5.

Assignment 5: Short Fiction

Students are given a short piece of fiction from the literary magazine North American Review entitled, *Small Pleasures* and are asked to do four sketch ideas.

Class 2: Review of four sketch ideas for Assignment 5: short fiction. In-class revision of final sketch. Approval of sketch by instructor. In-depth business discussion of copyright in illustration.
Homework: Execution of finished artwork for Assignment 5: short fiction.

Week 7

Class 1: Critique of short fiction assignment. Students work on a still-life in pastels. Instructor demonstration on use of pastel media. Students watch a videotape from the Society of Illustrators on John Collier.
Homework: Do four sketches for Assignment 6.

Assignment 6: Pastels/Book Cover

Students are asked to read a short novel, entitled *The Story of a Shipwrecked Sailor* by Gabriel Garcia Marquez
Class 2: Review of four sketch ideas for Assignment 6: pastels/book cover. In-class revision of final sketch. Approval of sketch by instructor. In-depth discussion of self-promotion in illustration.
Homework: Execution of finished artwork for Assignment 6: pastel/book cover.

Week 8

Class 1: Critique of book cover assignment. First half of the Society of Illustrators tape on David Macaulay. In-depth class discussion of book contracts and pricing.
Homework: Generate nine sketch ideas for Assignment 7.

Assignment 7: Watercolor/ Personality Portrait

Students are asked to research three personalities who have lived life in a creative fashion. The students generate three sketch ideas for each personality utilizing a different structural framework to "house" biographical information about their lives.

Class 2: Review of nine sketch ideas for Assignment 7: watercolor/personality portrait. In-class revision of final sketch. Approval of sketch by instructor.
Homework: Execution of finished artwork for Assignment 7.

Week 9

Class 1: Critique of watercolor assignment. Guest illustrator talks and gives slide presentation.
Homework: Generate eighteen sketch ideas for Assignment 8.

Assignment 8: Oils/Interior Illustrations

Students are asked to generate three sets of three interior illustrations for two short stories from the *Atlantic* magazine, entitled "Morse Code" and "Consider This, Señora."

Class 2: Review of eighteen sketch ideas for Assignment 8: Oils/interior illustrations. In-class revision of final sketch for first illustration in the series. Approval of sketch by instructor. Students watch second half of Society of Illustrators videotape on David Macaulay.

Homework: Execution of first finished piece of artwork for Assignment 8: oils/interior illustrations.

Week 10

Class 1: Critique of first finished piece of artwork for Assignment 8: Interior oil series. In-class drawing from the model.
Homework: Students are asked to tighten their sketches for second oil painting.

Class 2: Review of revised sketch for second oil painting in Assignment 8. In-class revision of final sketch. Approval of sketch by instructor. In-class drawing from the model.
Homework: Execution of second finished artwork for Assignment 8: Oils/interior illustrations.

Week 11

Class 1: Critique of second finished piece of artwork for Assignment 8: Oil painting series. In-class drawing from the model.
Homework: Students are asked to tighten their sketches for third oil painting.

Class 2: Review of revised sketch for third oil painting in Assignment 8. In-class revision of final sketch. Approval of sketch by instructor. In-class drawing from the model.
Homework: Execution of third finished artwork for Assignment 8: oils/interior illustrations.

Week 12

Class 1: Critique of third finished piece of artwork for Assignment 8. In-class painting from the model.
Homework: Generate six sketches for Assignment 9.

Assignment 9: Mixed Media/Earth Day Poster
Students are asked to do sketches for an Earth Day poster. Three are a "celebration" of the natural environment, and the other three show the "devastation" of the natural environment.

Class 2: Review of sketch ideas for Assignment 9: Mixed media/Earth Day poster. In-class revision of final sketch. Approval of sketch by instructor. Students watch Society of Illustrators videotape on Seymour Chwast. Two dozen different back issues of *Push Pin Graphic* are distributed to the class and discussed.
Homework: Execution of finished artwork for Assignment 9: mixed media/Earth Day poster.

Week 13

Class 1: Critique of finished piece of artwork for Assignment 9: mixed media/ Earth Day poster. In-depth discussion of "drop-offs" and portfolio interviews with art directors.

Homework: Students are asked to do sketches for a free media assignment. They are given two editorial articles published in *Time* magazine, entitled "The Best Refuge for Insomniacs" and "Pains of the Poet—And Miracles" and asked to do six sketches.

Class 2: Review of sketches for free media assignment.

Homework: Execution of finished artwork for Assignment 10. Free media: Magazine editorial.

Week 14

Class 1: Critique of finished piece of artwork for Assignment 10. Free media: Magazine editorial. In-depth discussion of portfolio preparation.

Homework: Students can re-do entire pieces or area of their assignments for the final critique.

Class 2: Field trip to the Albright Knox museum.

Week 15

Class 1: Final class critique. Students put up a panel of their work from the course. This panel consists of all twelve finished pieces of artwork. Students also hand in a short reaction paper to the book *The Art Spirit* by Robert Henri.

Class 2: The students are given four questions at the final exam session:

1. Which piece do you feel was your most successful this semester? Why?
2. Which piece needs further resolution?
3. How has your working methodology in illustration evolved this semester?
4. How do you intend to apply what you have learned this semester in illustration to your other courses in graphic design?

conclusion

All of the students will have developed their skills in generating creative concepts for illustration assignments. In addition, they will have identified a couple or possibly several illustration media for which they have a natural affinity.

goals and objectives

This course deals with the following topics through lectures and a variety of guest speakers: Professional expectations, deadlines and time-management, professional opportunities, creating a successful portfolio, freelancing, artists' representatives, studio contracts, competitions, self-promotion, understanding the market, targeting the market, regional differences in the illustration world, short-term and long-term professional goals, writing résumés, creating bids and invoices, and developing support systems and resources.

This course is directed toward the student's transition into the working professional world.

description of classes

Week 1

Lecture: "What's next? Life after college."
Hand out questionnaire on building goals and divide up into teams to discuss results.

Project 1: Portfolio

Students are required to put together a portfolio of current work to see the quality of their images and to create an appropriate portfolio system.

Week 2

Lecture: "Competitions and networking professional organizations."
Look at students' portfolios and have them write up specific goals for improvement.

Project 2: City Pages

Create a cover illustration for *City Pages*, a weekly arts and entertainment newspaper. Project is to encourage artistic and individual expression. Sketches due next week.

Week 3

Lecture: "Finding that first opportunity. Who uses illustration and how to put together the best illustrator's résumé."

Workshop: Résumés and cover letters.
Critique sketches for Project 2: *City Pages*.

Project 3: Résumé
Create a professional résumé.

Week 4
Visiting illustrator Mary Grand Pre.
Critique final art for Project 2: *City Pages*.
Critique Project 3: Résumés.

Week 5
Lecture: "Contracts, estimates, invoices, 5 reasons why the client may not tell you their budget, and other tales of the industry."

Project 4: Contracts
Create Estimate and Invoice forms to a specified project. This assignment will enable students to appropriately bid jobs, using resources such as *The Graphic Artist's Handbook to Pricing and Ethical Standards*.

Week 6
Visiting illustrator Carrie Hartman.
Critique invoices and estimate project.

171

Project 5: Group Health
Create a half-page illustration for a group health newsletter. Layout will be provided. This assignment is to encourage media exploration and diversity of images. Project includes formally presenting sketches and color copying final images into provided layout. Sketches due next week.

Week 7
Critique Project 5: Group health sketches.

Week 8
Guest speakers, illustrators from Target.
Critique final art for Project 5: Group Health.

Project 6: Comprehensive
Illustrate a brochure (2.5" × 14") for Hefty Products, highlighting reward trips for its successful sales staff. Select either New York or Los Angeles to illustrate. For New York, include the following symbols: Statue of Liberty, Empire State Building, and biking in Central Park, taxi or limo. For L.A., include a symbol representing Beverly Hills, Venice Beach, Hollywood, swimming pools and spa treatment. Sketches due next week.
Evaluation: This project will be evaluated on creativity, research, process, technical achievement, and professional presentation.

Week 9

Guest speaker Paul Peltz, a tax accountant who works with freelance illustrators and designers.
Critique sketches for Project 6: Comprehensive.

Week 10

Lecture: Making the best promos for fewer bucks and copyright/contract issues.
Handout from *HOW* magazine and its "Best of Promotion" issue.
Critique Project 6: Comprehensive.

Project 7: Promo

Create an amazing promotional piece. Sketches due next week.
Objective: To be able to produce a dynamic mailer with a limited budget.

Week 11

· Review sketches for promo pieces.

Week 12

Web design workshop.
Critique Project 7: Promo pieces.

Week 13

Assign Project 8: Portfolio.

Project 8: Portfolio

Students to rework their portfolios.

Week 14

Lecture: "10 ways of succeeding in business with really trying."
Artist representative Gail Fornaisere to talk about representing illustrators.

Project 9: Web Portfolio

Students are to document all of their projects from the semester by creating a digital folio of their work, using Dreamweaver software, and launching their sites.
Objectives: To learn how to document their images for reference and to create a Web-ready folio.

Week 15

Last day of class.
Outside guest panel including art directors and art buyers from Target, Polaris, Picture Window books, *Minneapolis Star Tribune*, and *Minneapolis–St. Paul Magazine* to review students' updated portfolios and Web sites.

goals and objectives

This course combines studio work with a historical survey of humorous and satirical art. We look at current artists and consider strategies for new artists to enter the field.

The goal is that students become aware of the long history of humorous and satirical art and that this knowledge inform their own creative work.

recommended reading

Understanding Comics, by Scott McCloud, Harper, 1994.
McSweeney's Quarterly, Issue 13, Chris Ware, editor, 2004.
99 Ways to Tell a Story: Exercises in Style, by Matt Madden, Chamberlain Bros., 2005.

Suggested Titles of Graphic Novels to Be Read for Brief Oral Report

Maus, a Survivor's Tale, by Art Spiegelman, Pantheon, 1986.
Ghost World, by Daniel Clowes, Fantagraphics Books, 1998.
La Perdida, by Jessica Abel, Fantagraphics Books, series began 2001.
Persepolis, by Marjane Satrapi, Pantheon, 2003.
Epileptic, by "David B.," Pantheon, 2005.

Additional Resources

Copacetic Comics (*www.copacetic.biz*).
The Center for Cartoon Studies (*www.cartoonstudies.org*).
Museum of Cartoon and Comic Art (*www.moccany.org*).
Jenny Everywhere, the copyright-free, open-source comic heroine
 (*www.jennyeverywhere.com*).
Scott McCloud's micropayment comic with free content (*www.scottmccloud.com*).
Editorial cartoons awarded the Pulitzer Prize (*www.pulitzer.org*).

Portions of the Following Films Are Sometimes Shown
Comic Book Confidential, a film by Ron Mann, 1988.
Crumb, documentary on R. Crumb by Terry Zwigoff, 1995.
American Splendor, based on the work of Harvey Pekar, 2003.

description of classes

The first class of each week begins with a lecture component. At the conclusion of the lecture, we begin studio time. The second meeting each week is all studio time. If a student is unable to complete studio work in class, it becomes homework. Brief critiques of previous week's work occur at the end of the weekly lecture.

Week 1

Lecture: Caricature Historical Overview. Some argue that humorous art began in prehistory, but we begin with Da Vinci's drawings of caricature "types," circa 1495. We study examples of artwork from early European printing, including illustrations by Lucas Cranach the Elder and contemporaries. William Hogarth's contribution to sequential art and the beginning of copyright protection for artists leads us to Rowlandson and Gillray's satirical works. Lecture concludes with Daumier's caricature prints.

Studio: Sketching caricatures. Use broad tip marker on layout bond for several ten-minute exercises drawing heads of classmates, exaggerating physical features, profile, and full front. Ten-minute "talking head" exercise: drawing the head of a newscaster from live TV or a tape. Trace original TV sketch repeatedly, increasing exaggeration to the point where likeness disappears.

Homework: Caricature—Pick any living figure from the fields of politics, sports, or entertainment. This work can be 2D or 3D. Consider ease of reproduction. 3D work can be head or full figure. Grade based on likeness, humor, and *ambition,* meaning a 3D rendering will be graded higher than a simple pencil sketch. Bring reference photos to class; do not copy from another caricature.

Week 2

Lecture: Comic Strips. Rudolphe Toppfer, his influence on the early German strips, Max and Maurice, and Katzenjammer Kids. We will look at original sized reproductions of early strips by Winsor McKay, and compare those with the size constraints in today's daily newspapers.

Studio: Hand out a current daily newspaper comics page. Create three panels with two characters from two different comics who would not normally be together. You may add your own character as well. Looking for the design, composition, craftsmanship, and, most of all, humor. Materials: Tech pen or India ink density pen on Bristol board or other bleed-proof paper.

Homework: A comic strip of your own original characters. Equivalent of one daily newspaper strip. Must include title and multiple panels. Can be a humorous or narrative strip.

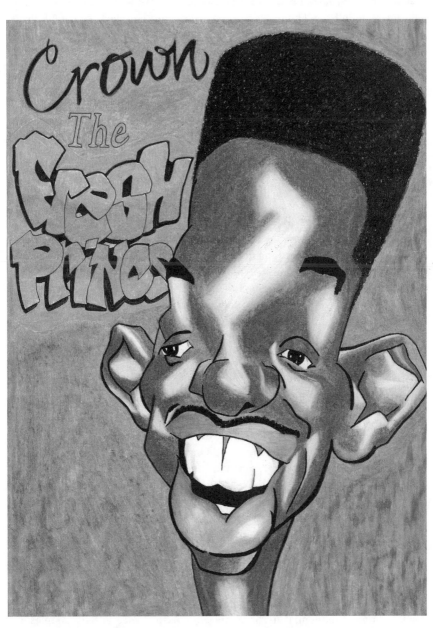

Will Smith caricature by Charlie Robinson

Week 3

Lecture: Newspaper Editorial Cartoons. We will look at artwork by masters ranging from Thomas Nast, Tony Auth, and Herblock, to Pat Oliphant. We will view portfolios of the most recent Pulitzer Prize winners. Discuss syndication and how op-ed art differs from traditional editorial cartooning.
Studio: Assignment: A topical editorial cartoon on a news story. Read about the issue. Collect visual reference. Art should be black and white, horizontal, width twice the height. Use India ink or a pen with India ink density. Evaluated for originality, concept, writing, and artistic execution. This can be a campus, regional, national, or international topic. Can be hand-lettered or computer typeset. Must be appropriate for a local newspaper with general readership.
Homework: Complete studio assignment if unable to do it at that time.

Week 4

Lecture: Magazines. Brief overview of European satirical magazines, France's *L'Assiette au Beurre*, Germany's *Simplicissimus*, and Britain's *Vanity Fair* and *Punch*. Explore diminishing markets for single-panel cartoons in U.S. View representative samples from *The New Yorker*, and *Utne Reader*.
Studio: We will use the current issue of *The New Yorker* caption contest to demonstrate the synergy of art and caption. Brainstorm new captions for cliché drawings, such as man and parrot on desert island, husband and wife at breakfast table, or two dogwalkers meeting in park.
Homework: From the newsstand or the library, find a magazine that has at least three cartoons. Photocopy a page with a cartoon; submit this page with your assignment. Draw an original cartoon for the magazine. Use format of the actual printed art as guide for dimensions. Your original drawing can be up to three times as large as it will appear printed. Hand in a reduced copy of your drawing to the scale of page, along with your finished art. Caption can be attached, rather than included in the art. Grade based on presentation, originality, concept, writing, artistic execution, and appropriateness of cartoon for your selected market.

Week 5

Lecture: Classic American Comic Books. We examine superheroes, Westerns, war, romance, humor, and weird tales. We note how often comic books have served as inspiration and virtual storyboards for successful film franchises.
Studio: Introduction of final assignment, the minicomic, a small staple-bound book of original sequential art. Students will have a chance to see examples of professional and past students' work. This project is graded on the same criteria as other assignments plus consideration of use of the medium of a book. In other words, the story should unfold or progress in a manner that takes advantage of the turning page and juxtaposition of images.

Week 6

Lecture: From Underground Comix to Graphic Novels. We look at work by Robert Crumb, Bill Griffith, and Gilbert Shelton. Autobiographical and semi-autobiographical book-length works by Art Spiegelman, Harvey Pekar, and Marjane Satrapi are discussed.

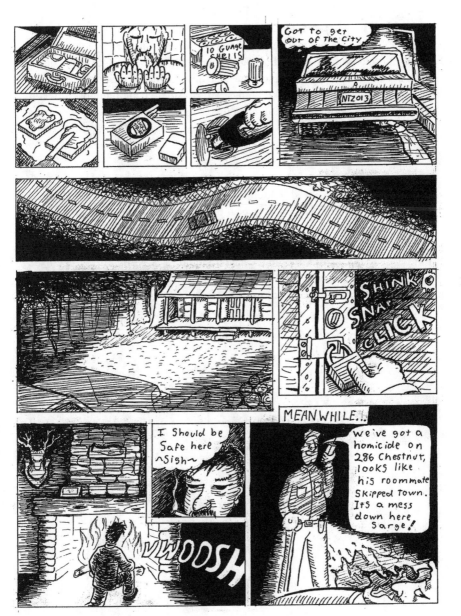

Page from a graphic novel by Shane Gebhard

Studio/Homework: Read one long-form modern comic or graphic novel for discussion next week. Suggested titles are listed at end of syllabus. Alternate student-selected titles are welcome. You may read during this studio class, or continue working on the minicomic.

Week 7

Lecture: The Future of Comics. We consider the question: Has Japan eclipsed the U.S. as the epicenter of comics? Discuss Internet as a vehicle for comics. Discuss the concept of micro-payments for pay-as-you-go Web comics. Look at comics deriving revenue from Web advertising, or character-related merchandise, such as T-shirts and mugs. We consider changing notions of copyright for comics, looking at the open-source comic heroine, Jenny Everywhere. Students come prepared to discuss and informally review the graphic novels they have read individually.

Final meeting: Final exam given and minicomic project due. For the final exam, you will be expected to identify significant artists and their creations. Any artist discussed in class may appear on exam. A partial list follows: Chris Ware, Marjane Satrapi, William Hogarth, Thomas Nast, George Herriman, Saul Steinberg, Robert Crumb, Gary Larson, Charles Schulz, Charles Addams, Todd McFarlane, Matt Groening, Chester Gould, Jack Kirby, Art Spiegelman, Sue Coe, Lynda Barry, Ronald Searle, Ralph Steadman, Bill Watterson, Elzie Segar, Leonardo Da Vinci, Daniel Clowes.

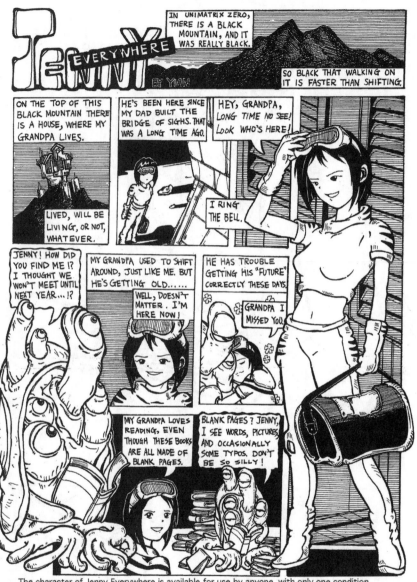

Page by Yian Yen

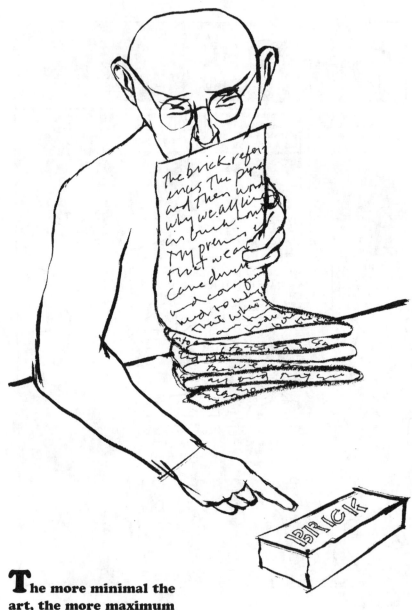

The more minimal the
art, the more maximum
the explanation.

—Hilton Kramer, Quoted in
Marilyn Bender's *The Beautiful
People* (1967)

senior

COURSE TITLE: ILLUSTRATION

INSTRUCTORS: Jonathan Barkat, Brian Biggs, Ralph Giguere, Mark Tocchet

SCHOOL: University of the Arts, College of Art & Design

FREQUENCY: Two fifteen-week semesters, once a week

CREDITS: Three per semester

goals and objectives

It is the senior thesis class, in that the thesis project (known as the William H. Ely Senior Thesis, or just "the Ely") is at the heart of the two semesters. The first six weeks of class are used by students to work on various target market assignments and to begin focusing on the kind of work that they will want to do for their thesis project. The thesis then takes up the remainder of the first semester and the first four weeks of the second, culminating in a show of their work.

The remainder of the year is spent on self-assigned projects that are aimed at the students' chosen markets and portfolio. The faculty act as advisors in this process, along with the faculty in the other required senior portfolio class. At the end of the year, the students must have a complete portfolio of twelve to fifteen finished illustrations in order to graduate.

Two main objectives will be emphasized throughout this class: the growth of the illustrator as an artist and the growth of the student as a professional. A successful illustrator approaches work with a creative and fresh eye while at the same time presenting this work in a professional way. Play and creativity is encouraged in the early stages of work, and the desired end result is a finished, marketable piece. Professional practices and standards are the basis of evaluation.

Finals are presented for wall critiques as color digital prints. "Original art" is not accepted. This encourages all students, even those who work in traditional methods and media, to become adept at scanning, saving, image correcting, and printing their work. These are skills they will need to have in today's marketplace and to make a portfolio.

description of classes

Fall Semester: Week 1

On the first day of class, students are given a one-week editorial assignment on a subject that they choose from a collection of five current articles clipped from sources such as the *New York Times* and the *Philadelphia Weekly* (the choices for 2005 included articles about the Ivory-billed Woodpecker, gentrification of Philadelphia neighborhoods, Philadelphia becoming the "sixth borough" of New York, new medical techniques being used for back pain, and romance in the workplace.) These kinds of jobs, clients, and deadlines are what many young illustrators face upon graduation. They must complete thumbnails within a few hours as well as sketches if they can. Finals are due at the beginning of the second class.

Fall Semester: Weeks 2–7

Three assignments are given as warm-ups for the Ely Thesis assignment, chosen from the list below. The first will be given on Week 2 and will be due the next week. The first assignment begins in class. Before the end of class, students need to have completed and faculty need to have seen at least twenty thumbnail sketches each (with type indicated) for the first assignment. Students cannot proceed without approval of their sketches and having a clear direction. The final illustration is due in one week.

The second assignment will be given on Week 3 and will be due two weeks later on Week 5. The third assignment will be given on that day and will be due two weeks later on Week 7. Students are encouraged to choose their projects carefully by thinking about which they can do in the span of one or two weeks' time.

Choose from the following assignments
Advertisement for a Philadelphia cultural institution, such as a museum, library, performance group, arts organization, and so on. Type included (name of institution and context of advertisement. Look at ads and posters and see what needs to be there). Choose the proportions for this assignment based on the advertisement's placement. That is, is it a poster, a magazine ad, a newspaper ad, a broadside of a bus, or some other format? Show references for your chosen proportions.

Create a likeness, caricature, or portrait of a newsworthy person. This can be a celebrity, a cultural figure, or a political figure—it doesn't matter as long as the person is famous. Consider your client: decide if it is an entertainment magazine such as *Premiere*, a newspaper like the *Wall Street Journal* or *New York Times Book Review*, or some other use. Show references of the person you are portraying as well as examples of the target market (i.e., the kind of publication you are using as your "client"). Size and proportion to be decided.

Book cover. Any book except picture books or graphic novels. Consider fiction, non-fiction, biography, academic text, and so on. Type included (book title and author). Choose an appropriate format/proportion.

Music CD cover. Any music, any genre. However, choose something that is appropriate to your illustration style rather than just something you like (you might listen to classical but paint like a punk). Proportions are square (4.75" × 4.75"). The final color print must be presented in a standard CD jewel case. Type is necessary (name of musician/compilation/band and title of CD).

Children's book spread. (A spread is two pages.) Choose something that is not already connected with a particular illustrator. That is, don't do your own version of, say, *Where the Wild Things Are*. Consider fables, fairy tales, Mother Goose, and folk tales. This must include the type. Size and proportions are up to you, but look at children's books and choose something appropriate.

U.S. postage stamp. Choose one of the following: one of the fifty states, a historic event, music, literature, or wildlife. (If you can think of something appropriate and better, get it approved by your faculty.) Type is necessary ("USA 39" and the thing being commemorated is typical) and you should consider whether it's a regular first-class stamp or airmail. Base the actual size on a real stamp. Show the reference.

Package or label design for any product. Think about wine labels, beer bottles, soda cans, cereal boxes, dishwashing detergent, cat food, toys, children's clothing, soap, a fancy boutique, and so on. Type is required (all type—product, manufacturer, net weight, etc.). Choose how best to present your design. If you can actually make a cereal box, do it. You can steam labels off beer bottles and affix your color print to the bottle. Photo retouching is ok. Whatever works best for your portfolio. Get creative with this aspect and talk to your faculty.

Newspaper illustration. 1) Cover of an alternative weekly such as *Philadelphia Weekly* or *The Village Voice*. Color. Include type. Size is typically 10" × 8.25". Topics: best of Philadelphia, mayoral race, holiday shopping guide or your choice. Discuss with faculty. **2)** Travel section feature. Choose an interesting destination or theme, like Alaskan cruises, snow-ski resorts in Vermont, or a safari in Kenya. Maybe an illustrated map. Discuss size with faculty (consider the format of the newspaper—what might you be able to do?) **3)** *New York Times* op/ed illustration. Choose a relevant, current topic. Black and white, 6.5" × 4".

183

Magazine full page. Choose an actual article from one of the following: *Sports Illustrated, Atlantic Monthly, Wired* (or some other tech magazine), or *Cat Fancy*. Color. Proportions based on actual magazine.

New York Times Book Review cover. Base it on one of the following subjects: Holiday books, special children's book issue, a specific writer of your choice, mysteries, or a bestseller.

Comic book cover. Mainstream superhero, or "alternative" such as that published by Fantagraphics and Top Shelf. Color. Include all relevant type. If it's a superhero comic (Marvel, DC, any mainstream publisher), use the appropriate size format. If it's alternative, you choose.

Magazine cover. There aren't as many magazines that use illustrated covers anymore. Some that do are *The New Yorker, The Atlantic Monthly, Time, Newsweek,* and *Bark* (a wonderful magazine about dogs). Choose one of these and create a cover, with complete type (magazine title, cover story, date, etc.). Choose your topic and discuss with faculty.

Greeting cards. Pick a theme: birthday, mother's/father's day, get well soon, marriage, over the hill, quitting job, new baby, and so on. Visit a greeting card aisle and get inspired. Choose a size format and write your own gag or sentiment. Color.

Theater or cultural festival poster: Renaissance fair, comic convention, car show, pet show, rock concert. Color. Include all type such as the date, venue, time, and so on. Proportions should be appropriate for a poster. Probably vertical, about 19" × 14" (or proportionally smaller for printing).

How-to or technical illustration. This market is becoming bigger and bigger, and few illustrators can pull it off. Recipes, technical manuals, operating instructions, maps, diagrams, airline safety brochures, and so on. Black and white or color. You choose the format. Consider doing this as a series. That is, multiple small illustrations. Clarity is key.

Illustrated textiles and clothing. Design a pattern or character(s) for children's clothing. Consider the primary use and any potential secondary uses, such as labels, toys, and so on. Know your market, do some research. Color, preferably.

Animated illustration. Create a five- to fifteen-second looped animated illustration in Flash. Base it on a news story or some kind of advertisement. No sound. Keep the file size small (under 100k). If you are not familiar with Flash, do not attempt this. Stay focused on the idea, not on the technical razzle-dazzle. File should be presented as a .swf file and must work seamlessly.

Advertising. Create an advertising illustration with type for any company or product of your choice. Size: 7.75" × 10.25".

Fall Semester, Weeks 8–15 and Spring Semester, Weeks 1–5: Thesis Assignment

Please select one project from any of the categories. It is imperative that you follow all designated requirements, both in the preliminary stages and in your

final project. Failure to meet these requirements will jeopardize your participation in the competition and exhibition, and will significantly affect your grade and ability to graduate. An absolute level of professionalism is required in all aspects, including creativity and execution. Your senior faculty is your Ely Thesis advisor and will be responsible for your grade; all three of the senior faculty (Ralph Giguere, Jonathan Barkat, and Brian Biggs) as well as the chair of the department (Mark Tocchet) will consider the quality of each work as to its merits and possibility of inclusion in the exhibition.

Timetable

The deadline for all final work is Week 5 of the spring semester at 1:00 p.m. All work will be collected at this time and should consist of your original art, if appropriate, as well as in final printed and matted form. Please see your class calendar for all other preliminary deadlines. If we receive a blizzard or other natural act on or near the deadline, it is your responsibility to know of any change in this deadline and abide by said change. We make all effort to contact everyone involved, but we will not take "I didn't know" as a good reason for an exception to the deadline.

Matting

Unless your work cannot be matted (multimedia or three-dimensional work, for instance), all work must be in a cream or white matte. No color and no black mattes. Mattes are to be 3" on the sides and top, and 4" on the bottom.

185

Works on canvas must be framed with ¾" × ¼" lattice stripping with either a clear finish or painted black. Discuss your individual project with your advisor well ahead of the deadline for any special arrangements regarding the presentation of your work. Please change your knife blades when cutting your mattes. Or better yet, have them cut professionally. You'd think this would be a non-issue, but it's not. A ragged or crooked matte has ruined some beautiful illustration work.

Size Restrictions

Because of the size of our exhibition area, some restrictions exist. All artwork done up size must in the correct proportions to the size of the final printed piece. The largest size for any piece, matted or unmatted, is 22" × 27". If matted, this means 16" × 20" vertical or 15" × 21" horizontal. Any exceptions (for instance, if you have no "original" art or you are creating posters) must have been previously discussed and approved by your advisor.

Evaluations and Calendar

You will be required to keep a weekly log of your progress and all deadlines. Each week you will have a specific deadline, which might be sketches, thumbnails, type and layout, research, and so on. Know what is due and keep track of it. Your advisor will be doing the same. Your final art is only part of your grade. *Everything* must be on time and up to professional standards. If you fall behind for any reason, it will be extremely difficult to catch up.

Back-up

Please make multiple copies of all your digital files as you work on the projects. Digital media is always sketchy.

Please choose one of the categories below as a basis for your thesis project:

Editorial

Magazine cover: Create four magazine covers, either for the same magazine or four different ones. Some magazines that continue to use illustration are *The New Yorker, The Atlantic Monthly, Harper's, Utne Reader, The Penn Gazette,* and, to a lesser extent, *Time* and *Newsweek.* You are free to do some research and find some more. Include all necessary type, such as the magazine's title, date, cover stories, bar code, and so on. Choose your four cover topics carefully, and get faculty approval before proceeding. Size: appropriate to your chosen magazine(s).

Portraits/likenesses/caricatures: Create a likeness of four celebrities. This can be movie stars, recording stars, political figures, or any newsworthy figure—as long as they are famous. Some magazines that use likenesses often are *Rolling Stone, Entertainment Weekly, Premiere, Time, Newsweek, New York Times Book Review, Philadelphia Magazine,* and several others. Each illustration should appear in the appropriate format and include some text. Know your "client" and work to the appropriate size and format. Use plenty of reference.

New York Times Book Review: Design and illustrate four covers for the Sunday *Book Review.* The covers should be based on any of the following subjects: A specific writer or book, special children's book issue, mysteries, summer reading guide, or holiday book guide. Appropriate text should be included (date, headline, author's name, book title, *Book Review* logo, etc.).Size: Full area is 10" × 12.75", which includes logo.

Magazine full-page illustrations: Design and illustrate four full-page illustrations for a magazine. These need to be spreads, including the headline and text of the article. The illustration can be larger than full page (many magazines publish illustrations over $1\frac{1}{2}$ of the spread). Look at periodicals such as *Society of Publication Designers* (in the library) for inspiration and appropriate format. Your design and layout skills are important here. Size appropriate to chosen magazine.

Alternative weekly: Design and illustrate four covers for an alt weekly such as *The Village Voice, Philadelphia Weekly,* or *City Paper.* Choose appropriate stories such as local political or cultural events and news stories. Use all appropriate type, including the correct logo, story title, author, date, and any other text. Size appropriate to newspaper format.

Product and Packaging

CD series: Design and illustrate a series of four compact discs. This series should be within the same style of music, such as jazz, pop, classical, children's, and so on. Consider series of the same composer's works, box sets, anthologies,

and so on. Choose something that is appropriate to your illustration style rather than just something you like. Type is necessary (name of musician/compilation/band and title of CD) and should be integrated with your illustration. Proportions are slightly horizontal (4.75" × 4.6875"). The final color print must be presented in a standard CD jewel-case (other appropriate packaging can be considered). Do some research.

Package or label design: Create a series of any product and the package or label design for the product. Think about wine labels, beer bottles, soda cans, cereal boxes, gourmet coffees, dish washing detergent, cat food, toys, children's clothing, soap, a fancy boutique, and so on. Type is required (product, manufacturer, net weight, etc.). Choose how best to present your design. If you can actually make a cereal box, do it. You can steam labels off beer bottles and affix your color print to the bottle. The technical aspect of this project varies. Consult your faculty regarding issues like how best to display this work, portfolio presentation, what constitutes a series, and so on. Spend a few hours at a retail establishment and get a feel for the marketplace in which your product would exist.

Greeting cards: Design, write, and illustrate a series of four greeting cards. Pick appropriate themes such as birthdays, get well, over-the-hill, new baby, marriage, and so on. Consider all aspects of the design, including the interior of the cards as well as the backs.

Illustrated textiles and clothing: Design patterns and colors of some kind of clothing series. A good example is children's clothing such as a onesie, a shirt, a dress, and pants. A series of Hawaiian pattern shirts might be another example. Consider secondary uses of your designs such as hangtags, labels, and shopping bags. Know your market. Size: variable. Consider your method of displaying the patterns and designs. Begin this process immediately as you work on your project.

187

Advertising and Institutional

Catalog covers: Design and illustrate a series of catalogs for a mail-order company. (Examples are L.L. Bean, Land of Nod, J. Crew, Eddie Bauer, and Archie McPhee. Know your market.) The four covers should be based on a theme such as the four seasons, annual events (back to school), or various holiday gifts. Size/proportions adapted from actual catalogs. Show your reference. Type would include the company name, the particular catalog theme ("Summer reading"), and the season, as well as any company logo/name.

Advertising campaign: Design, write, and illustrate a series of advertisements for a product or service. The four ads should work as a campaign. Format and size may vary, depending on the usage (magazine, poster, billboard, public transit ad, Web, etc.). Each ad must include advertising copy.

Travel posters/ads: Design and illustrate a series of travel posters for four different destinations. The posters need to be consistent in terms of style and

conception. These posters could be ads for an airline, travel agency, or hotel chain. Reference and research are very important for this assignment to evoke the mood and spirit of the location. Consider your typography and the use of color and texture. Size: vertical poster proportions. 13" × 19" would be appropriate.

Corporate/investment illustrations for annual report: Create four illustrations to be used in a corporate annual report for a company of your choice. The illustrations' themes should be derived from corporate/industry catch-phrases such as risk, vigilance, thinking outside the box, security, volatility, wisdom, networking, and so on. These are essentially conceptual business illustrations, and the actual subject matter can be pretty varied. Size: four full-page illustrations or two full-page and two spot illustrations (body text should be included on the pages with the spots).

Cultural event posters: Design and illustrate a series of posters/ads for a series of cultural events. Examples of a series would include four different rock concerts at one venue; a season of plays, opera, or musicals at a single theater (like the Prince, or a similar theme). Designs should carry a consistent theme and feel. This can be done with illustration or with the type layout. Do some research. Theater posters are some of the most dynamic and diverse designs of the last twenty years. Proportions and size appropriate to posters; 13" × 19" vertical is a good start. Use all appropriate type, including relevant date, times, event name, and location.

188 **Postage stamps:** Design a series of four postage stamps based on a theme like music, cultural figures, wildlife, or another appropriate subject. Get your subject approved by faculty before proceeding. Include appropriate text such as "USA 39" and the commemorative subject. Base the size on actual stamps, though your final prints will be much larger.

Publishing

Children's book: Four illustrations for a children's picture book. Choose a book that is not already associated with a particular author (for instance, *Where the Wild Things Are* wouldn't be appropriate). Consider fairy tales, fables, folk tales, Mother Goose, Brothers Grimm, and so on. You can easily find many books in the library and in bookstores of beautiful ethnic folk tales (Icelandic, Jewish, Russian, African, Asian, etc.). Get approval on text before beginning design and illustration. This project requires the design and illustration of the book's cover (with title and author's name), a two-page spread, a full-page illustration and text page, and a spot or half-page with text. Size is up to you, but look at many picture books and find an appropriate format for your book.

Book covers: Design and illustrate a series of four book covers that have a common theme or author. Themes include mystery, science fiction, horror, biography, folk tales, literature, young reader, and so on. Consider fiction and nonfiction. Choose an appropriate format and size. Include all appropriate text such as title and author.

Graphic novel or comic book: Design and illustrate a graphic novel based on a manuscript of your choice. Consider all genres, including superhero, alternative, and mainstream comics. This should be full color. Two format choices: 1) A complete four-page story (with title on the first page). 2) Cover, splash page, and two-page spread. Size appropriate to comic (mainstream comics are 10.25" × 6.75").

Multimedia: Create an interactive game or short story in Flash or Shockwave. This should be approximately two minutes long and include at least four distinct scenes, with introduction and credits. Make sure you are working from a fabulous concept and it should be funny or clever. Choose this only if you are already comfortable using the tools of multimedia including character design and the appropriate software.

Spring Semester, Weeks 5–15

At the end of the Thesis Project, students are asked to assign themselves three or four projects that will finish out the remaining ten weeks of the class. Each assignment must be a realistic project that works with their targeted market (editorial, children's, etc.) and portfolio goals. Students write a synopsis of the assignment, its purpose, its potential client, and a schedule that includes research, thumbnails, sketches, and final art. Students are made aware that they must consider their own strengths and weaknesses, and what they can accomplish in this time.

description of classes: week by week—fall semester

Week 1

Introduction to course and class overview.
Assignment 1 begins.
Homework: Final art for Assignment 1.

Week 2

Critique Assignment 1.
Begin Assignment 2.
Homework: Final art for Assignment 2, corrections for Assignment 1, and choose Assignment 3 from master list and begin research/reference and thumbnails.

Week 3

Critique Assignment 2, corrections for Assignment 1, and ideas and thumbnails for Assignment 3.
Homework: Finished sketches for Assignment 3 and corrections for Assignments 1 and 2.

Week 4
Critique Assignment 3 sketches and corrections for Assignments 1 and 2.
Homework: Choose Assignment 4 from master list and begin research/reference and thumbnails.

Week 5
Wall critique for Assignment 3.
Critique ideas and thumbnails due for Assignment 4.
Homework: Create sketches for Assignment 4.

Week 6
Thesis guidelines introduced and reviewed, deadlines discussed.
Homework: Final art for Assignment 4.

Week 7
Wall critique for Assignment 4.
Class discussion on choices of thesis projects. Turn in short synopsis of your project and goals.
Homework: Thesis research material presentation with thumbnails.

Mid-term: Must have all four assignments up to this point completed. You cannot proceed on your Ely thesis project until these are turned in and passable.

Week 8
Presentations: Show your visual references, inspiration, and subject material collected to this point.
Discuss mechanicals and the importance of the art director's layout.
In class, begin type layout with prints to show where all type and illustration will be. (This must be done in Adobe Illustrator or InDesign.)
Homework: Sketches on thesis Projects 1 and 2 with type and layout indicated.

Week 9
Class critique on sketches.
Homework: Sketches due on thesis Projects 3 and 4 with type and layout indicated.

Week 10
Class critique on sketches.
Work on layout and illustration sketches for thesis Projects 1 and 2.
Homework: Finished sketches due for thesis Projects 1 and 2 with type and layout included. Prepare to show both prints and digital files.

Week 11

Critique of finished sketches.
Homework: Final artwork for thesis Project 1.

Week 12

Class critique of thesis Project 1.
Begin working on artwork for thesis Project 2.
Homework: Work on final artwork for thesis Project 2.

Week 13

Work on final artwork for thesis Project 2 in class.
Homework: Final artwork for thesis Project 2.

Week 14

Class critique on thesis Project 2; possible comments from other faculty.
Homework: Thesis Projects 1 and 2 scanned, placed in layout
with type.

Week 15

Final semester review and critique.
Homework: Final artwork for thesis Project 3.

description of classes:
week by week—spring semester

Week 1

Work on final artwork for Projects 3 and/or 4 in your layout in class.
Homework: Work on final artwork for Thesis Project 3 and 4. Thesis Project
3 should be complete in layout for next class.

Week 2

Complete layout for Thesis Project 3.
Work on Project 4 layout in class.
Homework: All four thesis projects complete.

Week 3

Guest critique on all four thesis projects.
Homework: Final work and matting.

Week 4

Work on final work and matting in class.
Homework: Finalize all projects.

Week 5

Final projects due at 1:00 P.M. No exceptions. None whatsoever. Don't even ask.

The rest of the semester is spent with self-assigned projects.

COURSE TITLE: SENIOR THESIS AND SEMINAR:
INDEPENDENT WORK AND PROFESSIONAL
DEVELOPMENT
INSTRUCTORS: Thesis Faculty: Whitney Sherman
and Warren Linn; Seminar Faculty: Allan Comport
SCHOOL: Maryland Institute College of Art
FREQUENCY: Two semesters, once a week
CREDITS: Six

goals and objectives

In thesis, students determine their own independent direction of work with an expectation that they develop a body of work of high quality to use in creating a professional-grade portfolio from a working proposal and weekly schedule with specific goals and objectives. Senior-level students are guided to assess their best work and develop a professional studio model.

Student work is assessed during three individual meetings during the semester, one mid-term group critique, and final group critiques involving their thesis faculty, fellow students, seminar faculty, and visiting critics. Students must participate in weekly study groups and lead two. Students are given the opportunity to reassess their proposal at mid-term. The thesis and the seminar coursework is graded separately but averaged together. Senior thesis and seminar runs for two consecutive semesters.

Emphasis is placed on independent work, research on markets in conjunction with the seminar portion of the course, and networking with professionals in an effort to begin establishing their careers as illustrators. The thesis and the seminar portions are fully integrated and compatible, giving support to the artistic development and profession (or business) of becoming an illustrator.

Students are prepared at the end of their junior year by the thesis and seminar faculty with materials and a presentation on the content and methods of thesis and seminar. Other objectives include:

Develop a cohesive body of work of high quality for a professional grade portfolio. (Example: Can I tell that you are able to do the work I see again and again?)

Learn new skill-sets to augment existing ones. (Example: digital apps, sequential/animation, typography, design, or screenprinting, etc.)

Make one presentation on a new resource, book, skill demonstration, Web site, and so on to the class, and post the information on the class Web site.

Work within your study group, using it as a sounding board to deepen your thesis, learn networking, and create community.

course requirements: the summer before

During the summer prior to senior year, students write a proposal and schedule for their thesis. The work they propose should be advanced, in depth, and make a collection of works. From the assigned reading, students choose one interview and use it to underscore, within their proposal, their thesis idea: what they wish to accomplish independently.

- Read *Portraits* by Michael Kimmelman.
- Read/research other texts and resources on the area of your thesis.
- Write a minimum 125-word proposal citing research. This proposal will be presented on the first day of class in the fall. There are no exceptions.
- Develop a weekly schedule of semester goals.

thesis requirements

Fall Semester: Students will fulfill the goals they have set out for themselves independently over the summer, with guidance from their thesis faculty, seminar faculty, guest critics, and others chosen as mentors.

Spring Semester: Work started in the fall semester can be continued OR students can begin a second proposal, closely aligned with the first proposal. If a new thesis is begun, a new proposal must be presented in Week 1 of the spring semester.

The spring term ends with involvement in an exhibition. The department chairperson curates illustration department work. Additionally, the chairperson and a selected group of senior students design a portion of the exhibition. The thesis work, which lends itself to application on products, is encouraged and placed for sale. Inventory includes limited-edition books, anthologies and magazines, card sets, T-shirts, stickers and buttons, and animation anthologies. Students are guided to create and manage inventory sheets, organize teams to run the store, display products, and create promotional and packaging ideas.

description of classes—thesis

Weeks 1–7
Work assessment, presentations, study groups, and individual critiques.

Work Assessment
9 A.M.: Current work brought in and pinned up. Every student must bring in work each week. Progress must be noticeable. All students review each other's work with short notation.

Thesis-based Presentations
9:45 A.M.: Eight presentations per class, each about fifteen minutes. This could be an interesting Web site, a place to get quality printing done, a book, interview, or publication which was recently read (fifteen-minute review/report). The presentation to be promptly posted on class Web site as editable text in the Digital Dropbox. Please add images and give credit for material not originated by you.

Study Groups
10:15 A.M.: These run for approximately one hour. They consist of four or five students with a rotating leader who guides the group in critique, troubleshooting, resource sharing, or skill building. Each group member comes prepared to bring up one topic. Group leader facilitates and keeps discussion to approximately fifteen minutes. Group recorder logs study group notes on class Web site weekly.

Individual critiques
10:30 A.M.–2:45 P.M.: Individual critiques involve discussion/tips on skill/technical improvement, recommendations on ideas, research and networking depending on student needs. Students are graded on their quality of work, adherence to goals and schedules, participation in group critiques and exhibitions, imagination, professional attitude, motivation and demonstration of artistic and personal growth throughout the semesters.

195

Weeks 7–8

Mid-term Critique—9 A.M.–11 A.M.
Thesis faculty, seminar faculty, and fellow students conduct critiques of all the students' work so far during the first half of the class.

Guest Critic—11 A.M.–2:45 P.M.
A guest critic is invited to assess the students' work and give feedback during the second half of class.

Weeks 9–14
Presentations, study groups, eight individual critiques.

Weeks 14–16
Final critiques during the first half of the class. A guest critic is invited for the second half.

seminar requirements

Fall Semester: Written assignments completed on specific markets, critical essays, and interviews of professionals. They must also research selected topics for the weekly discussions.

Spring Semester: Students are required to make a portfolio, marketing materials (postcards, letterhead, card, etc.) appropriate to their area of interest, a CD of high- and low-resolution image files for use in e-mail promotion, and a list of researched contacts within the industry appropriate to their stated area of interest. Students present their portfolios to the class for critique and feedback on presentation.

description of classes: seminar

An artist's representative teaches this course, bringing the daily work experience of sales and contract/project negotiations to the classroom. Specific scheduling of weekly activities is kept flexible, allowing for faculty to use current work situations as fodder for class discussion.

Each week, students discuss professional issues and development as well as studio/business practices, including critical writing, documentation and archiving, networking with illustration and design professionals working in the field, portfolio and marketing with Web site and promotional materials, intellectual property, copyright issues, taxes, pricing, artist reps, and so on.

Students are presented with a "what would you do?" situation to respond to, followed by an account of a real situation. Examples of researching Web resources, creating a business plan development, deciding and negotiating prices and fees, and making presentations are some of the weekly exercises.

Presentations by professionals and the guest critics from the mid-term and final critiques give insight to ways to enter and engage in the field, and the current direction of contemporary illustration.

Students are encouraged to attend conferences, festivals, and conventions, stay informed on exhibition in illustration and other art forms, and continue library research and reading.

COURSE TITLE: SENIOR PROJECT

INSTRUCTOR: Rudy Gutierrez

SCHOOL: Pratt Institute

FREQUENCY: One semester, once a week

CREDITS: Four

goals and objectives

The main focus will be helping the student on his or her "path" or direction, with an emphasis on developing one's own visual "language."

With our quickly evolving marketplace, there has to be constant exploration on finding outlets for one's work whether it will be in a studio or with an entrepreneurial spirit and vision for initiating projects. There will also be much time devoted to business issues such as price negotiation, marketing/promotion, taxes, representation, and portfolio preparation. Jobs will be shown by the instructor that will emphasize real-life process and procedure in terms of interaction between the illustrator and art director or art buyer. In the past, there have been actual jobs given as assignments and this will continue as they come.

I hope that students will leave with a clear picture of how special it can be to use illustration as an outlet. Even with the constant struggle and perseverance that is necessary, it is an honor to be part of this brotherhood and sisterhood of artists.

"The spirit of passion, work ethic, integrity, and fun is respected here."

description of classes

Week 1

In class, students are asked to answer a set of questions that are written out. These answers are sometimes talked about in class, and they serve as good insight and reference in getting to know each student.

- What do you want or need from this class that you haven't received in previous classes, and what do you want to see continued that has worked?
- What is professionalism?
- Why do you want to be an illustrator?
- What do you feel about the illustration business?
- What and who are your influences (not just visual) and why?
- What is strong or weak about your work?

- What's the difference between fine art and illustration?
- What do you know? (This question is really designed to find out what each student is into, in terms of hobbies, life, etc. It opens opportunities for visual exploration.)

Some of my original work is shown with an emphasis on process and a talk about personal language. Thumbnails, finished sketches, revisions, final art, and published art are viewed from start to finish, including comments by art directors and clients. Students get to see the different kinds of paper that are used for reproduction, and the different results and adjustments that have to be made by the illustrator. I'll also talk about my career in terms of how I got to where I am, and the positive and negative aspects. The displays tend to open up discussions about business and technical aspects as well as conceptual thinking and what a client requires.

Students are then told about class requirements, policies, and so on and asked to bring in work from previous semesters for the following week. They are also asked to bring in proposals the following week that state how, why, and what they would like to do for the semester. They are proposing how many pieces will be done and what will be accomplished by the end of the semester. They are read proposals from previous years to get an idea of what is required.

Week 2

198 Students draw from the model in class. There are a series of poses starting with gestures and working up to five-, ten-, and twenty-minute sessions that sometimes include costumes.

Each student is met with individually to see previous work and discuss his or her proposal. It is important that the students' proposal matches the direction of what they want to do in terms of their career and that they are able to sustain it for a semester. There are times during the semester when either I or the student realizes that what was chosen is not working, and with consultation they make a change. I find that students can really start to get a sense of direction even from failed attempts.

All students are on a different page as far as what they are proposing. This way of working sets up a situation where the results are far ranging. For example, some may be working on children's books, and others are doing editorial assignments while someone else may be doing pre-production work geared toward a position in an animation studio.

Weeks 3–15

Students make presentations, their first installments are viewed, and their proposals are discussed with the class. Some will have sketches, and others who showed sketches the previous week might have finishes to critique. Students will consult with the instructor and choose a direction for the semester.

Assignments will be broken down individually and planned on a "one-on-one" basis between the instructor and each student. The process of thumbnail sketches to finished sketches to finished pieces will be stressed for some, while for others the procedure might culminate in production drawings or an animation. The relationship between in-class drawing and sketchbook work with finished projects will be explored. There will be model drawing and options to work on one's projects in class.

Students will meet with the instructor on a weekly basis. These sessions will generally alternate with critiques, guest lecturers, and class trips. Critique classes will usually start with some aspect of the business being covered. Topics included are billing, accounting, promotion, negotiating, and general dealing with clients. Actual contracts and e-mails with clients are shown and discussed so that the students will be prepared in terms of business.

COURSE TITLE: SENIOR SPOTS SEMINAR

INSTRUCTOR: Stephen Savage

SCHOOL: School of Visual Arts

FREQUENCY: One semester, once a week

CREDITS: Three

goals and objectives

Each week, students will produce spot illustrations for the headlines, captions, articles, and ideas currently in the news. Students will be offered ten items to choose from.

I give students actual articles and ask them to go through the same three-step process professional illustrators go through from rough sketch to tight sketch to final art. I act as art director, approving their work and allowing them to advance to the next stage of the process.

rules and requirements

Assignments and critiques will not be available via e-mail.

No food except at break time.

Switch off all cell phones and portable music players.

Show up later than 3:20 P.M. and you will be counted absent.

Three unexcused absences will give you an F. A doctor's note is the only thing that will excuse an absence.

required art materials

Pencils, pens, loose sheets of 20 lb. copier paper, tracing paper, kneaded eraser, one box of push pins, supplies for final art (to discuss later).

grading

Grading for this class is based on a point system: 90–100 points is an A, 80–90 points is a B; 70–80 points is a C; 60–70 points is a D; 0–60 points is an F.

description of classes

Weeks 1-2

Rough Sketches (one point each—sixty points maximum). You must contribute at least five roughs per class. Photocopy or print drawing on 8½" × 11", 20 lb. white paper (vertical), one rough per sheet.

Weeks 3-4

Tight Sketches (five points each). Must be accompanied by the approved rough and match trim size exactly. Photocopy or print drawing on 8½" × 11", 20 lb. white paper (vertical), one image per sheet.

Weeks 5-7

Final Art (seven points each). Must be accompanied by the approved rough and tight sketch and match trim size exactly. Photocopy or print art on white cardstock. You will receive points only for professional-looking work. Point totals will be posted at the end of each class.

Week 8: Introduction to Metaphors

Lecture: Metaphor

A metaphor is a comparison of two unlike things using the verb "to be." A metaphor is an implicit connection.

All the world's a stage,
And all the men and women merely players
They have their exits and their entrances
—William Shakespeare, *As You Like It*, Act II, Scene vii

A simile is the comparison of two unlike things using "like" or "as." A simile is an explicit connection.

She has a voice like butta.
He was standing still as a blade of grass on an August afternoon.

Why use one?

One reason is that it's clearer than a literal explanation. So, why use a figure of speech such as "The windmills of your mind" rather than just saying "Your mind is in turmoil"? We've already considered the fact that the two phrases differ in terms of their connotations—the ideas and images that are called to mind by association. When we think of windmills, we think of endless motion that goes nowhere, driven by outside forces we can't control (the wind), and

perhaps of grinding something down into dust (as windmills do corn). These are all images that have considerable force when they are linked to the mind, and which aren't connoted by the simple phrase "Your mind is in turmoil." The image of the mind having windmills in it is, while absurd, also a striking one in its own right. In fact, it's perhaps this absurdity that allows it to convey the idea of a mind in turmoil far better than any literal description could: a warped or hallucinatory description is the best way of evoking a warped and hallucinating mind.

"Love Is Like Oxygen" by Sweet

Love is like oxygen
You get too much you get too high
Not enough and you're gonna die.

"Love gets you high" uses an equally hyperbolic figure of speech to illustrate the importance of love. Without oxygen, human beings cannot live; love is like oxygen; therefore, by implication, human beings cannot live without love.

Reason two is that metaphors communicate a feeling more powerfully. They use the reader's or viewer's own memories to evoke feelings or ideas. For example, if you say "She smelled nice," it's not as powerful as if you say, "She smelled fresh and sweet, like roses and morning dew." Similarly, in an illustration, if you want to show an image of someone smelling sweet, showing a person sniffing and making a thumbs-up sign might show it, but not as powerfully as an image of someone floating dreamily along behind a person, his or her nose following an imaginary trail of roses.

Reason three: They allow us to discuss things that are hard to discuss, like sex. What do you think Martha and the Vandellas are singing about in their hit Motown song? "Love is like a heat wave. It's burning inside." Pharmaceutical advertising uses metaphors because in many cases, regulations prohibit the use of explicit imagery. (Think Viagra.) In other cases, ideas like bladder control are impossible to show without a visual metaphor.

And last but not least, they're funny! Making an absurd and unexpected connection often makes us laugh. Woody Allen, as Alvy Singer in his film *Annie Hall*, laments, "A relationship, I think, is like a shark. You know? It has to constantly move forward or it dies. And I think what we got on our hands is a dead shark." For a hilarious example of a badly chosen, contrived, and ludicrously over-extended metaphor, listen to "Sex Farm" from the soundtrack to *This Is Spinal Tap*:

Let's rock and roll
Working on a sex farm
Trying to raise some hard love
Getting out my pitch fork
And poking your hay

Scratching in your henhouse
Sniffing at your feedbag
Slipping out your back door
I'm leaving my spray

Sex farm woman
I'm gonna mow you down
Sex farm woman
I'll rake and mow you down

Sex farm woman
Don't you see my silo risin' high
Working on a sex farm
Hosing down your barn door
Bothering your livestock
They know what I need

Working up a hot sweat
I'm stretching in your pea patch
Plowing through your beanfield
Planting my seed

Sex farm woman
I'll be your hired hand
Sex farm woman
I'll let my offer stand
Sex farm woman
Don't you feel my tractor rumbling by
by-by-byyyy

Working on a sex farm
Wolfing down some cornbread
I'm turning on the TV
Joining the Grange.

Quiz 1 (hand-out)

1. Metaphors and similes make connections between two unlike things. True or false?

2. A metaphor makes an explicit connection, while a simile makes an implicit connection. True or false?

3. Metaphor or simile? (Circle one)

 a) "You are the wind beneath my wings." **M / S**

 b) "Me without a mic is like a beat without a snare. I'm sweet like licorice, dangerous like syphilis." **M / S**

 c) "I am a rock. I am an island." **M / S**

 d) "Give me things that don't get lost, like a coin that won't get tossed, rollin' home to you." **M / S**

 e) "Papa was a rolling stone." **M / S**

 f) "Like a virgin. Touched for the very first time." **M / S**

4. Why use a metaphor?

5. Give your own example of a metaphor and a simile.

Metaphors in Illustration (Handout)
Compiled by Thomas Fuchs

Quiz 2
Use the "Metaphors in Illustration" chart to categorize the illustrations on page 206.

Metaphor Sing-Along (Handout)
"You are the sunshine of my life
That's why I'll always be around,
You are the apple of my eye,
Forever you'll stay in my heart"

"Ebony and Ivory, work together in perfect harmony
On my piano keyboard
O Lord, why can't we?"

"I'm walking on sunshine, wooah
I'm walking on sunshine, wooah

	Connection A is associated with B	**Similarity** A is like B	**Opposition** A is not like B
Juxtaposition Two images side by side			
Fusion Two combined images			
Replacement Image present points to an absent image			

I'm walking on sunshine, wooah
And don't it feel good!"

"You could have a big dipper
Going up and down, all around the bends
You could have a bumper car, bumping
This amusement never ends
I want to be . . . your sledgehammer"

"We don't need no education.
We don't need no thought control.
No dark sarcasm in the classroom.
Teacher, leave those kids alone.
Hey, teacher, leave those kids alone!
All in all it's just another brick in the wall."

206

Creating Metaphors (Homework)

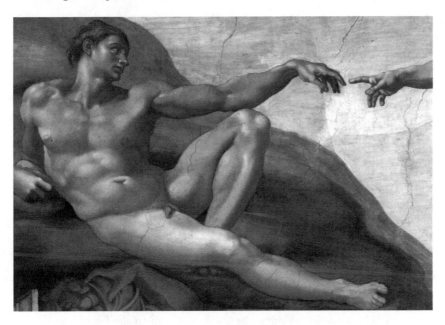

- Make four drawings where you replace Adam with your choice of the following items: a doorbell, a bowling ball, a chimpanzee, a policeman fingerprinting God's hand, a computer mouse, the White House, or Eve.
- Make two more drawings with Adam replacements of your own.
- Make four drawings where you replace God's hand with your choice of the following items: a chimpanzee's hand, a hand in a suit coat, an extraterrestrial's hand, a robot's hand, the hand of a person of color, a hand with ratty gloves with the fingers cut off, or a hand holding chopsticks.
- Make two more drawings with God's hand replacements of your own.

All twelve drawings must include one sentence explaining the meaning of each metaphor; be photocopied, one per 8½" × 11" sheet of paper (vertical); be bounded by a box, with at least 2" of white space surrounding it; and have your name on them.

Week 9: More Metaphors

Impossible Metaphor (Homework)

THE MYTH OF SISYPHUS

Sisyphus is the son of Aeolus (the king of Thessaly) and Enarete, and founder of Corinth. He instituted, among others, the Isthmian Games. According to tradition he was sly and evil and used to way-lay travelers and murder them. He betrayed the secrets of the gods and chained the god of death, Thanatos, so the deceased could not reach the underworld. Hades himself intervened and Sisyphus was severely punished. In the realm of the dead, he is forced to roll a block of stone against a steep hill, which tumbles back down when he reaches the top. Then the whole process starts again, lasting all eternity.

- Create eight drawings where you replace/alter the figure and boulder to illustrate the following ideas: Babe Ruth's home run record has been very hard to break; some problems are easier to solve than you think; Americans struggle with their weight; the key to home repair problems is finding the right tool for the job; falling behind at work? Get help! Hire a temp!; creativity can solve almost any problem.
- Make two more drawings of your own showing impossible tasks. *Do not* add text to the drawings. The class will try and guess what they mean!

All eight drawings must include at least one figure pushing something up a hill; be photocopied, one per 8½" × 11" sheet of paper (vertical); be contained within a box at least 5" square; have your name on them.

Week 10: Parade of Metaphors

Students are encouraged to let their imaginations go and to draw on their own visual vocabularies for concepts ("if you like to draw animals, then go ahead and use Bambi and Flipper in your illustrations.").

Students are shown a slide presentation called "Parade of Metaphors," featuring my work as well as that of Wes Bedrosian, Thomas Fuchs, Christoph Niemann, and David Suter.

These spot illustrations use visual metaphors.
Which one uses A) fusion B) juxtaposition C) replacement

209

Name _____ Score _____

SHOW	USING
the divine	a shadow
isolation	only animals
love	landscape/cityscape
revolution	an interior
leadership	only hands
fear	only a still-life
greed	a sequence

210

- Make seven drawings (one per 8½" × 11" sheet, vertical, photocopied) illustrating the items in the left-hand column below. Each drawing must contain a different pictorial device from the right-hand column. Use each device *only* once.
- Each drawing must be bounded by a box and be no wider than 6".

Week 11: Portraits in Spot Illustration

The class takes a break from hard-core concepts to draw movie stars for a current *New Yorker* magazine cinema assignment.

Current Cinema (Homework)

Illustrate the current cinema column in the *New Yorker*. Five items are due next week, and all must be photocopied:

1. Ten thumbnails of your composition. Spend five min. on each.
2. One photo reference sheet with at least five head shots of the film's star.
3. Two pencil studies of the film's star, any size.
4. Two sentences describing the film.
5. Three rough sketches (three separate ideas) for the piece. We must be able to recognize the film's star and get a sense of the film's story in these sketches.

Specifications: Trim size: width: 4.5", height: between 3" and 3.5".
Research Tips:

- Use Google to find pictures of your movie star and to research the movie.
- Go to: *http://www.apple.com/trailers/*.
- Rent another movie your star has been in. For example, if your item is Jake Gyllenhaal in *Jarhead*, then rent *Donnie Darko* and make drawings of him from that film.
- Body reference: pose your friends, then photograph and/or draw them.

Week 12: Use a metaphor to tackle a real problem

New York Times letters piece (Homework)

Make four drawings of the three stories (twelve total). The drawings must be at least twice the size of the print size (4" wide × 5" high). Photocopy sketches on 8½" × 11" paper (vertical).

Avoid the following: words (unless they are central to the idea), dollar signs/bills, hearts, other symbols. No stick figures or faceless characters. Don't take a comic approach to a serious subject.

Week 13: Three more letters pieces

Week 14: Visit to the *New York Times*

Students learn from a master: Gallery 9 exhibit of Christoph Niemann's work: "Little Niemann: 1000 Spot Illustrations."

Travel section art director Rodrigo Honeywell joins us in a final critique in the newspaper's cafeteria.

COURSE TITLE: SENIOR CONCEPTS/PORTFOLIO

INSTRUCTOR: Viktor Koen

SCHOOL: Parsons School of Design

FREQUENCY: One semester, once a week

CREDITS: Three

goals and objectives

The senior concepts/portfolio is a fast-paced opportunity to experiment on different applications of style and approach by producing portfolio images based on manuscripts and real assignments. Students can turn sketches into finishes and truly evolve as artists in concept, method, and craft. Having a professional portfolio is one of the most important tools an illustrator can have, maybe *the* most important. It is not only something to present in order to receive assignments but an ongoing log of production and as a result, an evolution in quality.

Students will create individual works on various pragmatic topics. Ideas and sketches on the assignments will be analyzed and sharpened prior to the start of finishes. These exercises and their solutions will explore the students' individual technical and conceptual interests while looking into their future professional direction and specialization. At the end of the course, students will gain the ability to:

- Digest manuscripts and assignment briefs
- Evaluate ideas on very specific subjects as far as quality, clarity, and impact
- Manage time and deadlines
- Actualize ideas and turn them into successful images

description of classes

Students will bring in new work to each class (sketch for new assignment and finish of the previous) and get conditioned to a pace where new work needs to be produced at all times and at the same time, old work will be corrected or taken from sketch to finish.

Students will participate in class discussions and critiques. They will meet individually with their instructor for personal feedback.

Portfolios will be reviewed and revised over the course of the semester, and the final portfolio will include approximately five to eight new finished pieces.

Week 1

Subject: *Ex libris*; must include family name and the words "ex libris"
Size: 4–8" × 4–8", full color

212

Week 2
Subject: Editorial illustrations for financial magazine (text will be provided)
Size: Full-page 8.5" × 11" full color; quarter-page 4" × 5" full color; spot 2" × 2" full color

Week 3
Subject: B movie poster re-illustrated and re-designed; original movie poster provided.
Size: 13" × 19", full color

Week 4
Subject: Bell Atlantic white pages book cover illustration
Size: 5.5" × 8.5", full color

Week 5
Subject: Door signs for the rest rooms of the Alternative Music Museum in Seattle
Size: Two illustrations 8" × 8", black and white

Week 6
Subject: MasterCard design and illustration for a nonprofit organization of choice. MasterCard template will be provided.
Size: 2" × 3.5", original artwork to be done at 200 percent, full color

213

Week 7
Subject: Create image for music band, to be used in the following formats:

- CD cover: 5" × 5", full color
- Ad: 8.5" × 5.5", grayscale
- T- shirt: 10.5" × 12.5" maximum, line-art

Week 8
Subject: The Learning Annex book series. Book cover based on a Learning Annex course description; every student has a different subject.
Size: 5.5" × 8.5", full color

Week 9
Subject: Illustration with specific photo provided for ad campaign of international consulting firm. Choice of Einstein, Picasso, or JFK.
Size: 8.5" × 11", full color

COURSE TITLE: DIGITAL PRESENTATION

INSTRUCTOR: Trey Hoyumpa

SCHOOL: Parsons School of Design

FREQUENCY: One semester, once a week

CREDITS: Three

goals and objectives

This course prepares students to organize their work for various media and markets, promote and present themselves, and the business basics of being an artist. Topics to be discussed include (but are not limited to): portfolios, branding, drop-offs, résumés, contracts, invoicing, intellectual property, business plans, bookkeeping, promotion, and Web site development and maintenance. Guest speakers are an important element of this class and will be brought in throughout the semester.

This course will introduce practical business basics while continuing the exploration of marketing and promotion of the illustrator/designer/artist. As a consequence, emphasis will be placed on developing a portfolio, both Internet and real world, in tandem with the portfolio class.

This class is designed to give illustrators a resource for input and support as they prepare for the inevitable: graduation. Other objectives include:

- Learning business basics
- Exploring of the world of promotion
- Packaging their bodies of work, physically and digitally, in such a way that their work is best complemented and their potential for impressing clients is maximized
- Preparing for digital aspects of the field
- Understanding how to scan artwork properly and prepare files electronically for both Web and print, and being able to send electronic files to prospective clients
- Becoming familiar with contemporary illustrators and how those illustrators present their work digitally and otherwise to prospective clients
- Creating promotional material/direct mail, digital promotion or otherwise to represent their work, in coexistence with their online presence
- Learning and sharing available resources for preparation and promotion of their work

214

assignments

If you do not complete an assignment by the deadline, bring it to the following class. Late assignments will receive a reduced letter grade. Missing projects will receive a failing grade. By the end of this class, you should have all of the following:

- Portfolio online and physical/real world
- Standard letter of agreement/contract
- Standard invoice
- Cost of living estimate
- Business plan
- List of names to send work to
- Resume and cover letter
- Senior work copyrighted

requirements

Class attendance and participation are vital. Not only are they required, but you cannot learn from others' experiences and will miss out on important conversations and information. Be ready to talk about your work and others. Bring the necessary supplies and assignments. By the end of this class, I hope that you feel empowered to pursue your field and have the understanding and resources to do so.

reading and resources

Inside the Business of Illustration, Steven Heller and Marshall Arisman, Allworth Press, 2004
Graphic Artist's Guild Pricing & Ethical Guidelines, 11th Ed., 2003
Business & Legal Forms for Illustrators, Tad Crawford, Allworth Press, 2004

attendance, evaluation, and grading

Assignments, quizzes, readings: 50 percent of final grade
Attendance and preparedness: 25 percent of final grade
Class participation and attendance: 25 percent of final grade

description of classes

Week 1: Introductions
Discussion: The syllabus (What is your ultimate goal?); exploration of resources

Week 2: A Critique

Group critique of all student work

Begin discussion on promotional materials and resources

Week 3: Promotion

Discussion: Directories; annuals; portfolio sites (such as theispot.com, altpick.com, and portfolios.com); competitions; trade shows; networking; market niches; creating campaign; explore resources

Week 4: Guest Speaker

Week 5: Web Site Ready

Group critique of all student Web sites (online)

Discussion: Web sites (Updating, management, stats); e-mail (professional addresses, etiquette, mailing lists, e-mailing images)

Week 6: Portfolios 101

Discussion: thesis; choosing work for portfolios; sketchbooks as a source; CD portfolios (how to create, options, branding); portfolio drop-offs

Week 7: Portfolios 201

Group critique on portfolios

Continue lecture on portfolios

Discussion: the business plan (quarterly, yearly, 3 year, and 5 year)

Week 8: Always Use Protection

Discussion: intellectual property (copyrights, trademarks, litigation, work for hire, work on spec, licensing—including stock art); guilds and societies as resources

Week 9: Ready, Set . . .

Discussion: more on business plans and copyright experience; resumes; cover letters; letters of recommendations; where to find work (resources)

Week 10: A Critique

Group critique on résumés and cover letters

Mid-term evaluations

Week 11: Guest Speaker

Week 12: The Nuts and Bolts, Part 1

Discussion: Phone and e-mail skills; cold calling; interviews; freelance; reps; galleries as a resource; aliases

Week 13: The Nuts and Bolts, Part 2
Discussion: Contact trade off; Buying lists (adbase.com); negotiations; pricing and estimates (*http://nwrain.net/ percent7emonlux/estimatetutorial.html*); contracts (*Business and Legal forms for Illustrators*, *GAG Guide*); kill fees; invoicing, bill collecting, and litigation

Week 14: The Nuts and Bolts, Part 3
Discussion: Bookkeeping/accounting; cost of living; taxes; tracking hours; health issues (insurance); retirement accounts

Week 15: Final Thoughts
Final presentations of online and real-world portfolios

goals and objectives

This class is devoted to the development of individual senior portfolios and the business of illustration. Here, students will combine their most successful work from previous semesters along with new works to create professional portfolios.

Each class has a corresponding section in which students expand their work into a digital portfolio. Students learn to organize their work, promote themselves, and send work to clients digitally. There will be a focus on scanning portfolio work, Web site design, use and upkeep, and PDF workflow.

Students will also achieve an understanding of the ins and outs of the business of freelance illustration. At the end of the semester, all students will have:

- A finished physical portfolio
- Standard letter of agreement/contract
- Standard invoice
- Cost-of-living estimate
- Business model for the next year, three years, five years
- List of 100 names to send work to
- Résumé
- Cover letter for a company they want to work for
- An understanding of the business of illustration
- Experience doing a drop-off
- A completed Web site design (coding will be optional)

required reading

The Graphic Artist's Guild Handbook
Business and Legal Forms for Illustrators, by Tad Crawford
Inside the Business of Illustration, by Steven Heller and Marshall Arisman

recommended reading

A book on cover letters/résumés
A book on Web design
Books on Photoshop, Illustrator, and Web programs

materials and supplies

Come to class each week with some way to save and share your files. I recommend a Flash drive.

description of classes

Classes will be broken up almost in half. The first hour and a half devoted to discussion of business and professional practices, the rest of class devoted to independent work on Web sites or other promotional projects. This course will work hand in hand with portfolio instructors to better integrate knowledge.

Week 1

In class: Discussion of syllabus. Getting to know students. What is your ultimate goal? Discussion and exploration of resources and books.
Students should order any forms they're going to need. Most will probably need short form VA. They will need these for Week 9.
Homework: Bring in your physical portfolio from last semester or what most accurately represents your current portfolio. If you don't have a physical portfolio, please have printouts of the work you are considering for your portfolio. Have Web sites up to date. If not online already, bring portfolio to class on CD for review. Start reading Heller and Arisman's book, and think about questions to ask them in a few weeks. Order copyright forms.

Week 2

In class: Review student portfolios and Web sites in class.
Discuss what they're going to need to focus on for the semester to help construct their final portfolio/Web site (What style/look they're going for, how many more pieces they need, what could be added or deleted, etc.); how to find names and addresses to send promotional cards to buying lists (adbase and langerman lists); researching names at the bookstore, networking, the Web, *aan.org*, etc.
Homework: Start researching list of names. Students need 100 names and addresses by the end of the semester to send promo cards to. Continue reading Heller and Arisman's book. Start working on Web sites. First critique on work-in-progress Web site in Week 5.

Week 3

In class: Continue reviewing students' portfolios/Web sites if still necessary. Discuss how to communicate with art directors in terms of finding work; proper e-mail etiquette and phone etiquette; how much you need to make a year to live; how much money you're going to devote to advertising; how many mailers you're going to be doing, and so on. Be very realistic.

Illustration Process 1—Promotion: How to create a successful promotional campaign and coming up with a plan of attack. Three or four mailers a year with the Web site info; directories and annuals; competitions; portfolio sites (TheiSpot.com, AltPick.com, Portfolios.com, etc.); trade shows; drop-offs; artist's representatives.

Homework: Continue/finish reading Heller and Arisman's book. Come up with four questions to ask them. Start working on the cost-of-living estimate (forms supplied by instructor). Cost-of-living estimates due Week 5.

Week 4

In class: Steven Heller and Marshall Arisman, guest lecturers.

Homework: Complete cost-of-living estimate for next week. Have in-progress Web sites ready to be looked at with the rest of the class for feedback. Discussion on Heller and Arisman's presentation. Discuss cost-of-living estimates and how that will affect their "plan of attack." Discuss putting forth a business model for the year based on that as well as longer goals (three years, five years).

Week 5

In class: More in-depth discussion on the drop-off. Discussion on physical portfolio as it relates to itself. What kind of portfolio do you want? What color paper, size, and so on? This is a different discussion than Weeks 2 and 3, which focused on the work in students' portfolios. In-progress Web site reviews.

Homework: Revise cost-of-living estimates if necessary. Do rough business model. Students are to find a place they want to do a drop-off for and get that information. Address, info, what days they do drop-offs, and so on. They will be required to do a drop-off later in the semester and will need to prepare their physical portfolio to their specific target.

Bring in sketchbooks. Start investigating portfolio options at Pearl and The Art Store, and other portfolio places to find the one they want. Will need to have a working physical portfolio ready by Week 9. Read pp. 78–87 in *GAG Guide* about negotiating and evaluating offers for discussion next week.

Week 6

In class: Discussion of thesis show and experience. Review sketchbooks and try to find work to refine into finished art for portfolios. Review Web sites that we didn't get to last week, if necessary.

Illustration Process 2—The Offer: We'll discuss what steps to take when an art director contacts you about a job. Estimating, negotiating, and accepting a job—things to know:

- What rights do they want?
- Time period.
- How big is the circulation?
- Where will the work be located (cover, interior, the Web, etc.)?
- Size of illo.
- Work for hire?
- Work done on spec?
- Negotiating.

Homework: Check out *http://nwrain.net/ percent7emonlux/estimatetutorial.html* for further knowledge and discussion. Read pp. 238–250 in *GAG Guide* about contracts for discussion next week.

Week 7

In class: Discussion on reading; contracts and lawyers.

Illustration Process 3—Accepting the Job: Prices have been worked out, and all usage and rights agreed upon. What to do now? Sending letter of agreement/contract. What to put on the letter of agreement:

- Rights transferred
- Due date
- Payment due date
- Kill fees
- Revisions
- Go over checklist in Tad Crawford book.

221

Homework: Students are to read Tad Crawford's section on letters of agreements and contracts. Also, check out the *GAG Guide* contract monitor as a resource. Students are to prepare a letter of agreement or contract for their project with their portfolio teacher. Due next week.

Read pp. 87–97 about record-keeping and collecting money in *GAG Guide* for next week's discussion.

Week 8

In class: In-progress Web site reviews.

Illustration Process 4—The Job: Sending sketches; doing revisions; turning in final art; how to send stuff to art directors; what's expected of you; what's reasonable, what's unreasonable

Illustration Process 5—Getting Paid: Invoicing; collecting money and keeping records; using an assumed name ("Doing Business As"); when is sales tax necessary; what to do in situations of non-payment; resources.

Homework: Read Tad Crawford's invoice checklist. Read pp. 20–31 on copyright and 97–109 on re-use in *GAG Guide*. Create an invoice for current assignment in portfolio class. Bring in copyright forms to class. Have portfolios "finished" for class next week.

Week 9

In class: Review physical portfolios.
Illustration Process 6—Copyright: How to copyright work; fill out a sample copyright form in class; trademark.
Illustration Process 7—Secondary Markets: Licensing, stock, creating products (shirts, mugs, toys, books, etc.)
Homework: Read the copyright section in Tad Crawford's book. Complete a copyright form, and register all works done within the past year with the copyright office. Revise portfolios if necessary for drop-off.

Week 10

In class: Review portfolios again, if necessary.
Discussion: where people are going to do their drop-offs; and where to find and look for jobs (day jobs).
Guest lecturer: Person from Writing Center or Career Services to talk about résumés and cover letters.
Homework: Finish portfolio and do a drop-off. Drop-offs to be done by next class or the week after, depending on schedule. Find a place you want to work for and write a cover letter. Write a résumé. Both due next week.

Week 11

In class: First draft cover letters due. Bring one copy for every student to read. Critique on Web sites.
Discussion: drop-off experiences.
Homework: Revise cover letters. Finished résumé due next week. Bring one copy for every student to read. One hundred names due for mailer next week.

Week 12

In class: Revised cover letters due. Final critique on Web sites/portfolios before last class.
Discussion: How to work with galleries; how to find gallery work; online galleries; renting your own space.
Homework: Finish portfolios.

Week 13

In class: Guest lecturer: someone who specializes in licensing (preferably accountant).
Homework: Finish all outstanding work.

Week 14

In class: Discuss miscellaneous topics: model releases, moral rights, student coaching with interview skills, freelance experiences, self-publishing, alternative methodology, health insurance, unions, health in general.
Homework: Finish all outstanding work.

Week 15

In class: Final presentations.

goals and objectives

I went back to art school at the age of 34, after eleven years of working in the public relations field with a business degree. Looking at my classmates who were so young and talented, at first I felt as if I had wasted half of my life figuring out what I wanted to do. Eventually, when I started rebuilding my life as a working illustrator around the second year in graduate school, I realized what I had learned in business school and in the business world actually was a big key to building my "small business" (= illustration). At the same time, I was surprised to learn that most undergraduate art students didn't have any knowledge of business, promotion, marketing, or even how to make their portfolios.

As an illustrator who has experienced both the side of hiring and being an illustrator, I felt it was my mission to teach young students the importance of being a good businessperson, as well as a good artist. The goal of this class is for students to get the knowledge of the basics (101) of everything a beginning illustrator has to know.

description of classes

Within these seven weeks, there are usually two or three guest speakers. Guest speakers are chosen among younger illustrators who are doing well and have good sense in business, or younger art directors who are illustrator friendly. They talk about their business experience and show their work and portfolio. Past guest speakers included: Maximilian Bode, Marcos Chin, John Hendrix, June Kim, Neil Swaab, and Minh Uong.

Week 1

Introduction: I show my portfolio as a sample of how an illustrator's portfolio should be. How it should be presented, how many pieces of images there has to be, how you include promotional materials in the portfolio.

Homework: Write about five-year plan/goal so they can start to visualize their future. One typed page. (This was given to me as an assignment in graduate school by instructor Mirko Ilic.)

Week 2

Lecture: The importance of applying to competitions. (I usually bring in different illustration competition annuals to show at the same time.) The second half of the class is spent on individual meetings. Students show me their work, so I have a better understanding of who they are and where they are at.

Homework: Write about influences and peers, so that they understand themselves and their work better. One typed page.

Research project entitled "Five publications I want to work for." Students do research projects and bring them back to class to share with classmates.

Week 3

Lecture 1: What is marketing research and how do I do it?

Lecture 2: Good and bad self-promotional materials. (I bring in a bunch of illustrators' and reps' self-promotion to show and discuss with students.)

Homework: Each student has to finish two self-promotional images at the end of the semester. Sketches are due on the fourth week.

Week 4

Lecture: Fine art as a possibility to consider.

Second half of the class is devoted to individual meeting about students' sketches. For con-ed, second half is spent on their research project results.

Homework: Write about dream jobs. One typed page.

Week 5

Demo: Three-hour crash course, "learn how to build a Web site in a day." Discuss what is a good site and what is not. Talk about importance of having a Web site.

Demo: HTML Web site building using Dreamweaver.

Week 6

Lecture 1: Basic knowledge in invoice, contract, fee negotiation, and freelancers' tax.

Lecture 2: "What is an agent, and do I need one?"

Week 7

Lecture: "Meet the art directors." Manners of contacting art directors, dropping off portfolio, and so on.

Individual meetings and review on self-promotional assignment.

An artist cannot speak about his art any more than a plant can discuss horticulture.

—Jean Cocteau, *Newsweek* (1955)

part 2
graduate

COURSE TITLE: COMPUTER ILLUSTRATION PORTFOLIO
INSTRUCTOR: Matthew Richmond
SCHOOL: School of Visual Arts
FREQUENCY: Two semesters, once a week
CREDITS: Six

goals and objectives

As digital illustration processes proliferate, and the Internet as a tool continues to saturate not only the visual art world but also the entire world, an artist's education must include a firm foundation of not only "newer" media and techniques but also the unparalleled artistic and professional benefits these tools make available.

The purpose of this class is to inspire and challenge students to comprehend, debate, and utilize new tools that will either aid them in the creation of new work and/or assist them in producing and distributing their projects and ideas. The course provides an extremely solid foundation covering the origins, basic history, logic of:

- The Internet: Including the Web, e-mail (e-mail clients), the domain registration process, the current global name-server system, file transfer, and peer-to-peer networking tools.
- Hardware and software: Covering computer systems and accessories (scanners, drawing tablets, cameras, hard drives, portable music players, and media) as well as commercial and open-source applications and software packages.

This class succeeds by alleviating the fear and frustration often associated with the complexity of computers, by removing the computer from the beginning of the creation process until such time that, together as a group, we learn how and why each individual student might utilize these newer media and techniques.

description of classes

All lectures, projects, and assignments are aimed at the needs of illustrators and designers interested and involved with story telling. Students receive advanced knowledge and hands-on training in:

- Digital design and illustration tools and processes: including Adobe Photoshop, Adobe Illustrator, Macromedia Flash, type tools, and supporting utilities.
- Self-promotion systems: Discussions and projects will cover Web sites, online and offline mailing lists, postcards, business cards,

228

promotional items, and all corresponding workflows, including online file compression and processing as well as offset printing practices and tips.

- Competent design: As the sole proprietor of an individual online and offline visual identity, an illustrator needs to be somewhat of a jack-of-all-trades. Students will be educated in competent typeface selection and time-tested grid-based layout and print designs.

Week 1

As we begin to rationalize computers as tools, it's important that we look at what those tools are capable of making. In a constantly shifting medium that is barely a decade old, we have no real history on which to base our shift in perceptions. Together as a group, we will attempt to define how the current state of the computer/network impacts your lives as artists.

We will briefly be discussing hypertext, tools like Dreamweaver/Golive and other HTML editors during today's class. Basic HTML links are ideal (feel free to add Flash, gifs, jpegs, or javascript if you can). For the next class, purchase and read *The Medium is the Massage* by Marshall McLuhan and Quentin Fiore.

For the next class, you are required to find, list, and present the following six items:

1. A URL or project you find experimental
2. A URL or project you find useful
3. A URL or project which is designed well
4. A URL or project which is not designed well
5. A digital illustration
6. A URL or project you wish you had made.

Spend an hour or so looking at what other people are making on the Web. You can't expect others to care about your projects if you are not looking at theirs. The purpose of this exercise is to identify your level of association with computers/networks.

Week 2

Discuss Assignment 1
Create and scan two new drawings that we will color in Photoshop.

- Each drawing should be 4" × 4".
- Each drawing should be black and white.
- One drawing should be high-contrast line work.
- One drawing should be grayscale with some shading.

Scanning instructions: minimum 600 ppi grayscale.

The source of your inspiration for these drawings will be two separate spreads or pages from the *The Medium is the Massage*. You are not allowed to select a spread or page containing fewer than forty words.

Week 3

Part 1: Below you will see a 4" square; you will use this to do three drawings (linework) that make one composition. Each drawing will represent a layer within your composition (foreground, middleground, background). Scan your work at 300 ppi and bring it in prepped and ready to go as three 4" files. You may use any scannable surface you wish. (Bring the originals in with you.)

Part 2: Bring either a digital photo or a scan of a photo of yourself (a head-shot, or well-lit image of your face). I will be showing you a few Photoshop tricks. I will explain more in class. This is powerful stuff, so take this request seriously. The alternative is me taking a photo of you in class.

Week 4

Your assignment last week was to draw at least three layers that were to be composed into one file/piece. Use the Photoshop techniques discussed in today's class to build out three variations of your composition.

Next week, bring with you to class three 300 × 300 ppi files at 4" × 4", and consider the following while producing variations of your composition:

- Color, texture, line weight
- Position and scale
- Can you shift the viewer's perception of your drawing?

In keeping with the topics discussed: your Photoshop files will be examined, try to work cleanly and efficiently. You are not permitted to draw or scan any additional source art for your compositions, bring the original drawings with you.

Week 5

As we started working in Photoshop, you were asked to create two new drawings (Assignment 2)—one line art and one continuous tone. The source of your inspiration was two separate spreads or pages from *The Medium is the Massage*; you were not allowed to select a spread or page containing fewer than 40 words.

Your assignment for next week is to select a third spread or page (same rules as above), create and digitally color a new drawing. You will use the lessons learned in today's class to build a new composition as well as print it out. Bring with you to class next week:

- Your drawing (or drawings)
- A 300 x 300 ppi psd file at 4" × 4"
- A high-quality print of your 4" × 4" file centered on letter-sized high-quality paper.

I urge you to build out your composition using multiple initial drawing layers (background, foreground, etc.) and composing them digitally using layers, layer groups, and layer masks. We will be looking at your digital files and prints to point out any successes or failures.

Week 6

Now that you have a fairly strong Photoshop foundation, your final Photoshop-only project is yet another composition.

For next week, you will create a narrative composition titled "Storm" using found elements. Bring one Photoshop file with you to class next week:

- 300 × 300 ppi RGB psd file at 4" × 4"
- your file should not be flattened, but chock full of layers and silhouetted stacks.
- your file must contain background/foreground objects and layers.

You are encouraged to use/take photographs, scan photographs, scan textures, silhouette scanned art. Anything created (drawn or painted) by hand, a photo of anything (drawn or painted) by hand, or any weather-related imagery are off-limits.

Week 7

The ability to efficiently compress images for the Web or e-mail is the cornerstone of every online project, portfolio, or e-mail. Now that we have discussed the making of things in Photoshop, we need to focus on the compression and distribution. This week, we put on our technician hats to compress images and make some useful actions/droplets. For class next week, you will bring the following:

- A high-res (4" × 4" 300 dpi) continuous-tone bitmap image and a compressed 72 dpi jpeg version.
- A high-res (4" × 4" 300 dpi) graphic bitmap image and a compressed 72 dpi gif version.
- Two useful actions containing a minimum of six steps that we can use next week in class.

A compressed version of any image is one in which file size is as small as possible without unacceptable image degradation. We will be comparing your before and after images!

Week 8

This week's discussion has been a two-prong approach to Web graphics. How to make your digital files as small as possible for quick delivery, and the wonderful world of gif animation.

The ability to efficiently compress images for the Web or e-mail is the cornerstone of every online project, portfolio, or e-mail. For next week, the first part of your assignment is to make ten "perfectly compressed" examples of your work. Go through your current portfolio and bring in:

- JPEG files not to exceed 600 × 600 pixels
- GIF files not to exceed 600 × 600 pixels (hint: pick projects that lend themselves to the right kind of compression).

Part two of your assignment is a new composition. This time you will scan, color, and then animate your project in image-ready. Your topic is "snacks."

Bring in one image-ready PSD file and the exported gif at 300 × 300 pixels, at least twenty frames.

Week 9

As you have seen in today's class, Adobe Illustrator is quite different than Photoshop. Regardless of your preferred method of working digitally, Illustrator is a large part of an illustrator's and designer's workflow.

Your assignment is a short, fun (albeit frustrating) one. We are going to do one of the hardest things you could do in Adobe Illustrator—I want you to draw a still life. For next week, find an object or setting that relates to a holiday and draw it in Illustrator, in color (while you are sitting at the computer, with the mouse or tablet!). I don't want traced images or scans, I expect you to use the pencil tool, brush tool, and potentially the Live Paint feature to draw a still life.

Week 10

This week's Illustrator discussion should have cleared up a lot of its strengths/weaknesses (as well as showed you some of the preferred workflows). Illustrator has the majority of the advantages, yet it requires a lot more time and intricacy over other applications.

For next week, you will make a new illustration (in Illustrator). Your theme is "transport." You are expected to use the layer approach to building a digital composition (foreground, background, etc.) And bring in sketches of your composition with: Bring one layered 4" × 4" Illustrator file. Your file should not be flat, but chock full of layers. Your file must contain background/foreground objects and layers.

The goal here is to make Illustrator look the way you want it to (hence starting with a sketch), not vice versa. How close can you get to making an Illustrator file look like the rest of your work?

Week 11

The goal of the initial projects that await you this semester is to quickly develop your awareness of a personal identity, while establishing a brand system that you can use to quickly create additional schwag. Today, in the studio we will be looking at and discussing identity systems.

i·den·ti·ty: *The distinct personality of an individual regarded as a persisting entity; individuality; the set of behavioral or personal characteristics by which an individual is recognizable as a member of a group.*

Your assignment will be to design and produce (print and trim) two post card designs. Select two of your illustrations for the front (this works best if you try and go for a range within your edit; experiment with typography, color, and the treat-

ment of everything). Postcards have backs; each of your two design treatments should have a matching back. It's up to you if the back of your postcard has additional art or just typography. Create two different designs that work well with both. That's production on four postcards total; different means not the same!

Postcards cost more when you print full color on both sides (we will discuss the printing costs as we critique). Use standard sizes, since square postcards are more expensive to mail.

Week 12

Your business card is quite often your visual first impression, a chance to impress future friends, patrons, and clients with your skills and clarity. Now that we have used the postcards to start a formal dialog between your identity and your work, it's time to trim off 70 percent of your working area and identify what's left.

Your business card should be a perfect blend of form and function. You are handing off a functional document that should inspire people to contact you. It should inform them as to how you prefer to be contacted.

For next week, you are to bring to class any changes to your postcard that you feel need to be made as well as four separate trimmed business card comps. A "standard" business card is 3.5" × 2"; you can stray from the standard but you will have to explain why. We will discuss the costs associated with printing or making 500 cards. Use both sides, 4/1 or 4/4, or spot color is up to you. Have fun, play with layout, composition, and a sample of your work.

**COURSE TITLE: PLEIN-AIR PAINTING
AND LOCATION DRAWING
INSTRUCTOR: Cliff Cramp
SCHOOL: California State University, Fullerton
FREQUENCY: One semester, once a week
CREDITS: Three**

goals and objectives

Advanced painting and drawing course that explores the theory and practice of representational art as applied to study of landscape as a subject. The research of drawing and painting concepts, of fundamentals and of historical precedents are stressed in this on-location course.

Students should seek to achieve an understanding of drawing, painting, and design strategies as they apply to landscape representation, including their learning to implement and discuss paint application; local, interpretive, and arbitrary color; the effects of light; and texture, movement, linear, and atmospheric perspective. They should also develop an understanding of compositional arrangement; historical stylistic movements; and an awareness of current trends in landscape painting through exposure to exhibitions by contemporary artists working in this genre.

course requirements

Your required assignments will include:

- A completed sketchbook journal: Sketchbook is used in every class. You will record throughout the semester your lecture notes, observational sketches, and conceptual studies for later use in finished paintings. Please draw fast and furious during the first half of the semester so when crunch time comes, you won't be filled with regrets.
- A minimum of twelve completed paintings of at least five sky studies, five texture studies, and two tree studies.
- A ten-page paper about a historically significant landscape painter or a compare-and-contrast paper dealing with regional and/or artistic differences.

grading

Regular class attendance is required. Semester exercises and projects are evaluated on the quality of concepts relative to intent of the painting and the quality of understanding and skill demonstrated in the craft. Semester grade will be based on the following:

- Finished art: 45 percent
- Sketchbook: 25 percent
- Preliminary studies/exercises: 10 percent
- Paper: 10 percent

required reading

Composition of Outdoor Painting, by Edgar Payne
Painting Better Landscapes, by Margaret Kessler

recommended reading

Fill Your Paintings with Light and Color, by Kevin MacPherson
Carlson's Guide to Landscape Painting, by John Carlson
The Artistic Anatomy of Trees, by Rex Cole
Drawing Scenery, by Jack Hamm
The California Impressionists, by Irvine Museum

description of classes

Week 1: Introduction

Lecture: "Landscape Composition"—design of a painting
Painting Demonstration: Discuss paint application—transparent and
 opaque qualities

Week 2: Location Painting: Seascape

Lecture: "Landscape Composition, Part 2"—discuss the design of a painting
Painting Demonstration: Hard and soft edges—blocking in the painting
Recommended Reading: *Composition of Outdoor Painting* by Edgar Payne,
 chapter 1

Week 3: Location Painting: Seascape

Lecture: "Creating Depth"—discuss atmospheric, linear, and color perspective
Painting Demonstration: Capturing movement in water
Recommended Reading: *Composition of Outdoor Painting* by Edgar Payne,
 pp. 27–48

Week 4: Location Painting: Seascape

Lecture: "Color and Value"—discuss hue intensity, tint, and shade in the landscape
Painting Demonstration: Reflection—open spaces
Recommended Reading: *Composition of Outdoor Painting* by Edgar Payne, pp. 49–70
Group Critique: 2:00–3:45

Week 5: Location Painting: Wetlands

Lecture: "Color and Value, Part 2"—discuss hue intensity, tint and shade
Painting Demonstration: Shapes to specific form
Recommended Reading: *Composition of Outdoor Painting* by Edgar Payne, pp. 71–104

Week 6: Location Painting: Inland

Lecture: "Silhouette"—discuss shape and form
Painting Demonstration: Shapes to specific form—trees and foliage
Recommended Reading: *Composition of Outdoor Painting* by Edgar Payne, pp. 105–128

Week 7: Location Painting: Inland

Lecture: "Color Strategies"—discuss local, interpretive, and arbitrary color; light
Painting Demonstration: Light—trees and foliage
Recommended Reading: *Composition of Outdoor Painting* by Edgar Payne, pp. 129–154
Group Critique: 2:00–3:45

Week 8: Location Painting: Inland

Lecture: No lecture
Painting Demonstration: Open paint day

Week 9: Mid-term Critique

Six paintings due for grading
Research paper due

Week 10: Location Painting: Inland

Lecture: "Mass"—discuss the importance of linking and massing shapes
Painting Demonstration: Abstracted shapes to specific form
Recommended Reading: *Painting Better Landscapes*, M. Kessler, chapters 1–3

Week 11: Location Painting: Mountains

Lecture: "Rhythm and Repetition"—discuss how to create unity in a painting
Painting Demonstration: Hills, mountains
Recommended Reading: *Painting Better Landscapes*, M. Kessler, chapters 4
and 8
Group Critique: 2:00–3:45

Week 12: Location Painting: Cityscape

Lecture: "Linear Design"—discuss the characteristics of line and the mood
it creates
Painting Demonstration: Blocking in with line and shape
Recommended Reading: *Painting Better Landscapes*, M. Kessler, chapters 9
and 10

Week 13: Location Painting: Cityscape

Lecture: "Tonality and Atmosphere"—discuss how tone and atmosphere
create mood
Painting Demonstration: Buildings
Recommended Reading: *Painting Better Landscapes*, M. Kessler, chapters 11–14

Week 14: Location Painting: Cityscape

Painting Demonstration: Open paint day

Week 15: Final Critique

Final six paintings due—Eight for graduate students

Week 16: Final Portfolio Due

Instructor-to-student critiques will occur during each painting session.
This schedule is subject to change based on the needs of the class.

COURSE TITLE: HISTORY OF AMERICAN ILLUSTRATION
INSTRUCTOR: Christian Hill
SCHOOL: California State University, Fullerton
FREQUENCY: One semester, once a week
CREDITS: Three

goals and objectives

This course focuses on the history and aesthetics of illustration in the United States from the American Revolution to the present. The class content will cover illustration in its various forms (editorial, commercial, narrative, decorative, fashion, etc.). To better understand the work presented in class, the course includes reviews of social, political, and cultural events and trends.

The learning goals of this course consist of introducing illustrators from the past and from the present who have made significant contributions to the field through their style, technique, philosophy, vision, or teaching. Appreciating the chronology of the history of American illustration, and the technological and cultural factors that influence it. Considering the place of illustration relative to other visual arts. Learning about the main branches within the field of illustration. And finally, evaluating the stakes in contemporary trends and controversies affecting the world of illustration, such as the defense of copyrights, the cultural and historical impact of images, concepts of national visual identity, global audiences, and more.

238

grading

- Field exposure: 10 percent
- Class presentation: 15 percent
- Paper: 20 percent
- Quizzes: 40 percent
- Final exam: 15 percent

required reading

Illustrator in America, 1860–2000, by Walt Reed

course requirements

Field exposure: One museum visit (where works of illustration are on display), documenting searches on the Internet for contemporary illustrators, and sharing them with the class

Class presentation and paper: Introduce the class to past illustrators with an oral presentation accompanied by a slideshow (PowerPoint preferred). In the paper, focus on analyzing those illustrators' uniqueness and if, why, and how they have made a significant contribution to the field of illustration by comparing them to preceding generations of artists and to their contemporaries, and by assessing how they influenced others.
Class exams: Four quizzes and one final exam

description of classes

Week 1
Introduction

Week 2
Definition of illustration
Survey of the history of American media (1750s to the present)
Basics of semiotics

Week 3
Definition of the types of illustration
Editorial and journalistic illustration: Thomas Nast, Frederic Remington, Winslow Homer, Tracy Sugarman, Joe Sacco

Week 4
F.O.C. Darley, Edwin Austin Abbey, Will H. Bradley

Week 5
The Golden Age of Illustration (1): Charles Dana Gibson, Joseph Clement Cole, Coles Phillips

Week 6
The Golden Age of Illustration (2): J.C. Leyendecker, Erté, John Held Jr., Maxfield Parrish

Week 7
Narrative Illustration (1): Howard Pyle, Frank Schoonover, Harvey Dunn

Week 8
Narrative Illustration (2): N.C. Wyeth, Dean Cornwell, Howard Chandler Christie, Jessie Willcox Smith, Elizabeth Shippen Green

Week 9
Lifestyle Illustration: Norman Rockwell, Coby Whitmore, Patrick Nagel, Robert McGinnis, Mead Schaeffer

Week 10
Portrait, Caricature, and Characters: Al Hirshfeld, C.F. Payne, Noli Novak, Steve Silver

Week 11
Conceptual Illustration: Milton Glazer, Robert Peak, Saul Bass, Saul Steinberg

Week 12
Fantasy, Sci-Fi, and Concept Art: Frank Frazetta, James Allen St. John, John Berkey, Jack Kirby, Chester Bonestell, Syd Mead, Ralph McQuarrie

Week 13
Children's Book Illustration: Dr. Seuss, A.B. Frost, Chris Van Allsburg, David Wiesner

Week 14
Comic Art (1): Winsor McCay, George Herriman, Milton Canniff, Mort Walker

Week 15
Comic Art (2): Will Eisner, Robert Crumb, Art Spiegelman, Chris Ware

Week 16
Class Wrap-Up

COURSE TITLE: CREATIVE WRITING: WRITING FROM
A VISUAL PERSPECTIVE
INSTRUCTOR: Michele Zackheim
SCHOOL: School of Visual Arts
FREQUENCY: Two semesters, once a week
CREDITS: Three

goals and objectives

The main purpose of this class is to individuate the visual art students' voice; and then to teach them how to place it in a context of the literary/visual world. To creatively write well is hard enough; but to write from the visual perspective is unique. To be more precise: to teach writing techniques that emphasize the writing process and help overcome writing barriers; to help students achieve fluency, vividness, depth, and precise expression; to have students become familiar with a variety of fiction, nonfiction, poetry, and playwriting.

description of classes

Every week, students will be assigned a short story. There will be an in-depth discussion at the beginning of each class about the story. Some of the issues to be discussed are: structure of story; psychological meaning of story; philosophy of story; "seeing" the story.

Week 1: Introduction/Metaphors

Discuss the importance of being able to intelligently read and deconstruct an assignment from a client; of writing well; being able to describe one's own work; of being able to read one's work aloud in class; and of being able to speak clearly, enunciate, get to the point.

In-Class Exercise 1

Write one sentence about the color orange. *Read aloud.*
Write one sentence about silence. *Read aloud.*
Write one sentence about rain. *Read aloud.*
(Note: Don't speak about metaphors at the beginning. Once everyone reads, discuss how they naturally used metaphors.)

In-Class Exercise 2

Definition of metaphor: The application of a word or phrase to an object or concept that it does not literally denote, in order to suggest comparison with another object or concept. *Read aloud.*

1. A blue cow is like —————————————————————————
2. An irate rose is like —————————————————————————
3. A delighted spider is like ————————————————————
4. A lost lover is like ——————————————————————————
5. A boring book is like —————————————————————————

In-Class Exercise 3

It is good to fear the worst, morning ——————————————————
Honor the old, teach ———————————————————————————
He who laughs not in the morning ——————————————————
Love, a cough, smoke, and money cannot ——————————————
When a mouse has fallen into the corn, he thinks ——————————
Patriotism is the last refuge of ——————————————————————
A bad penny always ———————————————————————————
Sweet is pleasure ———————————————————————————
A threadbare coat is ———————————— against ——————————
When one hits you with a ——————, hit him back with ——————
It is quiet people who ———————————————————————————
I would rather be a hog than ————————————————————————
The thought has —————— and the pen a ——————————————
Read aloud.

Inform students about the weekly short story assignments.
Assigned story: *Court in the West Eighties* by Carson McCullers

Week 2: Translating Visual Art into Literature

Wander throughout the Metropolitan Museum of Art. When a piece of art
catches your eye, stop and look at it. Does an idea for a story (a play, a poem)
come to mind? If not, move on until you find something that does. Take notes.
Roughly sketch the piece of art. What is it about the piece that "speaks" to you?
Homework: For next week, please bring to class the first paragraph of your
story, along with the sketch. Please type no more than one page into a com-
puter, remembering to double space and allow logical margins. And spell check!
There will be three drafts, with the last one due at the end of the semester.

Week 3: Fiction Writing

Turn in first draft of museum story.
Discuss *Court in the West Eighties* by Carson McCullers.
Lecture on fiction writing: How writers need to "draw" a sociological,
 psychological, and historical picture of the people they are writing about;
 How writers need to intimately know their characters.
Discuss: Hand out list of characteristics to determine when writing fiction:

- Gender
- Birth date
- Birth place
- Physical characteristics
- Parents (names, ages, professions, etc.)
- Politics of the world at the time of birth
- Politics of the world at the time of the story
- Politics of the country and the town
- Siblings (names, ages, genders, professions, etc.)
- Religion
- Financial situation
- Expectations from family
- Expectations from community
- Preferences
 - Food
 - Music
 - Art
 - Reading
 - Sports
 - Type of friends
- Trauma in the home
- Trauma in the world

In-Class Exercise 1

Write one visual line about each of the following sounds: a garbage truck on a small street; an electric drill in the next apartment; an off-key cello; a pigeon on your windowsill. *Read aloud.*

In-Class Exercise 2

Write one visual line about each of the following smells: a rose; a freshly mowed field; a candy factory; a laundry. *Read aloud.*

In-Class Exercise 3

Write one visual line about each of the following feelings: being pricked by a rose thorn; seeing an old lover; biting down on a piece of chocolate; putting on a warm coat in freezing weather. *Read aloud.*

In-Class Exercise 4

Choose one of the lines you wrote and extend it into a short story, no longer than one page. *Read aloud.*

In-Class Exercise 5

Write a first-person, past-tense description of the "invisible wind." Somewhere in the piece, use metaphors for the image of a rose, the color red, and the smell of dust. *Read aloud.*

Assigned story: *Rashomon*, by Ryunosuke Akutagawa

Week 4: Imagination

Discuss *Rashomon* by Ryunosuke Akutagawa

In-Class Exercise 1

Write the color of the story.
Write the smells of the story.
Write the sounds of the story.
What is the psychology of the story?
What is the philosophy of the story?

In-Class Exercise 2

The students are asked to write their own ending to *Rashomon*. Keep in mind the place and time. Hand out sheet with last line of the story. ". . . shortly after that the hag raised up her body from the corpses. Grumbling and groaning, she crawled to the top stair by the still flickering torchlight, and through the gray hair which hung over her face, she . . ." *Read aloud.*

In-Class Exercise 3

Hand out *The Brothers Karamazov* sheet. A paragraph from the book has been copied, leaving out key words. Fill in the blanks.

The Brothers Karamazov, by Fyodor Dostoyevsky

Dimitri, a young man of twenty-eight, of _____ height and _____ appearance, looked _____ than he was. He was _____ and _____. Yet there was something not _____ about his face. It was rather _____, his cheeks were _____ and his complexion _____. His large, _____, dark eyes had an expression of _____, and yet there was a _____ look in them too. Even when he was _____ and talking _____, his eyes somehow did not follow his _____, but betrayed something else, sometimes quite _____ with what he was saying. "It's hard to tell what he's thinking," many said. People who saw something _____ and _____ in his eyes were _____ by his sudden laugh, which revealed _____ thoughts while his eyes seemed so _____. A certain _____ look in his face was _____ to understand at such a moment. Everyone knew, or had heard of the _____ and dissipated life which he had been leading of late, as well as the _____ anger which he had _____ in his quarrels with his father. There were several stories in the town about it. It is true that he was _____ by nature, "of an _____ and _____ mind," as our justice of the peace, Katchalnikov, described him.
Read aloud.

The instructor reads aloud the original, and the class discusses the differences of perceptions.

Assigned story: *Let the Old Make Room for the Young Dead*, by Milan Kundera

Week 5: Writing from a Psychological Perspective

Discuss *Let the Old Make Room for the Young Dead* by Milan Kundera.
Hand out Psychological Profile Test. This is a simple test to encourage the students to be aware of people's nuances. They do not read the results aloud.
Talk about how to determine a character's psychology or character.

In-Class Exercise 1

Hand out photocopy of a postcard from Berlin of three people and a motorcycle.
Discussion: history of Germany in 1930. Write a profile of each of the people in the photograph. Choose one of the people to be your main character. Flesh this character out. Make notes.

In-Class Exercise 2

Write a story about the people in the postcard. *Read aloud.*
Assigned story: *A Temporary Matter*, by Jhumpa Lahiri

Week 6: Allegory

Discuss *A Temporary Matter* by Jhumpa Lahiri
Talk about the émigré experience in America and story telling.
Discussion: Allegory is a form of extended metaphor, in which objects, persons and actions in a narrative are equated with the meanings that lie outside the narrative itself. The underlying meaning has moral social, religious, or political significance. Characters are often personifications of abstract ideas, such as charity, greed, or envy. Thus an allegory is a story with two meanings—a literal meaning and a symbolic meaning. Examples: *Moby Dick* by Melville; *Aesop's Fables*; *Lord of the Flies* by Golding; *Animal Farm* by George Orwell; *The Seventh Seal* by Ingmar Bergman. The blindfolded figure with scales is an allegory of justice.

245

In-Class Exercise 1: Writing dialogue in the first person, present tense

Write a dialogue between a bolt of lighting and an old oak tree.
Write a dialogue between a wheel and the road.
Write a dialogue between a man and a woman who are sitting on a wall overlooking the sea. *Read aloud.*

In-Class Exercise 2: Writing dialogue in the first person, past tense

Write a dialogue between a grizzly bear and a seagull about the weather.
Write a dialogue between the Pluto and a star about the earth.
Write a dialogue between a man and woman about soccer.
Read aloud.

In-Class Exercise 3

Finish the following lines and add two more to make a complete thought.

- I walked across the mountain and smelled . . .
- I am sitting in an airplane and hearing . . .

• I looked out the window from the top of the Empire State Building and saw . . .
Read aloud.

In-Class Exercise 4

A woman enters a burial ground. She sees, far off in the distance, a man kneeling before a grave. There is something odd about the scene. As she walks toward him, she becomes anxious. Write a story from the woman's point of view.
Read aloud.

Assigned story: *Yellow Woman*, by Leslie Marmon Silko

Week 7: Dialogue and Finding Beauty in an Unpleasant Subject

Discuss *Yellow Woman* by Leslie Marmon Silko
Hand out photocopied image of Medusa. Medusa, in classical mythology, was the chief of the Gorgons. Legend says that she was a beautiful maiden, especially famous for her hair. But she dared to vie in beauty with Minerva, who thereupon transformed her hair into serpents and made her face so terrible that all who looked on it were turned to stone. (Minerva was the Roman goddess of wisdom and patroness of the arts and trades.)

Speak about how to write about ugliness; murder and mayhem; personally fearful stories, and so on. How to imply ugliness, rather than being too descriptive.

In-Class Exercise 1

Describe Medusa's personality when she was young.
Describe her physical characteristics before the violation.
Describe how she lived the rest of her life, considering she had snakes as hair.
Write a story based on your notes/descriptions.
Read aloud.

In-Class Exercise 2

Write a one-page ghost story about an ogre and a butterfly.
Read aloud.

Discuss how to write an essay. Research:

• The original city and country from which the subject's family came.
• The history of the world at the time of the subject's birth.
• The history of the village/town/city where the subject was born.

Write a two-page typed essay.

Assigned stories: *Mother Tongue*, by Amy Tan and *An Occurrence at Owl Creek Bridge*, by Ambrose Bierce

Week 8: New York Public Library/Reference

Meet at New York Public Library. Give students a short tour. Instructor sits at the back in the reading room and helps, when necessary.

Week 9: Essay Writing

Discuss. *Mother Tongue* by Amy Tan and *An Occurrence at Owl Creek Bridge* by Ambrose Bierce.

Discuss the library research. Talk about the idea of surprise in writing. *Students to read their essays.*

In-Class Exercise 1

Students are to exchange the essay with a person sitting beside them. Read and take notes.

- Was it clear? Was it unclear?
- Was it interesting? Was it boring?
- What was missing?
- Was there too much of one idea? Not enough?
- Could you "see" the story, or was it too black and white?
- Were you emotionally involved?
- Did you care what happened to the people, or did it leave you indifferent?

Give your notes to the other person. Each student is to discuss his or her notes with the class.

Assigned story: *The Lecture*, by Isaac Bashevis Singer

Week 10: Criticism

Discuss *The Lecture*, by Isaac Bashevis Singer
(Please note: I try to present this class after an evening spent at the theatre. It can fall anywhere in the first semester.)

In-Class Exercise 1

Hand out a photocopy of a February 1903 letter from *Letters to a Young Poet* by Rainer Marie Rilke. Ask students to read. Discuss criticism. Discuss being glib versus quick witted. Discuss how to deconstruct the criticism. How to make it clear. How to find the good in a piece. What to do about the bad.

Read aloud a John Leonard piece about ". . . some hard-won guidelines for responsible reviewing. First, as in Hippocrates, do no harm. Second, never stoop to score a point or bite an ankle. Third, always understand that in this symbiosis, you are the parasite. Fourth, look with an open heart and mind at every different kind of book with every change of emotional weather because we are reading for our lives and that could be love gone out the window or a

horseman on the roof. Fifth, use theory only as a periscope or a trampoline, never a panopticon, a crib sheet or a license to kill. Sixth, let a hundred Harolds Bloom."

Ask students to comment on reviews they have read about their work.

In-Class Exercise 2

Write a review about the play. Questions that need to be answered in a review.
When did the story take place?
Where did the story take place?
What did you like about the story? Why?
What didn't you like about the story? Why?
What did the story mean to you, both historically and personally?
Would you recommend the story to others? Why?
Read aloud.
Assigned story: *The Cloak*, by Isak Dinesen

Week 11: Individual Student Meetings

Week 12: Editorial

Discuss *The Cloak* by Isak Dinesen
Discuss writing an op-ed piece/essay.

In-Class Exercise 1

Hand out a photocopied collection of five current news stories. Ask students to read them and choose the one they are most interested in.

In-Class Exercise 2

Writing an op-ed essay. Choose a subject that concerns you; one that you intensely care about. Write your point (statement) in an interesting way. Pretend it is a headline. Support your statement with facts, anecdotes, statistics. Write tightly. Avoid jargon. Write simply and clearly. Focus on your point. Don't wander. If your essay lends itself, try humor. Don't be afraid to be personal, especially if it makes the point. Don't be afraid to be controversial, but don't be outrageous. Be careful about being fanatical. Offer an intelligent recommendation or conclusion.
Read aloud.

In-Class Exercise 3

Pass the op-ed essay to the person to your right. Now write a letter to the editor in response to the op-ed piece. Carefully read the op-ed piece. Do you agree with the writer? Why do you agree? Do you disagree with the writer? Why? Write the letter. Make your language clear. Be interesting. Be short. Get to your point quickly. *Read aloud.*
Assigned story: *Hunters in the Snow*, by Tobias Wolff

Week 13: Armchair Traveler

Discuss *Hunters in the Snow* by Tobias Wolff

Discuss "lie the truth." When writing about some topics, some of the time you can't tell the truth. This is the conflict of art and real life. Discuss how to write from an informed place—that is, research; but how to write it in an interesting way.

In-Class Exercise 1

Hand out photocopies of information about nineteen different places in the world to the students. Ask students to pretend that they are armchair travelers. Make notes on the following:

Have you ever been to this geographical place?

If not, how do you see it? Arid, mountains, sea, and so on.

How does it smell? Food? Land?

What sounds do you hear? City life? Rural?

Who are the people that live there? Is there a common religion?

Why do you find this place interesting?

In-Class Exercise 2

Write a story about your adventure.

In-Class Exercise 3

Exchange stories. Edit and pass back. Rewrite.
Read aloud.

Assigned story: *Patriotism*, by Yukio Mishima

Week 14: Comedy!

Discuss *Patriotism* by Yukio Mishima

Comedy! As Molly Ivins says, "Being earnest about humor is deadly—if you have to explain a joke, you kill it."

Talk about humor, irony, satire, wit, and the laws of comedy writing: You have to be able to throw out the best joke if it doesn't work as a whole. If you don't laugh, nobody else will. Character is a large part of comedy writing. Timing is an even larger part.

In-Class Exercise 1

Write one funny line about each of the following: a girlfriend; a coffee cup; a dog. *Read aloud.*

In-Class Exercise 2

Hand out *New Yorker* cartoons, without the punch lines. Write the punch lines. *Read aloud.*

In-Class Exercise 3

Write a one-page story about something funny that really happened in your life. Use dialogue.

Read aloud.

Assigned story: *Santaland Diaries* by David Sedaris

Week 15: Comedy, Too!

Discuss *Santaland Diaries* by David Sedaris

In-Class Exercise 1

Write a Christmas story. You are dressed as Santa Claus and standing outside
Saks Fifth Avenue collecting money for the Salvation Army. A young
woman comes up to you and asks you for money.

Include the following in your story: The weather; how the Santa Claus suit fits;
how you feel about the holiday; how evergreens smell in New York City;
a major conflict. *Read aloud.*

In-Class Exercise 2

Write a paragraph about wanting a particular gift and not getting it, and how it
felt. Even though this is a short piece, be conscious of writing in an artful way.
Read aloud.

Assigned story: *Sonny's Blues*, by James Baldwin

Week 16: Descriptive Writing

Discuss *Sonny's Blues* by James Baldwin

Discuss book project. You must be able to identify the heart of your book and
write it artfully; the same with the philosophy behind the book.

In-Class Exercise 1

How to describe in words what you are going to draw. Meaning: to be able to
describe your style of drawing. Write what you are going to draw for the book
project. *Read aloud.*

Give students a sheet of paper with each student's name on it. Instruct
them to take notes while the descriptions are being read. At the end of the
reading, go around the room and ask students to read their notes. If there is not
enough time, ask them to read the notes of the person their right. Give all the
students their notes back.

In-Class Exercise 2

Write each of the following:

What is your book about?

When does the story take place?

Where does the story take place?

Why is the story happening?

What is the philosophy of the book?

Why did you choose the subject?

Describe your style of drawing.

Write a "catchy" first line for the book proposal.
Write a paragraph to turn in to instructors.
Assigned reading: An interview with Robert Frost from the *Paris Review* by Richard Poirier

Week 17: Poetry

Discuss an interview with Robert Frost from the *Paris Review* by Richard Poirier. Hand out *The Road Not Taken* and read aloud. Show movie: *Robert Frost: A Lover's Quarrel With the World*. Discuss.

In-Class Exercise 1

As you are watching the film, jot down ideas for a poem. Does Robert Frost's work "speak" to you? How? Write a four-line poem in response to the film using your noted ideas. *Read aloud.*

In-Class Exercise 2

Write "the road not taken" on a sheet of paper. Now continue the poem, writing in four-line stanzas. *Read aloud.*

In-Class Exercise 3

Write a poem about a childhood memory. Use specific imagery—feelings, sights, sounds, smells, touches, and taste. Bring the reader into the memory. *Read aloud.*

251

 Hand out a collection of poems by Sharon Olds, Sylvia Plath, Philip Booth, Sappho, Ezra Pound, Paul Celan, Seamus Heaney, Emily Dickinson, Stanley Kunitz, Arthur Rimbaud, Buson, Issa, Yeats, John Berryman, Carolyn Forché, Mary Oliver, Allen Ginsberg, Mahmaud Darwish, Edna St. Vincent Millay, and Galway Kinnell.
Assigned reading: Each student is to pick his or her favorite poem for next week.

Week 18: Poetry and Writing With Color

Discuss the collection of poetry that was handed out last week. Talk about the differences and the similarities between the poems. Have each person read aloud his or her favorite poem.

In-Class Exercise 1

Deconstruct your favorite poet's poem. Reread the poem.
What are the feelings of the poet?
What are the images the poet uses?
Where does the poem take place?
When does the poem take place?
What story is the poet trying to tell?
What lessons/philosophy is the poet considering?

In-Class Exercise 2

Using your favorite poet as your teacher, write a poem in the same style. The subject of the poem needs to be about nature, love, hope, despair, or death. *Read aloud.*

In-Class Exercise 3

Make a list of the images that are associated with a favorite color.
Make a list of the symbols that are associated with the color.
Make a list of the personal associations the color holds for you.
Write a poem in which the name of this color is used.
Read aloud.
Assigned reading: *Another Time*, by Edna O'Brien

Week 19: Poetry from a Postcard

Discuss *Another Time* by Edna O'Brien
About one hundred postcards are spread out on tables. Each student is to choose the one he or she likes best.

In-Class Exercise 1

Study the postcard. Take a voice from the picture and assume it as your own. Write what you see in the postcard in as much detail as possible—narrating so that we can literally see what you are talking about. Then answer the following questions.
Is it a male or female voice?
What era and where?
Why did you choose it?
What does it say to you?
Do you relate to it in real life or in your imagination?
What colors do you see in the picture?
What smells can you conjure?
Is there music? Tune in to the rhythms and diction of the character's speech.

In-Class Exercise 2

Write a poem and choose one of the following perspectives or points of view:
Speak the poem as the photographer or painter.
Speak the poem as someone or something in the postcard.
Address the poem to the artist.
Read aloud.

In-Class Exercise 3

Choose one of the following perspectives concerning the manipulation of time.
Write a poem about what happened just before the postcard painting or photo-
graph was made.
Write a poem about what happened just after the painting or the photograph
was taken.

Write a poem as if you were planning to take the photograph or paint the picture. *Read aloud.*
Assigned story: *The Conjurer Made Off with the Dish*, by Naguib Mahfouz

Week 20: Guest Lecturer/Poetry
Discuss *The Conjurer Made Off with the Dish* by Naguib Mahfouz.
Next week's class is devoted to individual meetings to discuss the student's book project.
Assigned story: *Sweat*, by Zora Neale Hurston

Week 21: Individual Meetings

Week 22: Writing Poetry to Music or the subject being Love
Discuss *Sweat* by Zora Neale Hurston

I try to apply colors like words that shape poems, like notes that shape music.—Miro
Listen to music. Being aware of tempo and pacing, write a short poem about each of the following:

In-Class Exercise 1
Read first poem to classical music. Subject: Being alone

In-Class Exercise 2
Read second poem to jazz. Subject: Alone in a bar

253

In-Class Exercise 3
Read third poem to country and western. Subject: Longing for the wide-open spaces

In-Class Exercise 4
Read fourth poem to mambo. Subject: An urban love affair

In-Class Exercise 5
Write a poem taking two musical instruments as your main characters. The instruments need to be imbued with human attributes. At the beginning of the poem, give the instruments a gender, a hairstyle, a perfume, and a way of dressing. In the poem, you must describe movement with language. *Read aloud.*
Assigned story: *The Life of the Imagination*, by Nadine Gordimer

Week 23: Writing the Memoir
Discuss *The Life of the Imagination* by Nadine Gordimer
A memoir asks us to write honestly about our lives. This writing requires us to refine our artistic skills so we can effectively communicate the hard-won, deep layers of truth that are rarely part of conventional social discourse. Discuss with class.

In-Class Exercise 1

The main idea of this project is to write one's life—capturing one's essence through events, both internal and external. Write in three sections:

Childhood: This will set the tone for the piece—so be aware that the psychological milieu, which is your history, will forever color your life. Try to begin the piece with a life-changing experience—whether it was traumatic or not.

Adulthood: Keep in mind the natural progression of time—that is, love, marriage, children, careers, problems—and, of course, rebellion.

Old age: Project your life ahead as if you have lived to be ninety years old. You must keep in mind that whatever way you see yourself at ninety, you must be the same person that you were as a child and an adult.
Read aloud.

Assigned stories: *Death Constant Beyond Love* and *Someone Has Been Disarranging These Roses*, by Gabriel García Márquez

Week 24: Memoir Writing, Continued

Discuss *Death Constant Beyond Love* and *Someone Has Been Disarranging These Roses* by Gabriel García Márquez

In-Class Exercise 1

Write about someone from your past who made you feel that your work was not only good, but important.

In-Class Exercise 2

Write about someone from your past who made you feel that your work was not important, maybe a waste of time. *Read both aloud.*

In-Class Exercise 3

Write a portrait from someone you intensely dislike—knowing he or she will never read it. *Read aloud.*

In-Class Exercise 4

Write a portrait of how you see yourself in ten years. Try to be realistic, taking into account all you know about yourself.
Read aloud.

Assigned reading: *They're Not Your Husband*, by Raymond Carver

Week 25: How to Conduct an Interview and How to be Interviewed

Discuss *They're Not Your Husband* by Raymond Carver
This class is in preparation for learning to write about one's own work.
Students interview each other in groups of two.

In-Class Exercise 1

Interview questions:

Where do you come from?

What languages, beside English, do you speak? Are you fluent?

Do you think that where you come from influences your art? Why?

What is your philosophy? How does it influence your work?

Why are you attending this master's program?

Who is your favorite "fine arts" artist? Why?

Who is your favorite illustrator? Why?

Who is your favorite writer? Why?

What materials do you use in your art? Why do you choose these materials?

What materials would you like to use in your art . . . but are nervous about using?

How do you use the computer for making art?

Are you interested in using the computer to make art? Why?

Are you not interested in using the computer to make art? Why?

Do you use models to draw from? Why?

Do you use clips from books, and so on? Why?

Approximately how many sketches do you do before doing the finished art?

Which elements most influence your work: Literature? Painting? World events? Television? Movies? Computer games? Explain.

What do you "think" about when you are visualizing a drawing?

How would you describe your art?

Besides an obvious talent, why do want to be an artist?

What would you like to happen in your art career?

For the interviewer: Besides writing down the answers to the above questions, what are your impressions of the person you are interviewing?

At the end of both interviews, students are to look over the notes of the interviewer and ask questions.

In-Class Exercise 2

From this material, students are asked to write one paragraph about their work. The paragraph needs to have an eye-catching first sentence and needs to deal only with the students' art. This paragraph should not be about schooling or jobs held in the past, and so on.

Assigned reading: *Civil Peace*, by Chinua Schebe

Week 26: Children's books

Discuss *Civil Peace* by Chinua Schebe

This class is devoted to a guest writer and illustrator of children's books. The speaker spends the entire class lecturing and then taking questions. Historically, the questions are numerous and intricate. Note: The next class is on writing lyrics. Students are encouraged to bring in musical instruments.

Assigned reading: *Still Life with Watermelon*, by Bobbie Ann Mason

Week 27: Writing Lyrics

Discuss *Still Life with Watermelon* by Bobbie Ann Mason

In-Class Exercise 1

Answer each of the eight areas.

1. Decide who is your audience.

2. Decide the subject of your song, the idea or message you want to convey—and the story it will tell.

3. Write the chorus of the song first. Write it as four sentences. The chorus is a bridge or connection from one verse to the next. From the words in the chorus, find the title of your song.

4. Write the first verse again in sentence form.

5. Write the second verse, keeping in mind the story.

6. Write the third verse, telling more of the story.

7. Write the last verse, bringing it all to a conclusion.

8. Now cast the sentences into lyrical/poetic lines, changing it so as to make it rhyme, somewhat. Each lyric needs to be similar in length so as to make the song move smoothly.

The songs are performed. Last half of class is spent in student meetings, regarding their book projects.

Assigned reading: *Brother*, by Mary Gallagher (a ten-minute play)

Week 28: Writing a Ten-Minute Play

Discuss *Brother* by Mary Gallagher

Ten-minute plays are perfect for small productions. By this time of year the students are comfortable in the class and know each other well. They have had a full range of writing experiences that makes this class not only fun, but filled with good writing. Students are to work in pairs. I assign the pairs.

In-Class Exercise 1

Laying out the play

Theme of play. Name of play can come later.

Reason for play—that is, heart of the play, philosophy.

Determine the two characters

Psychological profiles, including where they come from, age, gender, etc.

Determine where the story is taking place and describe.

Determine when the story is taking place and describe.

Determine why the story is taking place and describe.

If you are going to use props, keep it simple. Describe here.

In-Class Exercise 2

Write the play.

Week 29: Theatrical production

Depending on the number of students, there are approximately nine 10-minute plays, each of which is performed on a stage in the classroom. Since these are visual art students, their theatrical sets are often quite elaborate. They have rehearsed before the class begins. Some of the ten-minute plays use original music.

Week 30: Reading and Party at Instructor's House

Each student is required to read a poem or story.

COURSE TITLE: BOOK SEMINAR

INSTRUCTOR: Viktor Koen

SCHOOL: School of Visual Arts

FREQUENCY: Eight weeks, once a week

CREDITS: Three

goals and objectives

Students will experiment and create a body of works based on the short story "Street of Crocodiles" by Bruno Shaltz. Even though the course title is "book seminar," the students are not confined to the book format. They will outline their ideas in a thesis statement prior to the start of the course. This written statement will serve as a point of departure and later as a point of reference while the work evolves to its final stages.

This project will explore the students' individual technical, aesthetic, and conceptual interests while looking into their future professional direction and specialization. Learning outcomes include:

- ability to evaluate ideas as far as quality, clarity, and impact
- ability to write a cohesive project proposal that serves their visual interests and the subject
- ability to manage time and pragmatically plan a project based on a series of multiple images
- ability to actualize an approved idea to its full potential

description of classes

Week 1

Reading of individual project ideas, discussion and elaboration.

Instructions on the choice of subject treatment and scheduling tips.

Conclusions and reevaluation of individual ideas and scope of projects.

Homework: Final "project proposal" for collection. Ten portfolio images for review. Thumbnail sketches, diagrams, notes, and visual materials.

Week 2

Critique of first sketches. Establishing working titles of works, number of works, installation ideas.

Collection of final "project proposals" (hard copy). Reviews and final changes. Introduction of project-management methods.

Review of preparatory materials and overview of research methods.
Homework: at least three sketches and new thumbnails.

Week 3

Critique of new sketches and corrections of previous sketches, analysis of the
series, technique re-evaluations, corrections.
Choice of first sketch to be finished.
Homework: First finish three corrected final sketches.

Week 4

Critique of first finish. Choice of next images to be finished.
Pragmatic project evaluation and technique adjustments.
Homework: Entire project presentation in finish (at least two), sketches
and thumbnails.

Week 5

Critique of complete projects, in different stages, evaluation of continuity, and
relation between sketches and "project proposals."
Review of new work—relation to work so far and adjustments, identification of
problems on different levels, composition, color, sequence within the series.
If necessary, adjustment of technique to be applied to the rest.
Homework: Overall project corrections, in sketches and finishes.

Week 6

Critique of sketches and complete images.
Production tips/assessment of deadlines/prevention of unpleasant surprises.
Homework: Last sketches and any finishes in process that need review.

Week 7

Reviews of work, execution time calculations and adjustments.
Review of final installation plans, evaluation of images, identification of those
that need to be replaced or drastically changed.
Discussion about development of peripheral items to the projects and introduc-
tion of design aspects in order to widen the scope and apply the images so
far finished.
Homework: Entire project for final review.

Week 8

Installation and presentation of project for final review.
Conclusion and comments on corrections and editing of projects before they
are included in portfolios or promotions.

COURSE TITLE: VISUAL ESSAY SEMINAR

INSTRUCTOR: Marshall Arisman

SCHOOL: School of Visual Arts

FREQUENCY: One semester (seven weeks), once a week

CREDITS: Three

goals and objectives

To acquaint the student with historical background as it relates to the artist's role in creating a book.

description of classes

Week 1—William Blake (1757–1827)

Slide presentation and lecture: Blake's self-published books of his poetry that were surrounded by his illustrations that he colored by hand. Examples include the "Songs of Innocence" (1789) and "Songs of Experience" (1794), and his versions of "Prophetic Books" (1783–1804).

Discussion: Blake's visionary quality and his stylistic impact on Art Nouveau.

Suggested reading: *Book of Urizen* by William Blake.

Homework: visualize in your own way a page of poetry from Blake. Type and image should reflect Blake's approach to the book.

Week 2—Art Nouveau

Slide presentation and lecture: The Art Nouveau movement and how it applied to the book form that spread across Europe and America in the 1890s. Flat patterns were used, based on a naturalistic conception of plants rather than a formalized type of decoration.

Discussion: Art Nouveau's writing forms from nature and Blake's visionary forms.

Homework: using the principles of Art Nouveau, create a book jacket with image and type.

Week 3—Arts and Crafts Movement and the English Book Illustrators (1850–1900)

Discussion: The Arts and Crafts movement of William Morris may be the progenitor of Art Nouveau, but the focus of the class is how the book form evolved. Slides and lecture include Beardsley, Rackham, and Dulac.

Blake's influence on subject matter, fairies, demons, and spiritual forces are cross-referenced.

Homework: imagine a fairy or demon in a real form giving you a toothache, headache, or any personal discomfort or pleasure you have experienced.

Week 4—Howard Pyle and the Brandywine School's Impact on American Books (1900–1930)

Slides and lecture: The focus of the class is Howard Pyle, often called the father of American illustration, and the students he accepted into his private art school now known as the Brandywine School, including N.C. Wyeth, Maxfield Parrish, and numerous alumni. Examples of the American approach to the illustrated book are cross-referenced with the English book illustrators.

Homework: using Pyle's technique of under painting, create a dramatic moment from a drawing.

Week 5—The Periodical, the Magazine, and Their Impact on Illustrated Books

Discussion: *The Studio* (1893), a periodical that featured illustration with text, helped spread word and image on the printed page. In Germany, there was a movement called Jugendstil, after a magazine *Jugend* (Youth), which was first published in 1896.

Slides and lecture: artists who contributed to *Simplicissimus*, a weekly anti-fascist newspaper. Artists included George Grotz, John Heartfield, Kate Kollowitz, and others.

Homework: create a social commentary based on any aspect of our society.

Week 6—Magritte

Discussion: The Belgian surrealist and his impact on conceptual, contemporary illustration.

Homework: illustrate in your own way the principles of Magritte taken from his journals.

Week 7—Survey of Contemporary Illustration

Summary of class

Introduction to the next seven-week course "Book Seminar."

Were art to redeem man, it could do so
only by saving him from the seriousness of life and
restoring him to an unexpected boyishness.

—Jose Ortega y Gasset, *The Dehumanization of Art* (1925)

contributors

Sal Amendola graduated in 1969 from the School of Visual Arts, and has taught there since October 1974. Primarily known for having done the art and writing for Superman, Batman, and Archie Comics, he had been part of almost every facet of the comic book art/craft/science, and has "dabbled" in other branches of illustration and the arts, from advertising to portrait painting.

Jonathan Barkat is an illustrator and photographer whose clients include Random House, *Time, Rolling Stone*, Scholastic, and HarperCollins. His work is atmospheric, using light and color to create images that are seamless blends of fantasy and reality. His work has been recognized by the Society of Illustrators and *Print* magazine's Design Annual. He grew up in Cape May, New Jersey, and graduated from the University of the Arts in Philadelphia. After many years in New York City, he currently lives with his wife and daughter in Philadelphia.

George Bates is interested in the codification of perception. His illustration involves a variety of approaches to visual communication, which have originated from extensive sketchbook explorations. Often the sketchbooks serve as the only portfolio a client sees. Clients have the option of using preexisting images out of the books for publication or commissioning new work based on particular explorations.

Wesley Bedrosian's editorial illustrations have appeared in numerous magazines and newspapers, including the *New York Times*, the *Wall Street Journal*, *Time*, and *Forbes*. He has received awards from *Communication Arts* and *American Illustration*. He also art directs at the *New York Times* and teaches at the School of Visual Arts. He currently lives and works in Montclair, New Jersey.

Jorge Benitez is a painter, printmaker, and designer with a Master of Fine Arts. Born in Cuba, this former Marine has worked in advertising as a creative director and designer. Fluent in French and Spanish, he has shown his work at the Corcoran Gallery in Washington, D.C., and his work is in the permanent collection of the Virginia Museum of Fine Arts in Richmond.

Brian Biggs is an illustrator, designer, animator, writer, and assistant professor of illustration at the University of the Arts in Philadelphia. He is a graduate of the Communication Design program at Parsons School of Design and has worked as a designer and art director in Paris, Ft. Worth, and San Francisco before answering the call of the wild and becoming a freelance illustrator. As an illustrator, his clients include the Museum of Modern Art, Random House Children's Books, National Public Radio, Capitol One, the *New York Times*, and numerous newspapers and magazines.

Cliff Cramp's work in illustration includes background painting for animation; storyboard and visual development art for feature film and television; and editorial and book illustration. He is an associate professor in illustration and illustration area coordinator at California State University, Fullerton. He instructs classes in traditional and digital illustration and painting with a focus on narrative illustration.

Bill Finewood is an associate professor of illustration at Rochester Institute of Technology with a Master of Fine Arts from Syracuse University and has been in the illustration and graphic design business since 1974. He has served as a member of the board of directors for ICON4 2005 in San Francisco. His illustration has been commissioned by clients including Kodak, Xerox, Mobil, DuPont, Chase Manhattan, Citibank, Federal Reserve Bank, Dunn and Bradstreet, Pfizer Pharmaceuticals, Nalge Company, *Time*, Fisher-Price Toys, and Habitat for Humanity. Bill's dimensional illustration has been exhibited in shows including the Society of Illustrators and the Dimensional and Digital Illustrators Awards Show.

Tom Garrett is an associate professor and illustration coordinator at the Minneapolis College of Art and Design. He has been teaching since 1986 and his work has been recognized in *Communication Arts*, *Print*, *How*, *American Illustration*, the Society of Illustrators of Los Angeles, Dimensional Illustrators, the Society of Publication Design, and the New York Art Director's Club. His clients include *Atlantic Monthly*, *U.S. News & World Report*, *Business Week*, *National Journal*, The *Washington Post*, *Chicago Tribune*, *Fortune*, *TV GUIDE*, Bloomberg, The *Wall Street Journal*, *Good Housekeeping*, *McCall's*, *Kiplinger*, and *National Geographic Traveler*.

Chris Gash is an illustrator for the *New York Times*, *Time* magazine, *Newsweek*, and others. He is currently a part-time instructor in the fine arts department at Montclair State University in New Jersey.

Ralph Giguere is a graduate of the illustration department of the University of the Arts. His illustrations have appeared in *The New Yorker*, *Atlantic Monthly*, and the *Boston Globe*, among others. His work has been included in the Society of Illustrators Annual, *Communication Arts* Illustration Annual, *Graphis*, and *American Illustration*.

Rudy Gutierrez is a Pratt Institute graduate whose award-winning art has appeared nationally and abroad. Among his honors, Gutierrez includes the Dean Cornwell Recognition award, Distinguished Educator in the Arts award, and a Gold Medal from the New York Society of Illustrators. He has lectured and taught at various institutions, and has been a faculty member at Pratt Institute since 1990 where he is the illustration coordinator.

Christian Hill has freelanced as an illustrator and computer graphic artist for clients such as the Smithsonian and Disney since 1995. As an aficionado of comic art, he encourages its practice through courses, workshops, and events, and he promotes its appreciation through presentations and scholarly publishing. He is working on graphic novels for children and adults, and he is a pioneer in the field of gallery comics.

Mike Hodges earned a Bachelor of Fine Arts from Auburn University and a Master of Fine Arts from Syracuse University. He continues to work as a freelance illustrator and fine artist, and has received numerous awards for his work. He has twenty-five years of college teaching experience and is currently teaching illustration at Ringling School of Art and Design in Sarasota, Florida.

265

Nick Jainschigg is an illustrator and teacher. He lives in Rhode Island with his wife, Monica, and almost enough books.

Federico Jordán is an editorial and advertising illustrator, after formal training as an architect and taking some workshop courses in Antigua Academia de San Carlos in Mexico City. Among his clients are AARP, *Forbes*, the *Wall Street Journal*, the *Washington Post*, *Harvard Business Review*, Stanford University, and American Airlines. He is currently a professor at the Universidad Autónoma de Nuevo León's School of Visual Arts (Facultad de Artes Visuales) in Monterrey, Nuevo León, Mexico.

Viktor Koen holds a Bachelor of Fine Arts from the Bezalel Academy of Arts & Design in Jerusalem and a Master of Fine Arts with honors from the School of Visual Arts. He serves on the faculty of Parsons School of Design and the Master of Fine Arts Illustration program of the School of Visual Arts. His images are regularly published in the *New York Times Book Review*, *Time*, *Newsweek*, and *Esquire*. His award winning prints are exhibited in galleries and museums worldwide.

Nora Krug studied set design, documentary film, and illustration in Liverpool, where she earned a Bachelor of Fine Arts, and in Berlin, where she

earned a Master of Fine Arts. A Fulbright scholarship brought her to New York to study in the Master of Fine Arts Illustration program at the School of Visual Arts. Nora has been working as a freelance illustrator for clients such as the *New York Times*, *Playboy*, and Comedy Central. Her work has been recognized by the Society of Illustrators, *American Illustration*, and the New York Art Director's Club. Her animated project *How-to-Bow* was selected for the 2005 Sundance Online Film Festival. Nora spends half the year in northern Germany as an illustration professor at the Muthesius University in Kiel.

Peter Kuper co-founded of the political 'zine *World War 3* in 1979 and remains on its editorial board to this day. He has taught courses in Illustration and comics since 1986 and is also an art director of INX, a political illustration group (INXart.com). His work appears regularly in *Time*, the *New York Times*, and *MAD* where he illustrates "SPY vs. SPY" every month. He has written and illustrated many books including *Comics Trips*, a journal of an eight-month trip through Africa and Southeast Asia. Other works include *Stripped: An Unauthorized Autobiography*, *Mind's Eye*, and *The System*, a wordless graphic novel. He has done adaptations of Upton Sinclair's *The Jungle* and numerous short stories of Franz Kafka, all of which can be seen in *SPEECHLESS*, a coffee table art book covering his career to date. His most recent books are an adaptation of Franz Kafka's *The Metamorphosis* and *Sticks and Stones*, a wordless graphic novel about the rise and fall of empires. More of his work can be seen at *www.peterkuper.com*

266

Julie Lieberman has been teaching illustration since 1986. She has taught at East Carolina University, Pratt, School of Visual Arts, and currently at the Savannah College of Art and Design. Her work has appeared in *Communication Arts*, *Print*, Savannah Danse theater posters, among other venues. She continues to do freelance illustration, personal paintings, and professional sand sculpture along with updating her book project *Survey of Illustration*, which was published in Korea, 2002.

Kevin McCloskey's first piece of paid journalism was an illustrated dispatch from Saigon, 1971. He has worked in a factory, a funeral parlor, and a tavern. He was once Santa Claus at Macy's. In 1986 he received his Master of Fine Arts from the School of Visual Arts. Currently teaching illustration at Kutztown University of Pennsylvania, he loves his job.

Jon McDonald received his MFA in painting and drawing from the San Francisco Art Institute. Fort the past 26 years he has been a professor of illustration at Kendall College of Art and Design. His paintings can be found in the collections of MacDonald's Corporation and Steelcase Corporation among others.

Robert Meganck is professor of illustration, graphic design, and digital imaging in the communication arts department at Virginia Commonwealth University and a freelance illustrator and president of Communication Design,

Inc. He received a Bachelor of Fine Arts from the Center for Creative Studies in Detroit and a Master of Fine Arts from Cranbrook Academy of Art in Bloomfield Hills, Michigan. Robert has received numerous professional awards and been included in *American Illustration*, the Society of Illustrators Annual, *3 X 3*, *Print*, and *Communication Arts*.

James Miller is a painter born in Scotland and chair of the communication arts department at Virginia Commonwealth University in Richmond, Virginia. He attended Newcastle College of Art and Leeds College of Art in England where he received the Dip. A.D. (Hons.). He received the Master of Fine Arts from University of Arkansas. The recipient of an Individual Fellowship grant from the National Endowment for the Arts, he is also a founding member and president of 1708 GALLERY, the first artist-directed gallery in Virginia, and has shown his work in galleries and museums throughout the United States and abroad.

Dan Nadel is the director of the Grammy-Award winning visual culture studio and publishing house PictureBox, which produces *The Ganzfeld*, an annual book of pictures and prose. Other PictureBox books include *Cheap Laffs*, *Paper Rad*, *B.J. and Da Dogs*, and *The Wilco Book*. He is the author of the *Art Out of Time: Unknown Comics Visionaries 1900-1969* (Harry N. Abrams, 2006) and is a visiting professor at the Parsons School of Design.

Michael O'Shaughnessy is a senior lecturer in graphic arts (illustration) at Liverpool School of Art & Design. His recent clients have included Elbow / V2 Records and Love Creative Manchester. His Web site is moshaughnessy.co.uk.

John A. Parks is a painter currently represented by the Allan Stone Gallery in New York, John Bloxham Galleries in London, and by Paul Holoweski Fine Art in Michigan. His work is in the collection of the Victoria and Albert Museum in London as well as many private collections. He has been a member of the School of Visual Arts faculty since 1979 and is also a contributing editor of *Watercolor* magazine. In addition to showing widely as a painter since the late 1970s, he has published many articles on art and travel in publications ranging from the *New York Times* to *Sculpture*.

Lynn Pauley is a New York City artist and illustrator who believes in making compelling authentic pictures that matter. Her expressive onsite illustrations have appeared in the *New York Times*, *The New Yorker*, *Sports Illustrated*, and *Boy's Life*, to list a few. Corporate installations include large-scale commissions for Dean & Deluca, the Orlando Convention Center, and four original wraparound murals for Pentagram Design and the Robin Hood Foundation's Library Initiative in Bronx elementary schools. The illustration lesson plans included in this book were developed and used to teach sophomore level Illustration students at Pratt Institute in Brooklyn, New York.

Carole Potter is a senior lecturer in graphic arts (interaction) at Liverpool School of Art & Design.

George Pratt is an internationally known illustrator, graphic novelist, and painter. He is associate professor in the communication arts department at Virginia Commonwealth University. He also teaches each in the summer with the Illustration Academy.

Matthew Richmond is a founding partner and creative director at The Chopping Block, Inc. (*www.choppingblock.com*), a full-service graphic design studio founded in 1996 on the principle that good design spans all mediums. His work has won notable recognition from *Communication Arts*, *I.D. Magazine*, *HOW Magazine*, Flash Forward, and The Cooper Hewitt National Design Museum's Triennial Exhibition. When not in the studio, Matthew can be found teaching digital illustration, Flash, and advanced techniques to the graduate students at the School of Visual Arts.

Richard Ross is coordinator of the communication design program at the State University of New York, Buffalo. His illustrations have been commissioned by magazines, newspapers, book publishers, and corporations, including *Newsweek*, the *Washington Post*, Random House, International Paper Corporation, and Merrill Lynch. Richard's work has been featured in *Graphis*, *Print*, *American Illustration*, and the Society of Illustrators Annual.

268

Stephen Savage was born in Los Angeles and grew up in Minneapolis. His illustrations appear regularly in the *New York Times*, *Entertainment Weekly*, and *Vibe* magazine. He illustrated the bestselling children's book *Polar Bear Night*, which was also named a *New York Times* Best Illustrated Book and a *New York Times* Notable Book for 2004. He has received numerous awards from *Communication Arts*, *American Illustration*, and the Society of Illustrators. He has taught at the School of Visual Arts in Manhattan since 2002.

Frederick Sebastian's Illustrations have appeared in the *New York Times Book Review*, *Los Angeles Times Magazine*, the *Washington Post*, and *The Ottawa Citizen*. He has a Bachelor of Arts in Art History from Carleton University, winning the President's Medal, and has his Baccalaureate in Education from Ottawa University. He is an instructor in the arts, media & design department at Algonquin College and the undergraduate Information Technology program.

Yuko Shimizu graduated in 2003 with Master of Fine Arts from the Illustration as Visual Essay program at the School of Visual Arts. Her clients include Target, NPR, M.A.C. Cosmetics, *Rolling Stone*, *Vibe*, *Spin*, *Entertainment Weekly*, *Premiere*, *Interview*, *Esquire*, *NYLON*, the *New York Times*, the *Financial Times*, the *Wall Street Journal*, *Fortune*, and *The New Yorker*.

Jeffrey Smith was born in Los Angeles and moved to New York after earning his Bachelor of Fine Arts in illustration from the Art Center College of Design. While in New York, Smith did cover and feature assignments for *Sports Illustrated, Newsweek, Time, Rolling Stone, Wig Wag,* the *New York Times,* and the *Boston Globe* magazines. He earned his masters from the School of Visual Arts, and taught in the undergraduate illustration department there. In 1994, he moved to Los Angeles and has continued to thrive as an editorial illustrator while teaching at the Art Center College of Design.

Dugald Stermer chairs the illustration department at California College of the Arts in San Francisco. His illustrations have appeared in the *New York Times, Esquire, Time, Rolling Stone, Utne Reader, Washington Post, The New Yorker,* and other magazines. His clients include Nike, BMW, and Jaguar. He is the author of various books on fauna and flora.

Mark Tocchet is an award-winning illustrator, designer, and chair of the illustration department at the University of the Arts in Philadelphia, where he lives with his wife, two sons, and daughter. His clients include the American Museum of Natural History, Campbell's, Citibank, CBS, Harlequin, Random House, Sierra Club, and Penguin Group. He is currently principal of Tocchet Studio, a design and illustration studio specializing in creative visual problem-solving for the book publishing and package design markets. His work has been recognized by *Communication Arts, Print,* and the Society of Illustrators.

269

Bruce Waldman is an illustrator, printmaker, and designer. He is also the director of the New York Society of Etchers and an adjunct professor at the School of Visual Arts. His work is in the permanent collections of the Metropolitan Museum of Art, Library of Congress, Smithsonian Institute, Hackley Museum of Art, Housatonic Museum of Art, and the New York Transit Museum.

Michele Zackheim teaches creative writing from a visual perspective in the Master of Fine Arts illustration program at the School of Visual Arts. As a visual artist, she has work in the permanent collections of the National Museum of Women in the Arts, Grey Art Gallery of New York University, the New York Public Library, and many others. As a writer she has been published by Riverhead Books, a member of the Penguin Group. Her books include *Violette's Embrace; Einstein's Daughter: The Search for Lieserl; Mary Cole;* and *The Portrait of Sophie Marks.*

Learning makes a man fit company for himself.
—Thomas Fuller, M.D., *Gnomologia* (1732)

index

271

275

Books from Allworth Press

Allworth Press is an imprint of Allworth Communications, Inc. Selected titles are listed below.

American Type Design and Designers
by David Conseugra (paperback, 9 × 11, 320 pages, $35.00)

Teaching Graphic Design
edited by Steven Heller, (paperback, 6 × 9, 304 pages, $19.95)

The Education of a Graphic Designer
edited by Steven Heller (paperback, 6¾ × 9⅞, 288 pages, $18.95)

The Education of an Illustrator
edited by Steven Heller and Marshall Arisman (paperback, 6¾ × 9⅞, 288 pages, $19.95)

The Education of an E-Designer
edited by Steven Heller (paperback, 6¾ × 9⅞, 352 pages, $21.95)

The Education of a Design Entrepreneur
edited by Steven Heller (paperback, 6¾ × 9⅞, 288 pages, $21.95)

Graphic Design History
edited by Steven Heller and Georgette Balance (paperback, 6¾ × 9⅞, 352 pages, $21.95)

Texts on Type
edited by Steven Heller and Philip B. Meggs (paperback, 6¾ × 9⅞, 288 pages, $19.95)

Editing by Design, Third Edition
by Jan V. White (paperback, 8½ × 11, 256 pages, $29.95)

The Elements of Graphic Design: Space, Unity, Page Architecture, and Type
by Alexander White (paperback, 6⅛ × 9¼, 160 pages, $24.95)

Citizen Designer: Perspectives on Design Responsibility
edited by Steven Heller and Véronique Vienne (paperback, 6 × 9, 272 pages, $19.95)

Inside the Business of Graphic Design: 60 Leaders Share Their Secrets of Success
by Catharine Fishel (paperback, 6 × 9, 288 pages, $19.95)

Looking Closer 4: Critical Writings on Graphic Design
edited by Michael Bierut, William Drenttel, and Steven Heller (paperback, 6¾ × 9⅞, 304 pages, $21.95)

Please write to request our free catalog. To order by credit card, call 1-800-491-2808 or send a check or money order to Allworth Press, 10 East 23rd Street, Suite 510, New York, NY 10010. Include $6 for shipping and handling for the first book ordered and $1 for each additional book. Eleven dollars plus $1 for each additional book if ordering from Canada. New York State residents must add sales tax.

To see our complete catalog on the World Wide Web, or to order online, you can find us at
www.allworth.com.